WEYLAND·YUTANI CORP

INSIGHT EDITIONS

San Rafael, California

WARNING

THIS REPORT CONTAINS PRIVILEGED INFORMATION THAT IS THE PROPERTY OF THE WEYLAND-YUTANI CORPORATION. CLEARANCE LEVEL S2 AND ABOVE ONLY. EMPLOYEES AND CONTRACTED WORKERS WITH CLEARANCE LEVELS BELOW S2 FOUND IN POSSESSION OF THIS REPORT CAN EXPECT IMMEDIATE TERMINATION AND SUBSEQUENT LEGAL PROSECUTION. THE INFORMATION WITHIN SPANS THREE CENTURIES OF WEYLAND-YUTANI CONTACT WITH NON-HUMAN INTELLIGENCE, FOCUSING ON XENOMORPH XX121— ITS LIFE CYCLE, BEHAVIOR, RECORDED INTERACTIONS WITH HUMANS, AND THE RESOURCES INVOLVED IN ITS CAPTURE AND CONTAINMENT. THROUGHOUT THIS REPORT, ▮▮▮▮▮ ▮▮▮▮▮ INDICATES CONFIDENTIAL INFORMATION THAT FALLS OUTSIDE OF YOUR SECURITY CLEARANCE. ONLY BY SHOWING YOUR WORTH TO THE WEYLAND-YUTANI CORPORATION WILL THIS INFORMATION BECOME AVAILABLE. IF YOU ARE READING THIS REPORT WITHOUT LEVEL S2 AUTHORIZATION, IMMEDIATELY DISCONTINUE AND CONTACT CORPORATE SECURITY, AVAILABLE AT ALL TIMES AT 349000/S21/WYS@CORP.NET. REPORT AS ENCRYPTION SECURITY FAILURE. FAILURE TO REPORT AN UNSECURED COPY WILL RESULT IN MAXIMUM PENALTIES.

A L I E N

THE WEYLAND-YUTANI REPORT

S. D. PERRY

INSIGHT EDITIONS

San Rafael, California

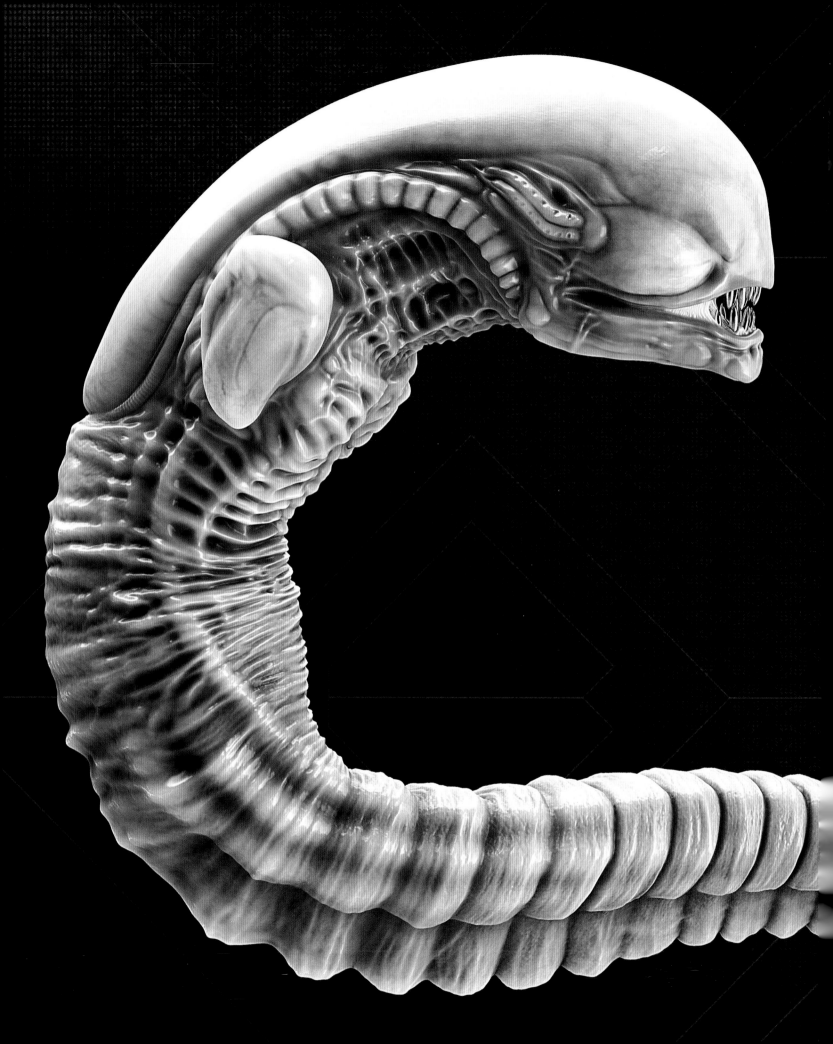

CONTENTS

COMPANY STATEMENT OF INTEREST

when multinational political changes on earth and within the core systems required the breakup of the weyland-yutani corporation only decades ago, the company agreed to a designation change. to the general public and most military interests, there is no longer a company, and obviously, the need to appear respectful of the law is ongoing. with the empty empire of the united systems military on the decline, however, the laws will be changing soon. considering the usm's recent unprecedented mishandling of the xenomorph, we feel that it is time to reclaim our public status—as weyland-yutani—and prioritize a new era of research and development based on xenomorph xx121.

two centuries ago, we wanted to harness the creature's superior power for bioweapons applications, but consider how much more this species has to offer. the advances to be made in pharmacology, bioengineering, defense—possibilities we can't yet dream of—are without limit. we have the resources; all we need is the xenomorph.

the urgency of obtaining a specimen demands the attention of every w-y employee worthy of clearance. there is new data already being collated regarding the most recent contact, and as prospects arise, the decisions we make regarding these opportunities may well define the course of humanity for centuries to come. it is time for us to honor the brilliance and ingenuity shown by sir peter weyland over three centuries ago, when he set forth to lead us to new worlds. sir peter visualized solutions to the impossible by seeing further than any man before him. now, we look to the xenomorph and can see the future of weyland-yutani.

WEYLAND·YUTANI CORP

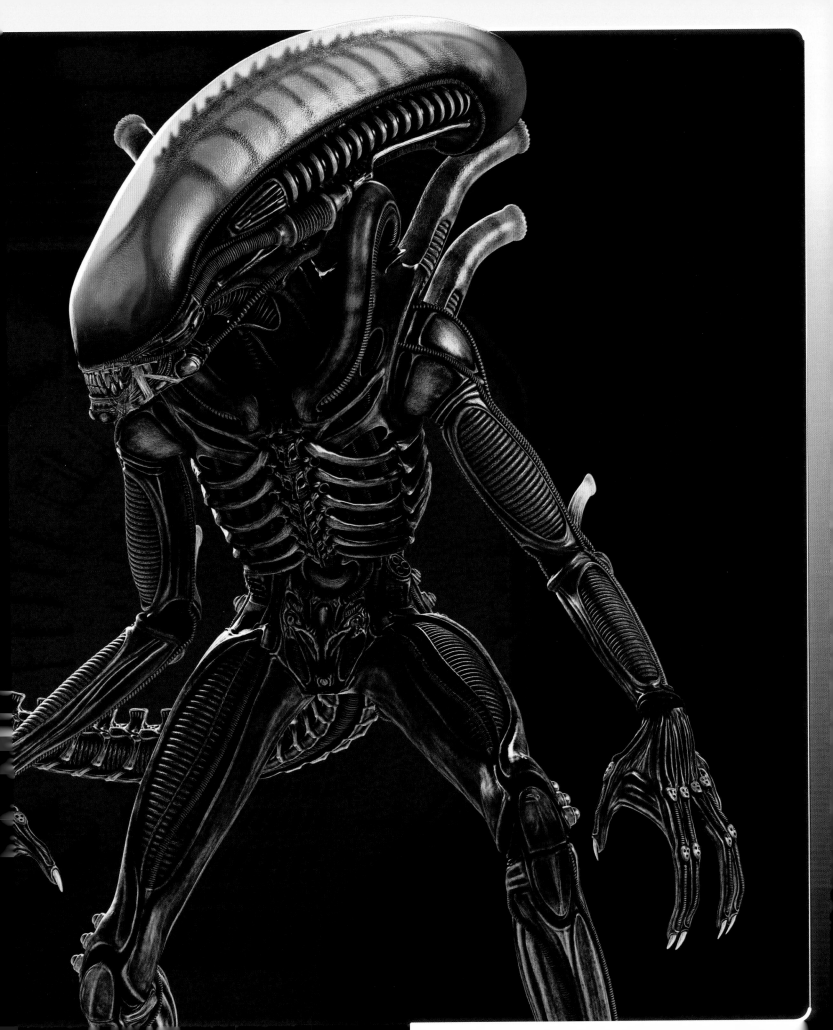

COMPANY TIME LINE

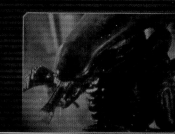

2012 The Weyland Corporation is formed.

2023 First patent for Method and Apparatus for Cybernetic Individuals granted to the Weyland Corporation.

2039 The first breathable atmosphere is created on an extrasolar planet—GJ 667Cc—following deployment of a Weyland Atmosphere Processor.

2093 Sir Peter Weyland dies on LV-223.

2094 Doctor Elizabeth Shaw transmits

2104 South, Central, and North America form a financial collective, the United Americas.

2122 First recorded contact with Xenomorph; LV-426 and USCSS *Nostromo*.

2130 Cofounded by the Weyland-Yutani Corpora Gateway Station is constructed.

2137 Civilian Amanda Ripley encounters Xenomorph at Sevastopol.

2157 Hadley's Hope, a Weyland-Yutani terraforming colony, is established on LV-426.

2000 **2025** **2050** **2075** **2100** **2125** **2150** **2175**

2091 The *Prometheus* mission leaves for LV-223.

2034 The first FTL-capable vessel, the *Heliades*, is introduced by the Weyland Corporation.

2101 The United States Colonial Marine Corps is established.

2099 The Weyland Corporation absorbs cybernetics rival Yutani; the Weyland-Yutani Corporation opens with the largest share value ever recorded on the Systems Exchange.

2179 Third and fourth recorded contacts Xenomorp LV-426/U *Sulaco* an Fiorina 16

2202 United Americas, EU/UK, China, Heelal Yo, and four independent Core System colonies form the United Systems.

2226 United Systems Military is established.

2349 Megacorporations are banned; Weyland-Yutani loses final appeal to retain designation three years later.

2293 Rival company Ridton markets advanced FTL drive; Weyland-Yutani loses USM contract for FTL vessels.

2376 The first auton is manufactured, an android designed by androids.

2291 Weyland-Yutani colony at Nu Indi successfully sues for independence.

| 2200 | 2225 | 2250 | 2275 | 2300 | 2325 | 2350 | 2375 | 2400 |

2219 The *Geryon/Kadmos* mission leaves for LV-223; contact with the *Kadmos* is terminated after

2306 Artificial Persons from the Alethea Collective are granted civil rights; all cybernetics divisions suffer financial loss.

2379 Following a violent uprising on Luna/AE, autons are recalled and destroyed.

2356 DNA samples from a Xenomorph-implanted human (Ellen Ripley) are rediscovered by the USM.

2381 Most recent recorded contact with Xenomorph; USM *Auriga*.

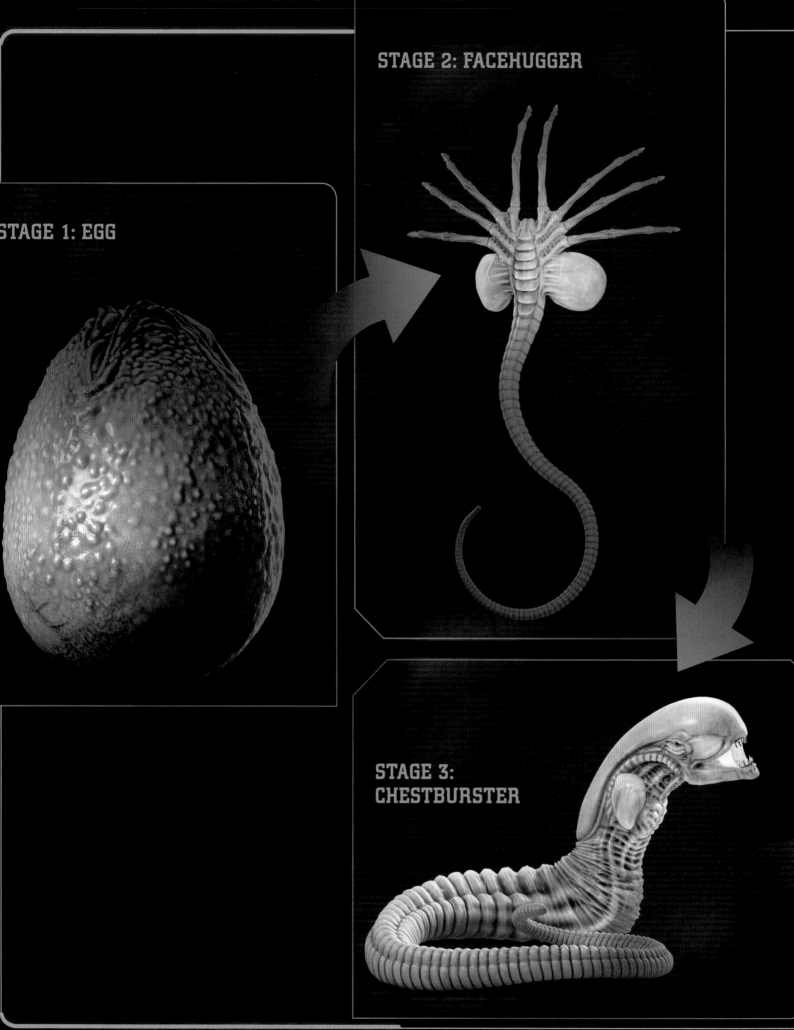

STAGE 1: EGG

STAGE 2: FACEHUGGER

STAGE 3:
CHESTBURSTER

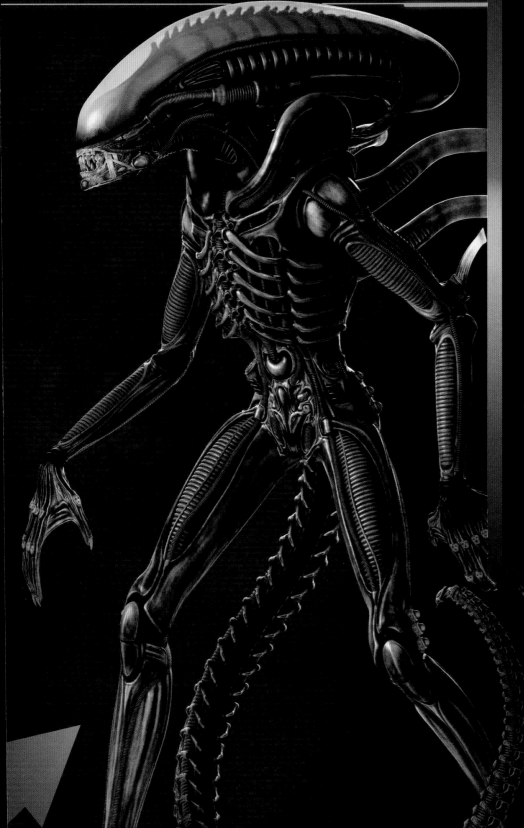

XENOMORPH XX121—BASIC LIFE CYCLE

SO THAT EVERY EMPLOYEE UNDERSTANDS THE NATURE OF THIS INVALUABLE RESOURCE, WHAT FOLLOWS IS A SOMEWHAT SIMPLIFIED OVERVIEW OF THE XENOMORPH'S LIFE CYCLE. VARIATIONS FROM THIS CYCLE ARE ADDRESSED IN OTHER SECTIONS AND WHERE APPLICABLE.

STAGE 4: DRONE

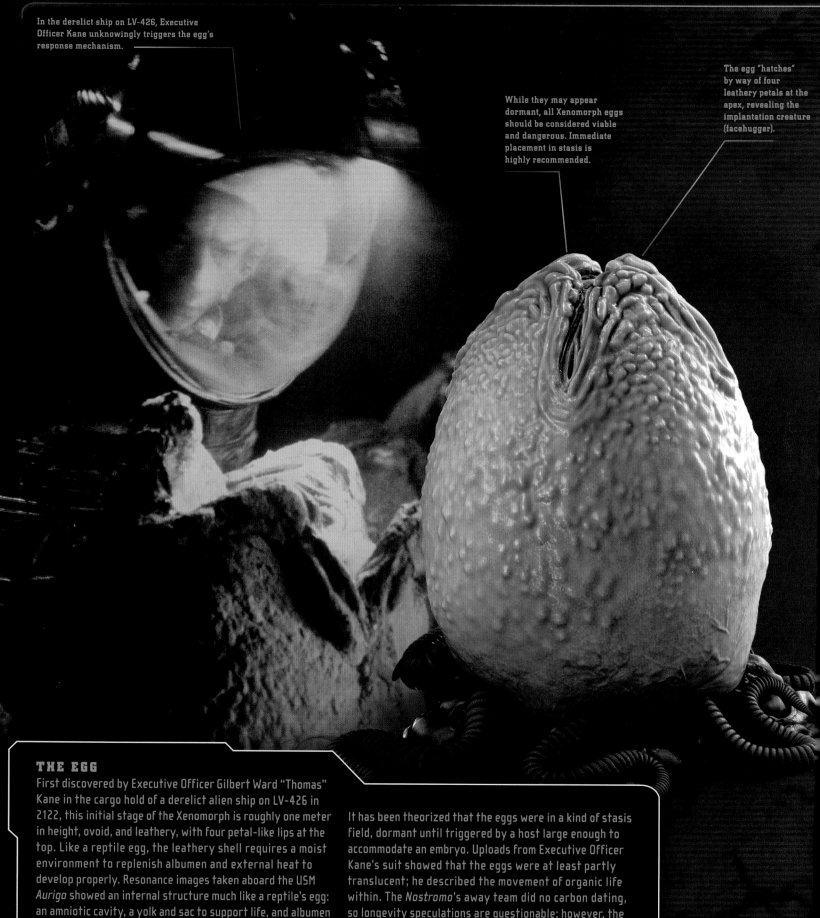

In the derelict ship on LV-426, Executive Officer Kane unknowingly triggers the egg's response mechanism.

While they may appear dormant, all Xenomorph eggs should be considered viable and dangerous. Immediate placement in stasis is highly recommended.

The egg "hatches" by way of four leathery petals at the apex, revealing the implantation creature (facehugger).

THE EGG

First discovered by Executive Officer Gilbert Ward "Thomas" Kane in the cargo hold of a derelict alien ship on LV-426 in 2122, this initial stage of the Xenomorph is roughly one meter in height, ovoid, and leathery, with four petal-like lips at the top. Like a reptile egg, the leathery shell requires a moist environment to replenish albumen and external heat to develop properly. Resonance images taken aboard the USM *Auriga* showed an internal structure much like a reptile's egg: an amniotic cavity, a yolk and sac to support life, and albumen to supply hydration and shock absorption.

Besides remarking on the humid heat of the cargo hold, Executive Officer Kane also described a kind of field surrounding the eggs, consisting of directed light and a mist.

It has been theorized that the eggs were in a kind of stasis field, dormant until triggered by a host large enough to accommodate an embryo. Uploads from Executive Officer Kane's suit showed that the eggs were at least partly translucent; he described the movement of organic life within. The *Nostromo*'s away team did no carbon dating, so longevity speculations are questionable; however, the team noted that the alien ship seemed to have crashed or set down decades, or possibly centuries, before, and at least one of the eggs was still active in 2179, when an LV-426 colonist was implanted.

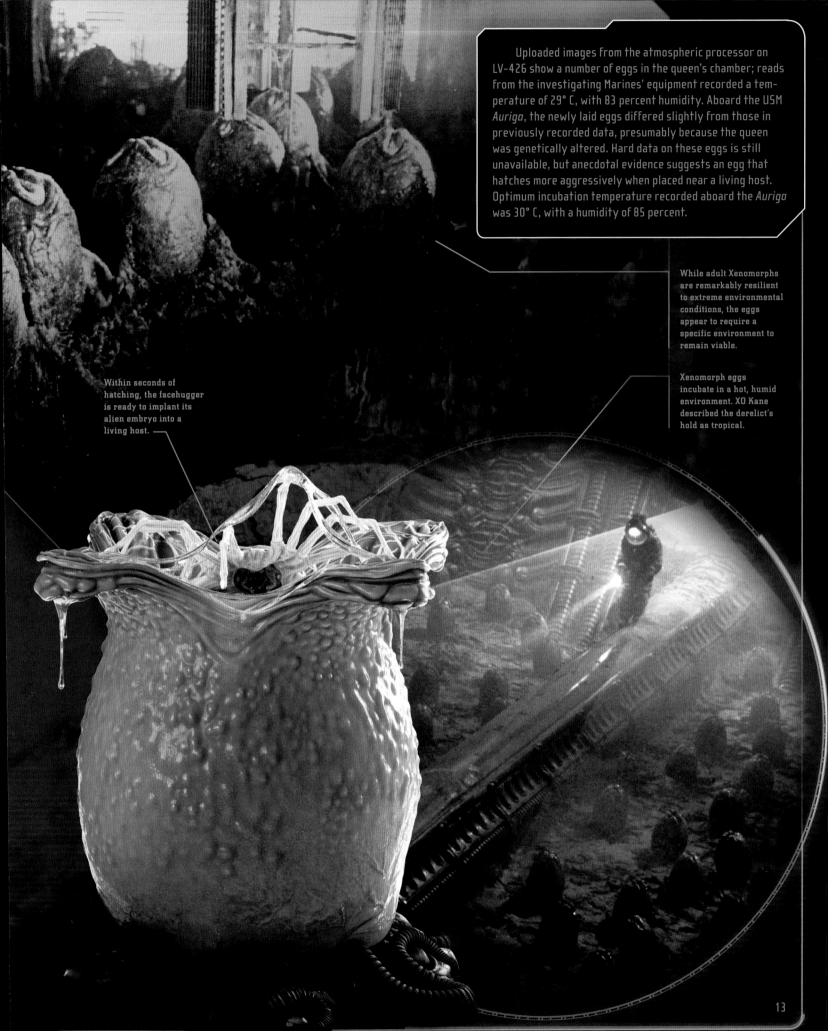

Uploaded images from the atmospheric processor on LV-426 show a number of eggs in the queen's chamber; reads from the investigating Marines' equipment recorded a temperature of 29° C, with 83 percent humidity. Aboard the USM *Auriga*, the newly laid eggs differed slightly from those in previously recorded data, presumably because the queen was genetically altered. Hard data on these eggs is still unavailable, but anecdotal evidence suggests an egg that hatches more aggressively when placed near a living host. Optimum incubation temperature recorded aboard the *Auriga* was 30° C, with a humidity of 85 percent.

While adult Xenomorphs are remarkably resilient to extreme environmental conditions, the eggs appear to require a specific environment to remain viable.

Within seconds of hatching, the facehugger is ready to implant its alien embryo into a living host.

Xenomorph eggs incubate in a hot, humid environment. XO Kane described the derelict's hold as tropical.

13

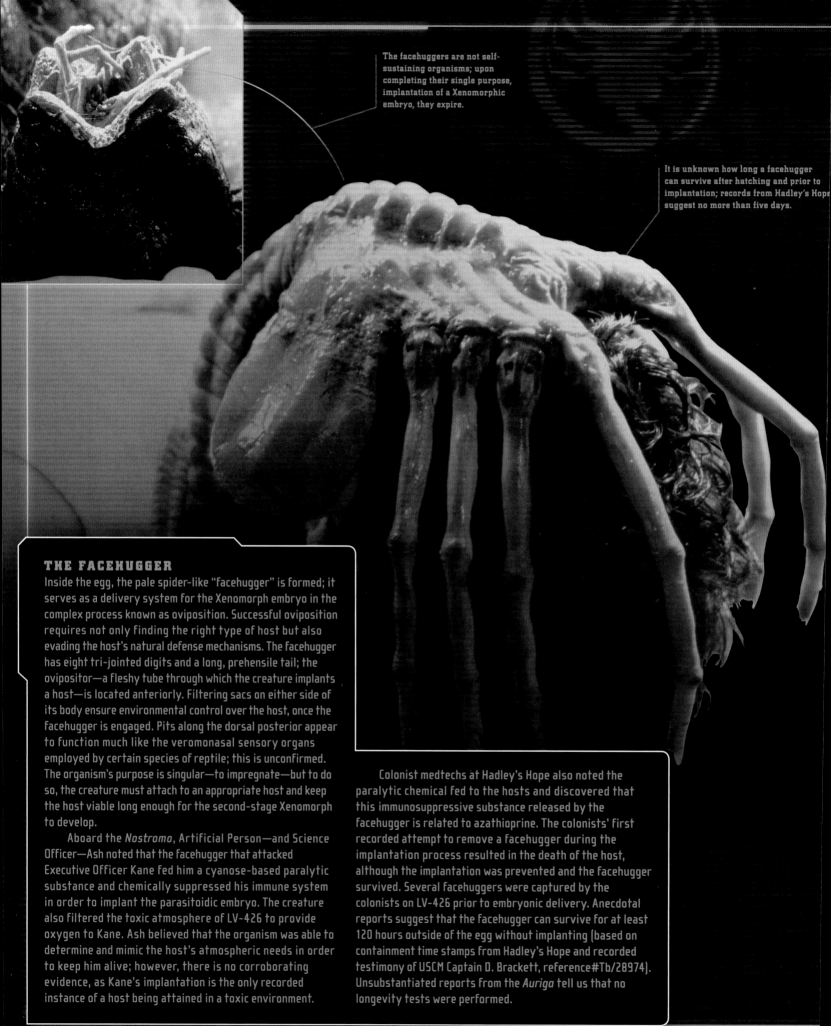

The facehuggers are not self-sustaining organisms; upon completing their single purpose, implantation of a Xenomorphic embryo, they expire.

It is unknown how long a facehugger can survive after hatching and prior to implantation; records from Hadley's Hope suggest no more than five days.

THE FACEHUGGER

Inside the egg, the pale spider-like "facehugger" is formed; it serves as a delivery system for the Xenomorph embryo in the complex process known as oviposition. Successful oviposition requires not only finding the right type of host but also evading the host's natural defense mechanisms. The facehugger has eight tri-jointed digits and a long, prehensile tail; the ovipositor—a fleshy tube through which the creature implants a host—is located anteriorly. Filtering sacs on either side of its body ensure environmental control over the host, once the facehugger is engaged. Pits along the dorsal posterior appear to function much like the veromonasal sensory organs employed by certain species of reptile; this is unconfirmed. The organism's purpose is singular—to impregnate—but to do so, the creature must attach to an appropriate host and keep the host viable long enough for the second-stage Xenomorph to develop.

Aboard the *Nostromo*, Artificial Person—and Science Officer—Ash noted that the facehugger that attacked Executive Officer Kane fed him a cyanose-based paralytic substance and chemically suppressed his immune system in order to implant the parasitoidic embryo. The creature also filtered the toxic atmosphere of LV-426 to provide oxygen to Kane. Ash believed that the organism was able to determine and mimic the host's atmospheric needs in order to keep him alive; however, there is no corroborating evidence, as Kane's implantation is the only recorded instance of a host being attained in a toxic environment.

Colonist medtechs at Hadley's Hope also noted the paralytic chemical fed to the hosts and discovered that this immunosuppressive substance released by the facehugger is related to azathioprine. The colonists' first recorded attempt to remove a facehugger during the implantation process resulted in the death of the host, although the implantation was prevented and the facehugger survived. Several facehuggers were captured by the colonists on LV-426 prior to embryonic delivery. Anecdotal reports suggest that the facehugger can survive for at least 120 hours outside of the egg without implanting (based on containment time stamps from Hadley's Hope and recorded testimony of USCM Captain D. Brackett, reference#Tb/28974). Unsubstantiated reports from the *Auriga* tell us that no longevity tests were performed.

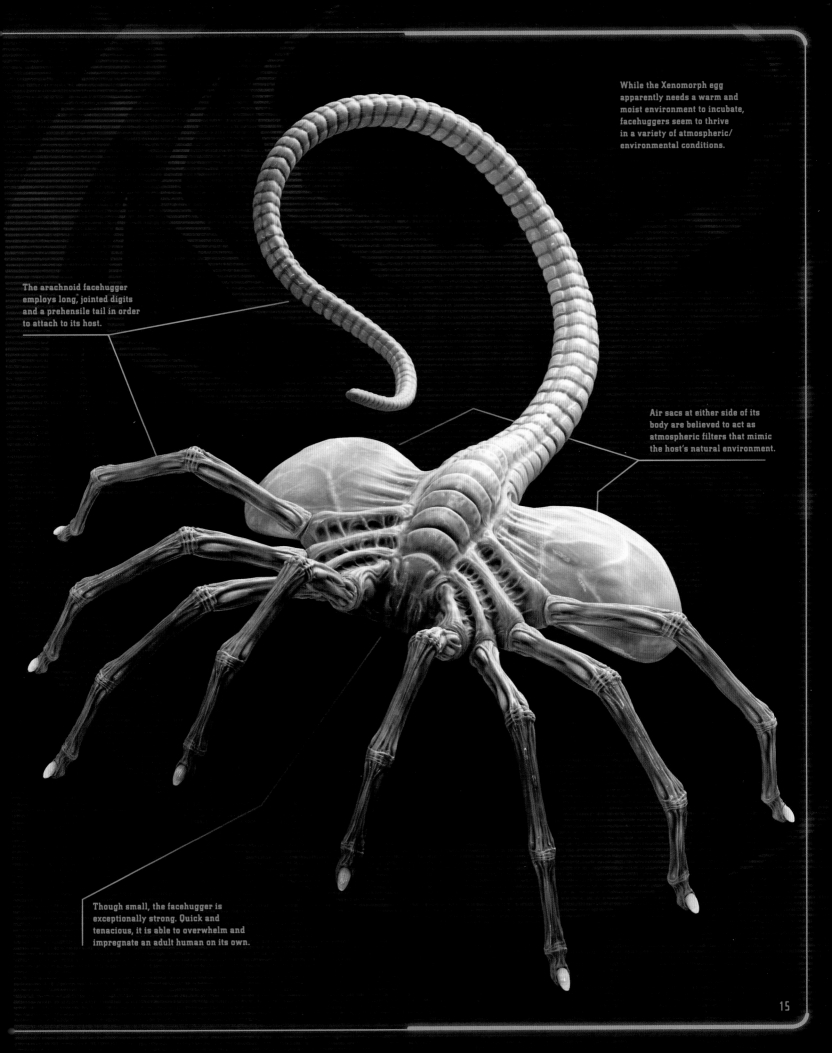

While the Xenomorph egg apparently needs a warm and moist environment to incubate, facehuggers seem to thrive in a variety of atmospheric/environmental conditions.

The arachnoid facehugger employs long, jointed digits and a prehensile tail in order to attach to its host.

Air sacs at either side of its body are believed to act as atmospheric filters that mimic the host's natural environment.

Though small, the facehugger is exceptionally strong. Quick and tenacious, it is able to overwhelm and impregnate an adult human on its own.

After delivery of the necrotrophic embryo, the face-hugger stays attached to the host until the implantation is secure; times appear to range from twenty minutes to sixteen hours. It is unknown how the facehugger receives the signal to disengage from the host, although scant evidence implies a recombinant plasmid chemical pulse. Its semelparous purpose fulfilled, the facehugger then crawls away to die. The host often wakes shortly thereafter and does not appear to be aware of the implantation. After-effects noted include a sore throat and a slight temperature.

All recorded variations of the facehugger are capable of expelling acid. The creature encountered by the crew of the *Nostromo* melted through Kane's face shield in seconds to gain direct access to a suitable orifice; aboard the USS *Sulaco*, a facehugger carrying a queen embryo similarly accessed Ellen Ripley's hypersleep chamber. Records from Hadley's Hope suggest that initial attempts to contain the facehuggers failed, resulting in several deaths; the LV-426 colonists finally enclosed specimens in an alkaloid nahcolite water bath, which apparently rendered their acid ineffective. Containers were made of W-Y Medgrade Tempurglass.

SO Ash was the first to suggest that Xenomorph XX121's blood is fluorine based. When the AP attempted to remove the facehugger from XO Kane, the organism bled a highly caustic compound that subsequently ate through two full decks of the *Nostromo*. At Hadley's Hope, an undetermined number of colonists were burned or killed in attempts to remove implanting facehuggers. All stages of Xenomorph XX121 exhibit this biology.

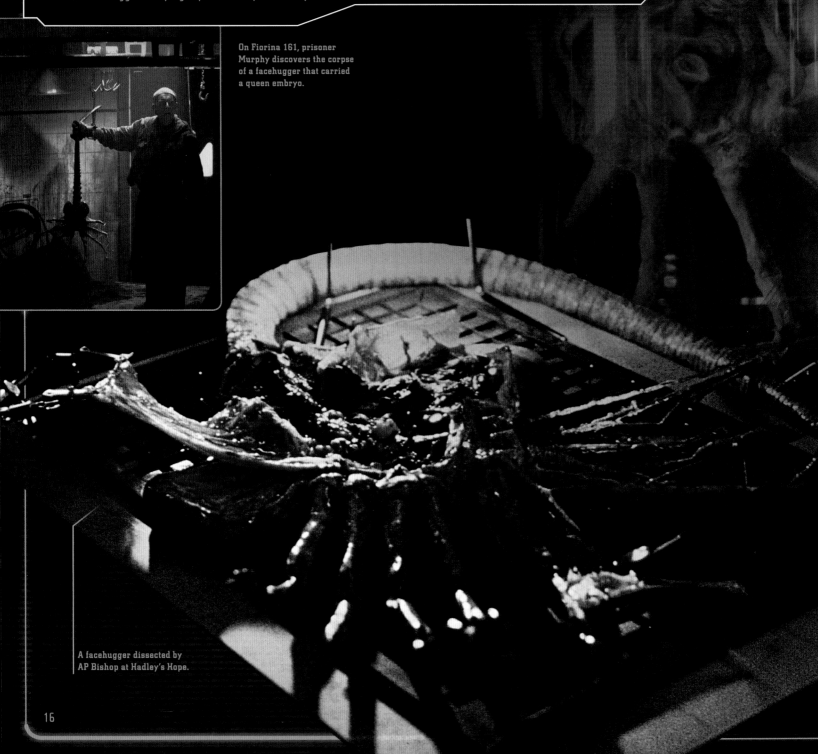

On Fiorina 161, prisoner Murphy discovers the corpse of a facehugger that carried a queen embryo.

A facehugger dissected by AP Bishop at Hadley's Hope.

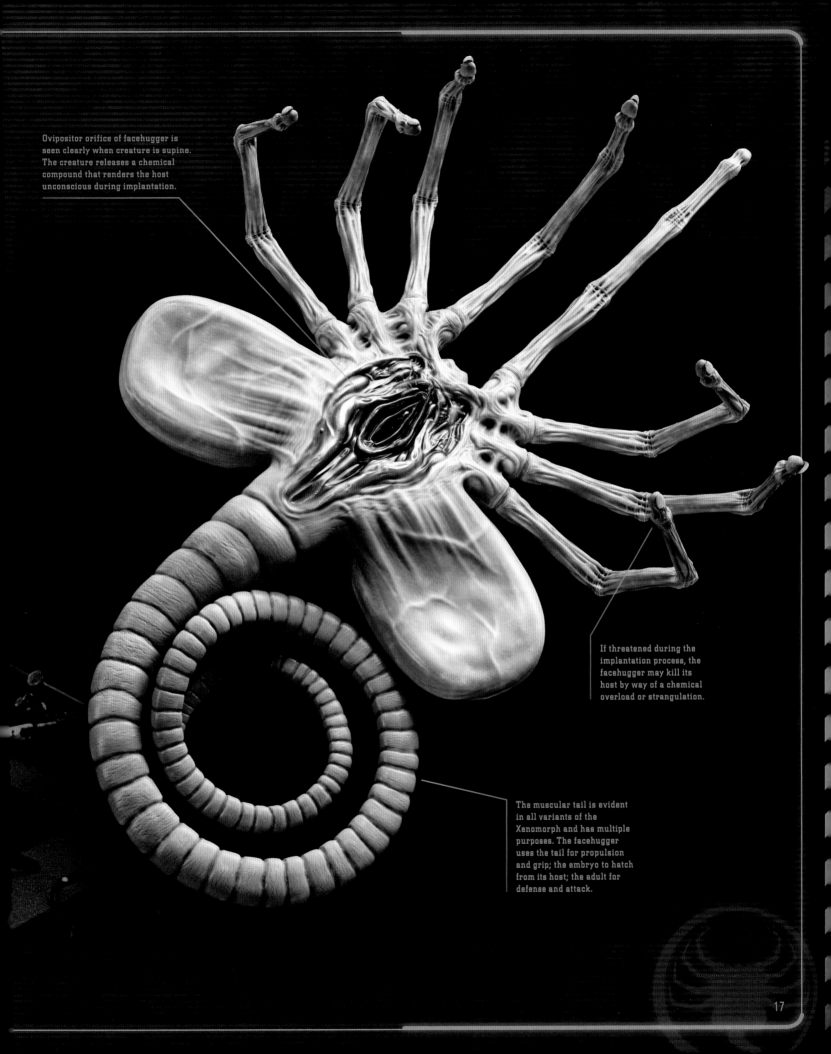

Ovipositor orifice of facehugger is seen clearly when creature is supine. The creature releases a chemical compound that renders the host unconscious during implantation.

If threatened during the implantation process, the facehugger may kill its host by way of a chemical overload or strangulation.

The muscular tail is evident in all variants of the Xenomorph and has multiple purposes. The facehugger uses the tail for propulsion and grip; the embryo to hatch from its host; the adult for defense and attack.

17

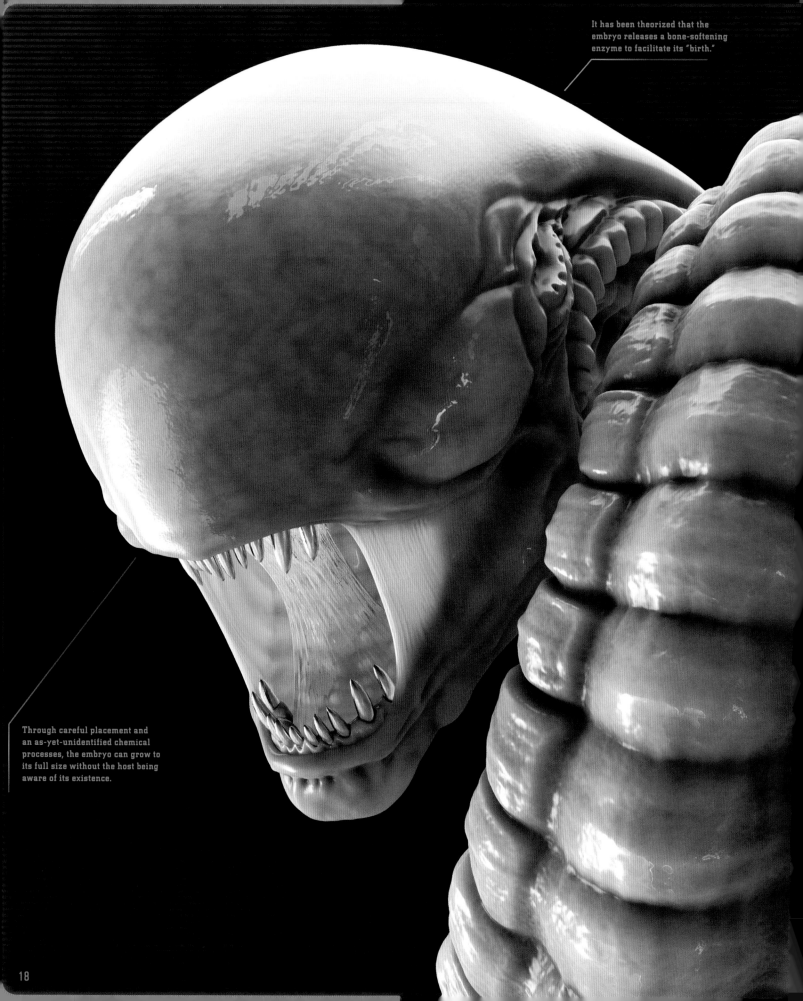

It has been theorized that the embryo releases a bone-softening enzyme to facilitate its "birth."

Through careful placement and an as-yet-unidentified chemical processes, the embryo can grow to its full size without the host being aware of its existence.

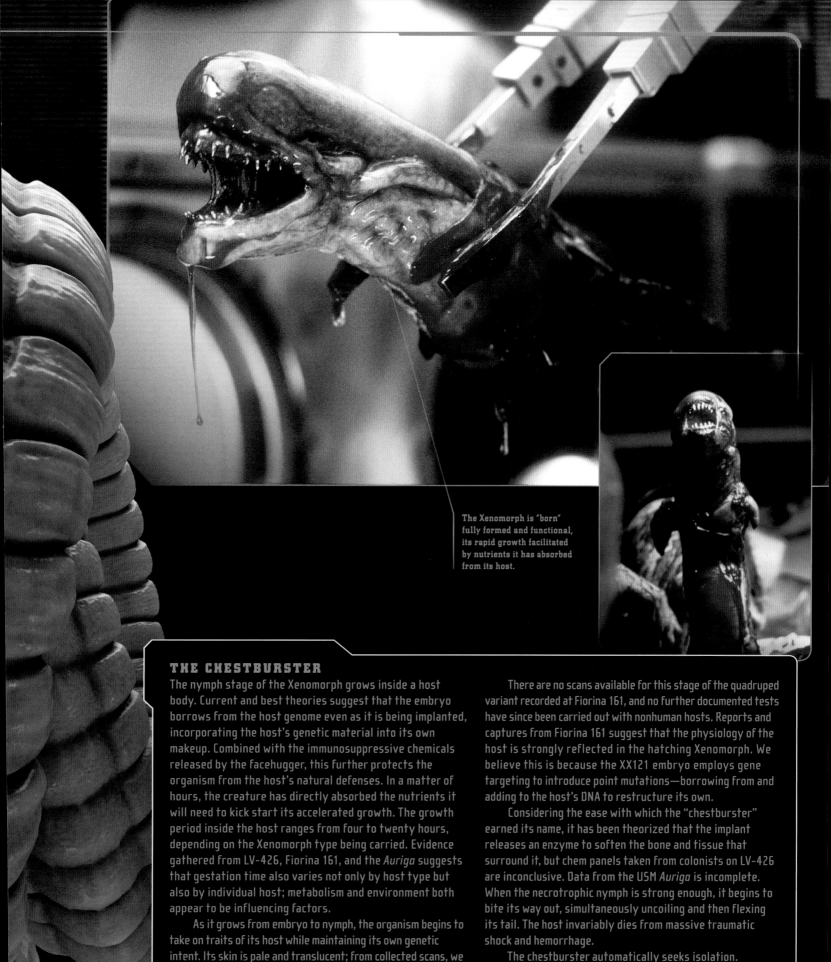

The Xenomorph is "born"
fully formed and functional,
its rapid growth facilitated
by nutrients it has absorbed
from its host.

THE CHESTBURSTER

The nymph stage of the Xenomorph grows inside a host body. Current and best theories suggest that the embryo borrows from the host genome even as it is being implanted, incorporating the host's genetic material into its own makeup. Combined with the immunosuppressive chemicals released by the facehugger, this further protects the organism from the host's natural defenses. In a matter of hours, the creature has directly absorbed the nutrients it will need to kick start its accelerated growth. The growth period inside the host ranges from four to twenty hours, depending on the Xenomorph type being carried. Evidence gathered from LV-426, Fiorina 161, and the *Auriga* suggests that gestation time also varies not only by host type but also by individual host; metabolism and environment both appear to be influencing factors.

As it grows from embryo to nymph, the organism begins to take on traits of its host while maintaining its own genetic intent. Its skin is pale and translucent; from collected scans, we see the inner pharyngeal jaws of the adult forming within one hour of implantation. Note also the long, eyeless skull, the rudimentary extremities, and development of the muscular tail.

There are no scans available for this stage of the quadruped variant recorded at Fiorina 161, and no further documented tests have since been carried out with nonhuman hosts. Reports and captures from Fiorina 161 suggest that the physiology of the host is strongly reflected in the hatching Xenomorph. We believe this is because the XX121 embryo employs gene targeting to introduce point mutations—borrowing from and adding to the host's DNA to restructure its own.

Considering the ease with which the "chestburster" earned its name, it has been theorized that the implant releases an enzyme to soften the bone and tissue that surround it, but chem panels taken from colonists on LV-426 are inconclusive. Data from the USM *Auriga* is incomplete. When the necrotrophic nymph is strong enough, it begins to bite its way out, simultaneously uncoiling and then flexing its tail. The host invariably dies from massive traumatic shock and hemorrhage.

The chestburster automatically seeks isolation. Observations aboard the *Auriga* confirm that within seconds of breaking free of its host, the organism searches for an uninhabited space in which to develop unmolested.

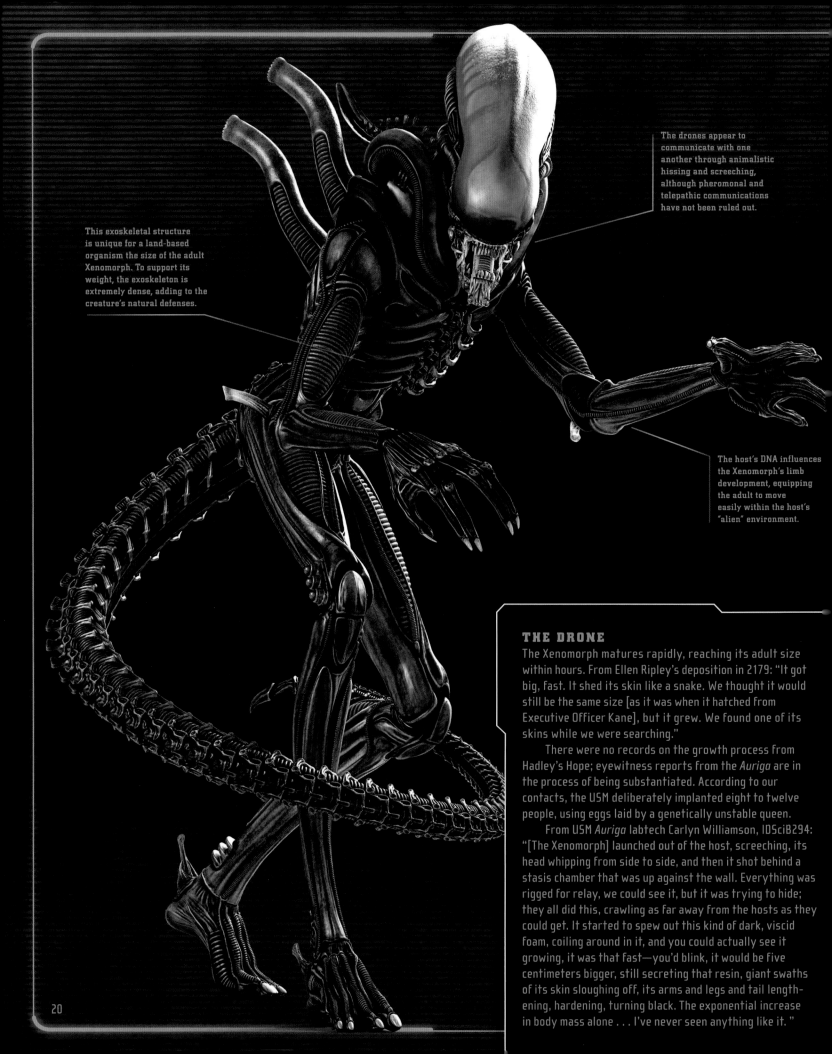

This exoskeletal structure is unique for a land-based organism the size of the adult Xenomorph. To support its weight, the exoskeleton is extremely dense, adding to the creature's natural defenses.

The drones appear to communicate with one another through animalistic hissing and screeching, although pheromonal and telepathic communications have not been ruled out.

The host's DNA influences the Xenomorph's limb development, equipping the adult to move easily within the host's "alien" environment.

THE DRONE

The Xenomorph matures rapidly, reaching its adult size within hours. From Ellen Ripley's deposition in 2179: "It got big, fast. It shed its skin like a snake. We thought it would still be the same size [as it was when it hatched from Executive Officer Kane], but it grew. We found one of its skins while we were searching."

There were no records on the growth process from Hadley's Hope; eyewitness reports from the *Auriga* are in the process of being substantiated. According to our contacts, the USM deliberately implanted eight to twelve people, using eggs laid by a genetically unstable queen.

From USM *Auriga* labtech Carlyn Williamson, IDSciB294: "[The Xenomorph] launched out of the host, screeching, its head whipping from side to side, and then it shot behind a stasis chamber that was up against the wall. Everything was rigged for relay, we could see it, but it was trying to hide; they all did this, crawling as far away from the hosts as they could get. It started to spew out this kind of dark, viscid foam, coiling around in it, and you could actually see it growing, it was that fast—you'd blink, it would be five centimeters bigger, still secreting that resin, giant swaths of its skin sloughing off, its arms and legs and tail length-ening, hardening, turning black. The exponential increase in body mass alone . . . I've never seen anything like it. "

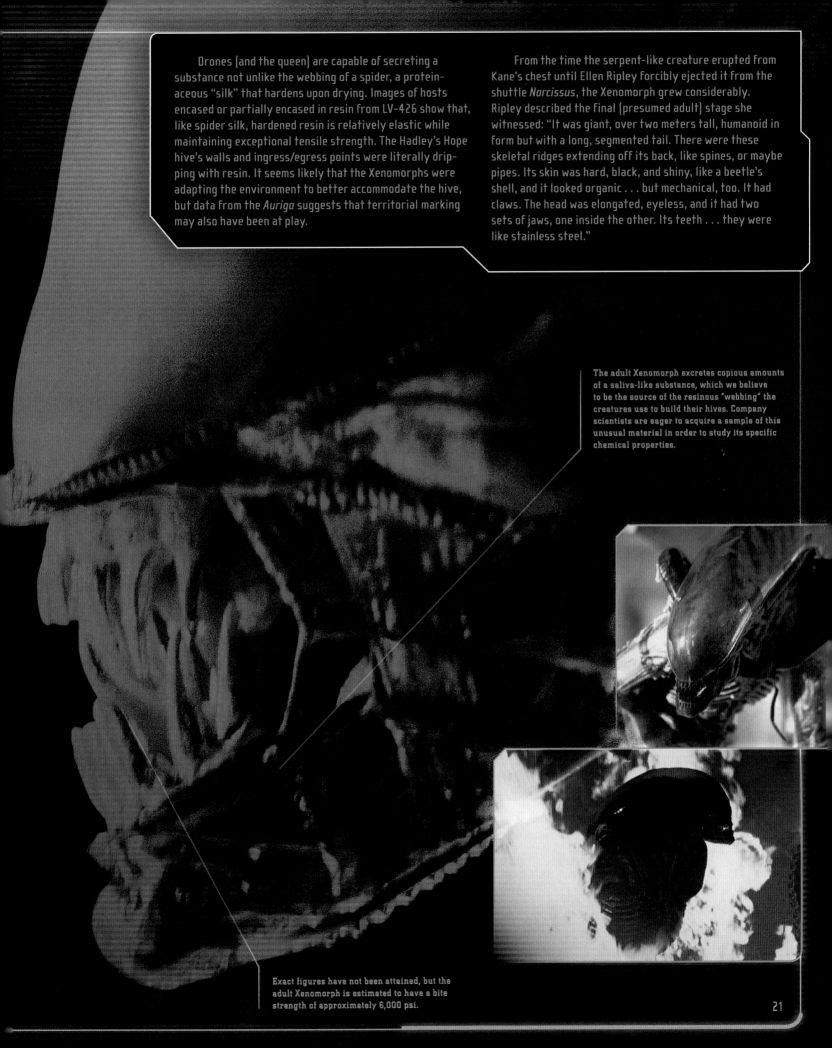

Drones (and the queen) are capable of secreting a substance not unlike the webbing of a spider, a protein-aceous "silk" that hardens upon drying. Images of hosts encased or partially encased in resin from LV-426 show that, like spider silk, hardened resin is relatively elastic while maintaining exceptional tensile strength. The Hadley's Hope hive's walls and ingress/egress points were literally drip-ping with resin. It seems likely that the Xenomorphs were adapting the environment to better accommodate the hive, but data from the *Auriga* suggests that territorial marking may also have been at play.

From the time the serpent-like creature erupted from Kane's chest until Ellen Ripley forcibly ejected it from the shuttle *Narcissus*, the Xenomorph grew considerably. Ripley described the final (presumed adult) stage she witnessed: "It was giant, over two meters tall, humanoid in form but with a long, segmented tail. There were these skeletal ridges extending off its back, like spines, or maybe pipes. Its skin was hard, black, and shiny, like a beetle's shell, and it looked organic . . . but mechanical, too. It had claws. The head was elongated, eyeless, and it had two sets of jaws, one inside the other. Its teeth . . . they were like stainless steel."

The adult Xenomorph excretes copious amounts of a saliva-like substance, which we believe to be the source of the resinous "webbing" the creatures use to build their hives. Company scientists are eager to acquire a sample of this unusual material in order to study its specific chemical properties.

Exact figures have not been attained, but the adult Xenomorph is estimated to have a bite strength of approximately 6,000 psi.

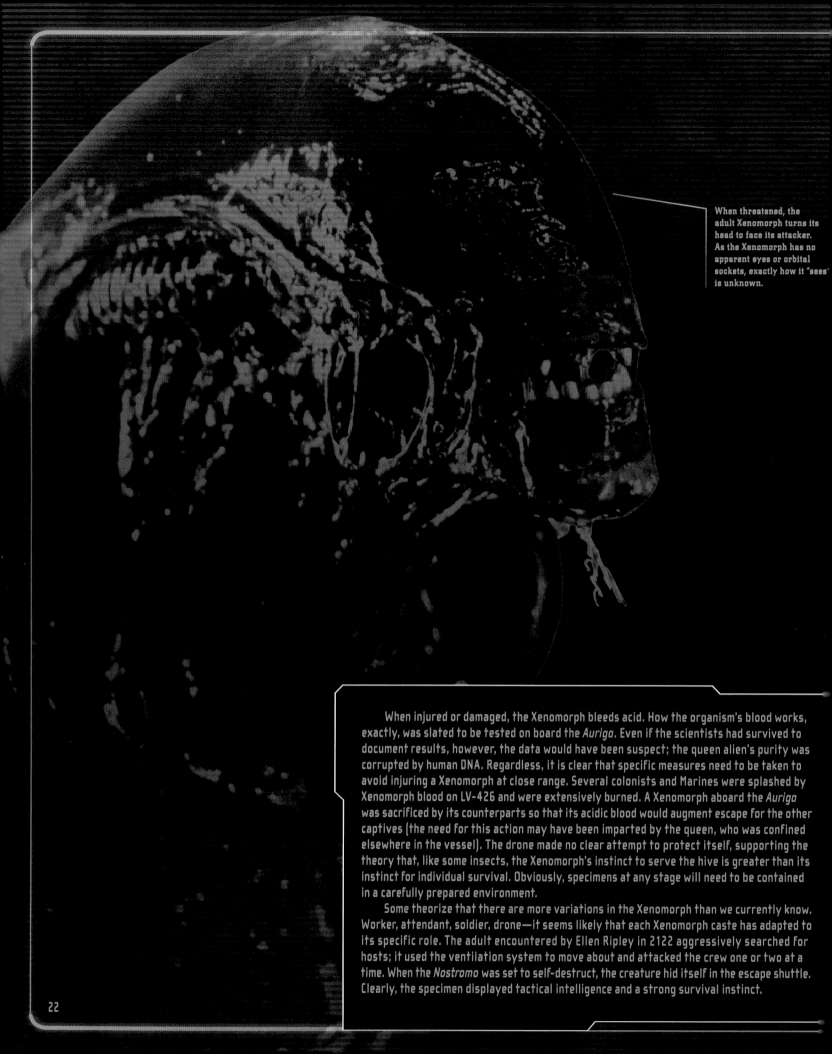

When threatened, the adult Xenomorph turns its head to face its attacker. As the Xenomorph has no apparent eyes or orbital sockets, exactly how it "sees" is unknown.

When injured or damaged, the Xenomorph bleeds acid. How the organism's blood works, exactly, was slated to be tested on board the *Auriga*. Even if the scientists had survived to document results, however, the data would have been suspect; the queen alien's purity was corrupted by human DNA. Regardless, it is clear that specific measures need to be taken to avoid injuring a Xenomorph at close range. Several colonists and Marines were splashed by Xenomorph blood on LV-426 and were extensively burned. A Xenomorph aboard the *Auriga* was sacrificed by its counterparts so that its acidic blood would augment escape for the other captives (the need for this action may have been imparted by the queen, who was confined elsewhere in the vessel). The drone made no clear attempt to protect itself, supporting the theory that, like some insects, the Xenomorph's instinct to serve the hive is greater than its instinct for individual survival. Obviously, specimens at any stage will need to be contained in a carefully prepared environment.

Some theorize that there are more variations in the Xenomorph than we currently know. Worker, attendant, soldier, drone—it seems likely that each Xenomorph caste has adapted to its specific role. The adult encountered by Ellen Ripley in 2122 aggressively searched for hosts; it used the ventilation system to move about and attacked the crew one or two at a time. When the *Nostromo* was set to self-destruct, the creature hid itself in the escape shuttle. Clearly, the specimen displayed tactical intelligence and a strong survival instinct.

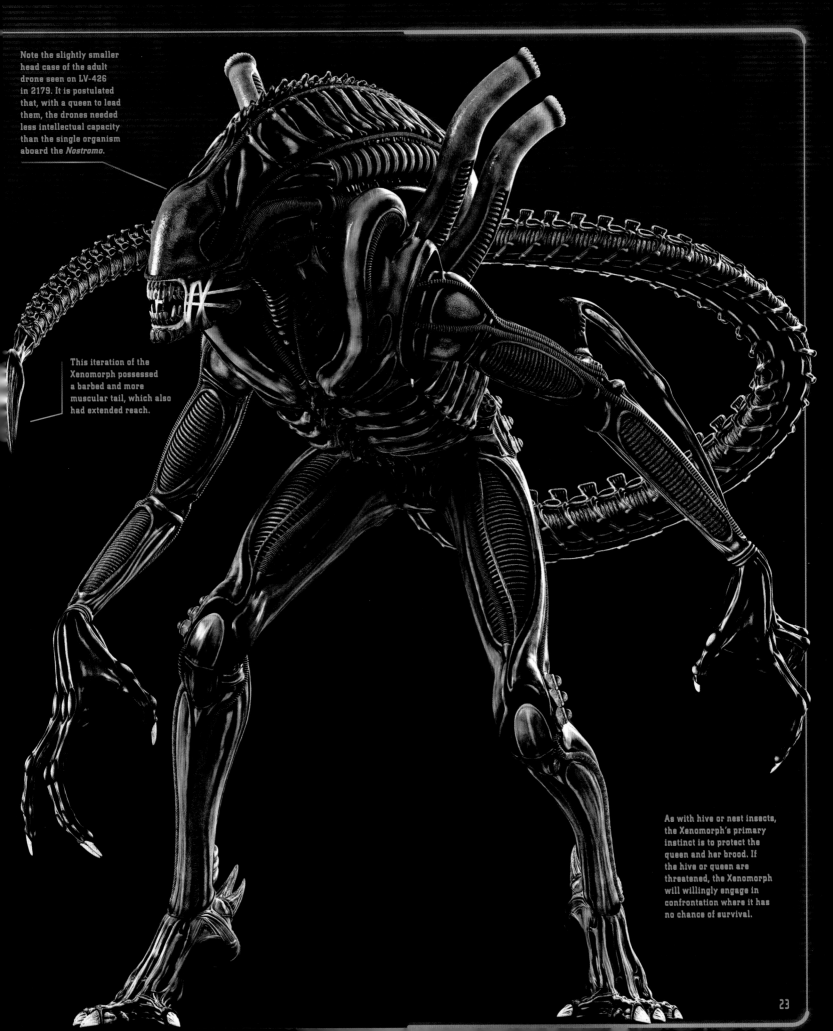

Note the slightly smaller head case of the adult drone seen on LV-426 in 2179. It is postulated that, with a queen to lead them, the drones needed less intellectual capacity than the single organism aboard the *Nostromo*.

This iteration of the Xenomorph possessed a barbed and more muscular tail, which also had extended reach.

As with hive or nest insects, the Xenomorph's primary instinct is to protect the queen and her brood. If the hive or queen are threatened, the Xenomorph will willingly engage in confrontation where it has no chance of survival.

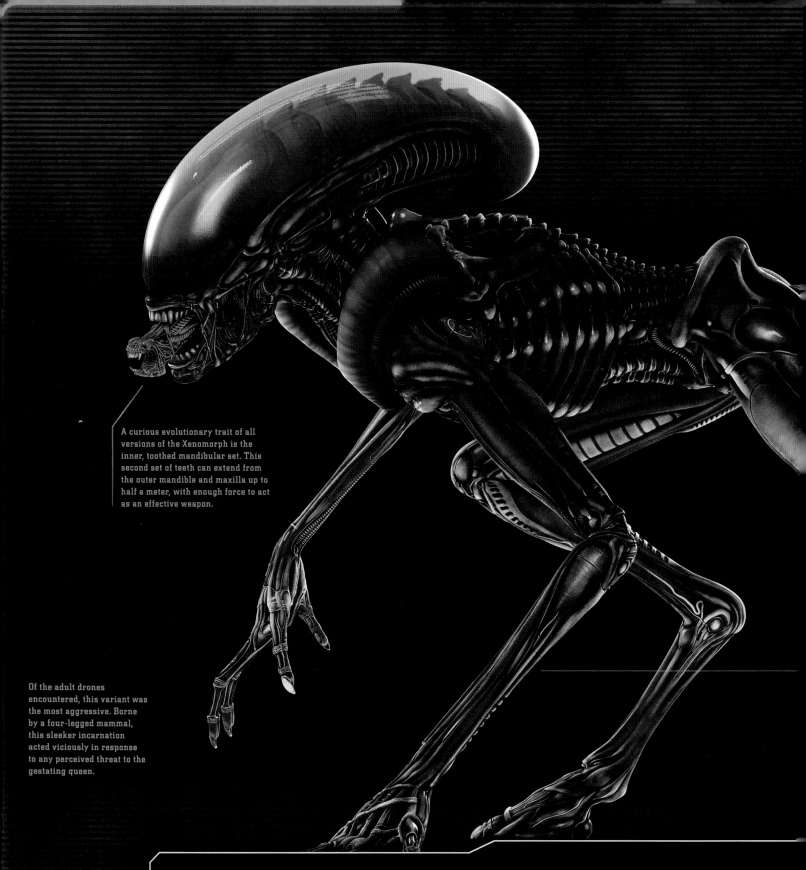

A curious evolutionary trait of all versions of the Xenomorph is the inner, toothed mandibular set. This second set of teeth can extend from the outer mandible and maxilla up to half a meter, with enough force to act as an effective weapon.

Of the adult drones encountered, this variant was the most aggressive. Borne by a four-legged mammal, this sleeker incarnation acted viciously in response to any perceived threat to the gestating queen.

It is also possible that in the absence of a queen, a single drone or worker can transform into an egg-producer—although we only have anecdotal evidence to support this theory. If true, this indicates a certain level of intelligence that would not normally be associated with a so-called "drone." The individual Xenomorph would have to complete a complicated series of tasks to create a safe and suitable hive and to find and capture hosts. Granted, all of these behaviors may be instinctual, but on the *Nostromo*, the lone Xenomorph adapted quickly to extreme variables with clear problem-solving skills. On LV-426, the attacking drones apparently cut the power to the facility in which the Marines were entrenched. While it is possible that this was under the queen's direction, we should not assume that the drones lack intelligence.

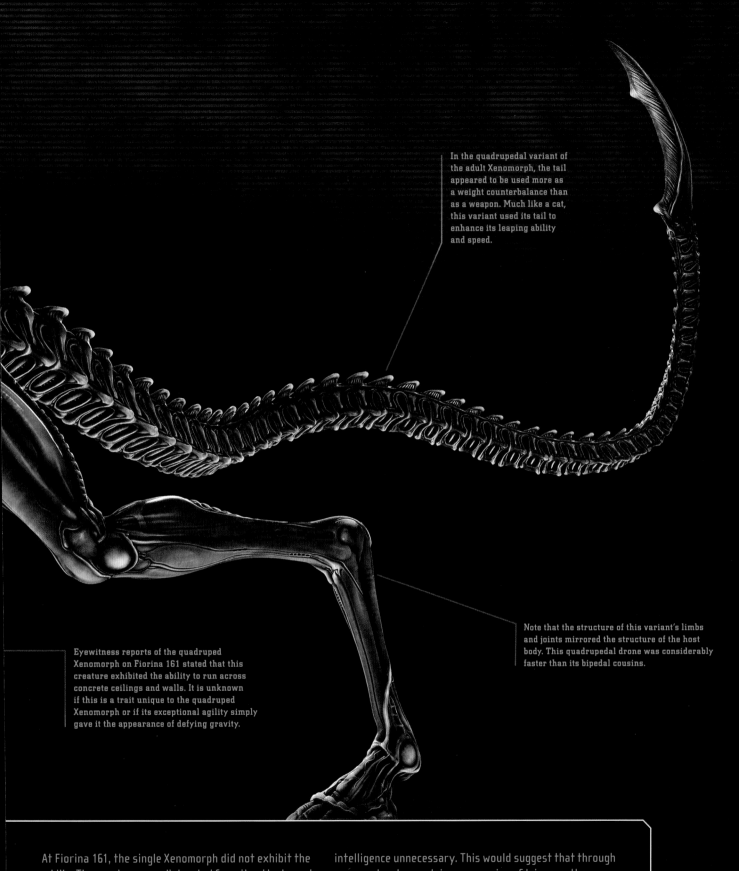

In the quadrupedal variant of the adult Xenomorph, the tail appeared to be used more as a weight counterbalance than as a weapon. Much like a cat, this variant used its tail to enhance its leaping ability and speed.

Note that the structure of this variant's limbs and joints mirrored the structure of the host body. This quadrupedal drone was considerably faster than its bipedal cousins.

Eyewitness reports of the quadruped Xenomorph on Fiorina 161 stated that this creature exhibited the ability to run across concrete ceilings and walls. It is unknown if this is a trait unique to the quadruped Xenomorph or if its exceptional agility simply gave it the appearance of defying gravity.

At Fiorina 161, the single Xenomorph did not exhibit the same skills. The specimen was distracted from its attacks and easily lured into a series of traps. We, therefore, theorize that the fact that its host was a four-legged mammal (a dog or possibly a herd animal) influenced the creature's intelligence. Alternatively, it is possible that the presence of a gestating queen made the need for problem-solving intelligence unnecessary. This would suggest that through an as-yet-unknown trigger or series of triggers, the appropriate caste is chosen through environmental cues. Perhaps the caste "triggered" at Fiorina 161 was only needed to secure the hive from threat. Unfortunately, without further study, we have only conjecture.

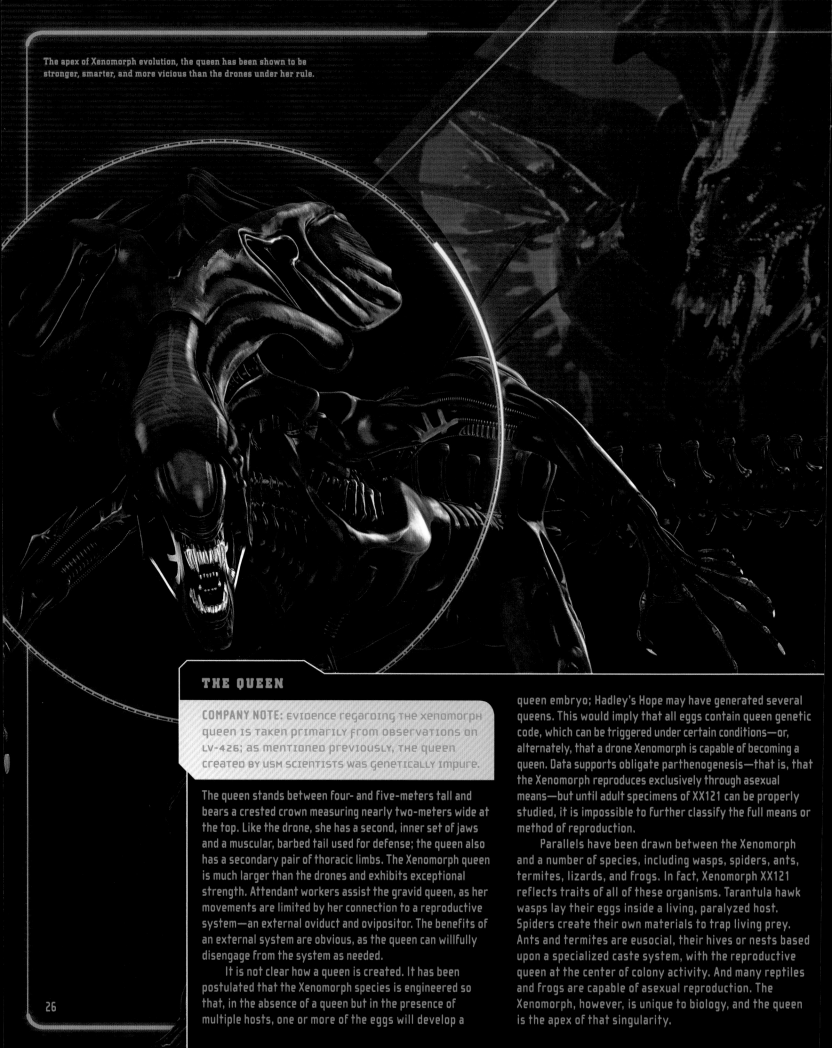

The apex of Xenomorph evolution, the queen has been shown to be stronger, smarter, and more vicious than the drones under her rule.

THE QUEEN

The queen stands between four- and five-meters tall and bears a crested crown measuring nearly two-meters wide at the top. Like the drone, she has a second, inner set of jaws and a muscular, barbed tail used for defense; the queen also has a secondary pair of thoracic limbs. The Xenomorph queen is much larger than the drones and exhibits exceptional strength. Attendant workers assist the gravid queen, as her movements are limited by her connection to a reproductive system—an external oviduct and ovipositor. The benefits of an external system are obvious, as the queen can willfully disengage from the system as needed.

It is not clear how a queen is created. It has been postulated that the Xenomorph species is engineered so that, in the absence of a queen but in the presence of multiple hosts, one or more of the eggs will develop a queen embryo; Hadley's Hope may have generated several queens. This would imply that all eggs contain queen genetic code, which can be triggered under certain conditions—or, alternately, that a drone Xenomorph is capable of becoming a queen. Data supports obligate parthenogenesis—that is, that the Xenomorph reproduces exclusively through asexual means—but until adult specimens of XX121 can be properly studied, it is impossible to further classify the full means or method of reproduction.

Parallels have been drawn between the Xenomorph and a number of species, including wasps, spiders, ants, termites, lizards, and frogs. In fact, Xenomorph XX121 reflects traits of all of these organisms. Tarantula hawk wasps lay their eggs inside a living, paralyzed host. Spiders create their own materials to trap living prey. Ants and termites are eusocial, their hives or nests based upon a specialized caste system, with the reproductive queen at the center of colony activity. And many reptiles and frogs are capable of asexual reproduction. The Xenomorph, however, is unique to biology, and the queen is the apex of that singularity.

EXCERPT FROM TRANSCRIPT, RECORDED 2179 USS *SULACO*:

conversation between Ellen Ripley and AP Bishop 341-B.

RIPLEY: Hicks is out.

BISHOP: That's good. Check that the green and blue lights are on before you run the program.

RIPLEY: Got it.

BISHOP: OK. You can wrap me up, and I'll power down. All of the *Sulaco*'s systems are set for auto-control, so you don't have to worry about anything.

RIPLEY: That'll be a nice change.

BISHOP: Out there, the Xenomorph. That was the queen, wasn't it?

RIPLEY: Yeah. She hitched a ride, when you came back for us. Remember when you hit that resistance? I thought we'd snagged on debris, but I think that was her, climbing on.

BISHOP: Survival instinct? You think she knew the processor was about to blow?

RIPLEY: No. She was following me.

BISHOP: Why?

RIPLEY: I pissed her off. I torched her hive.

BISHOP: You think she came after you for vengeance?

RIPLEY: I know she did. I killed her children, she wanted to kill me and mine.

BISHOP: But that would suggest a much higher order of intelligence than we encountered with the others—

RIPLEY: She figured out how to use an elevator, watching me. And there were other aliens there in the hive, her workers—when I threatened her eggs, she made them retreat.

BISHOP: But why did you incinerate her hive if she—

[Rebecca Jorden entered the room, dressed for hypersleep.]

RIPLEY: Enough questions, Bishop. It's over now, and we need to sleep. I promise to tell you all about it when we get home.

BISHOP: All right. Sleep well.

RIPLEY: [wrapping Bishop in plastic] Thank you. That's the plan.

Whether Xenomorph embryos are hermaphroditic or are capable of protandry (biological sex change from male to female, which would allow a drone to become a queen) is unknown at this time. The species may, in fact, be intersexual. Where multiple Xenomorphs are encountered, it should be assumed that there is a queen nearby.

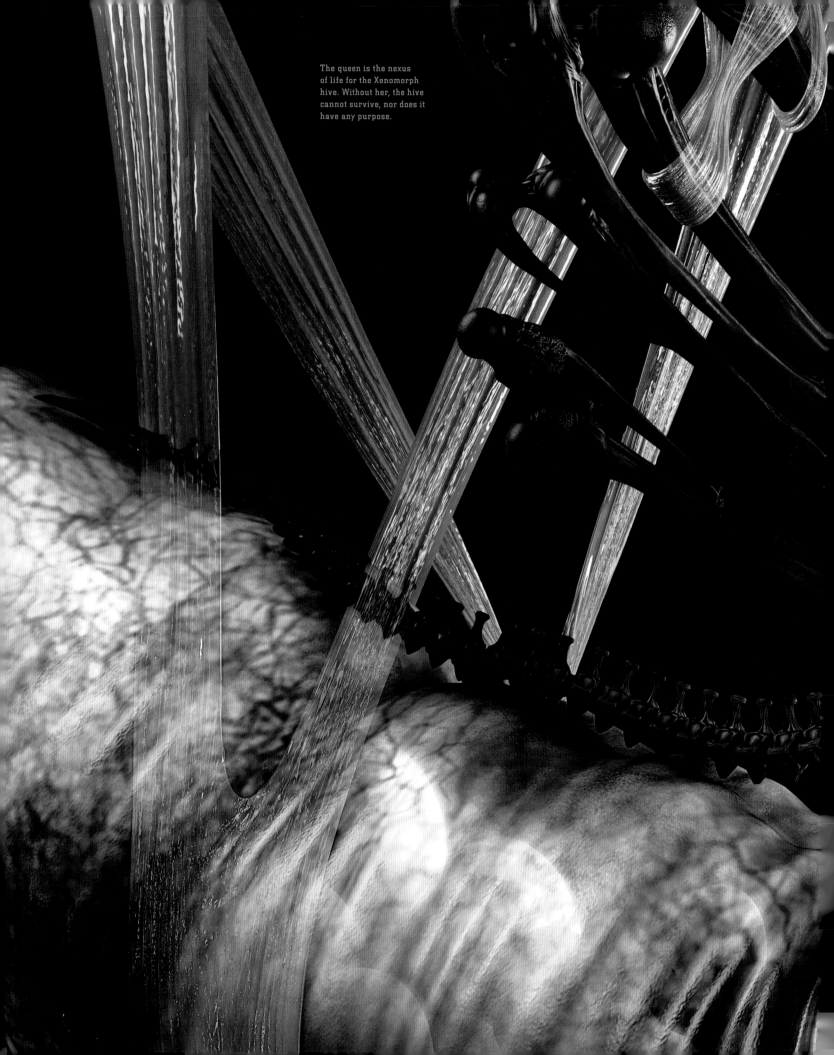

The queen is the nexus of life for the Xenomorph hive. Without her, the hive cannot survive, nor does it have any purpose.

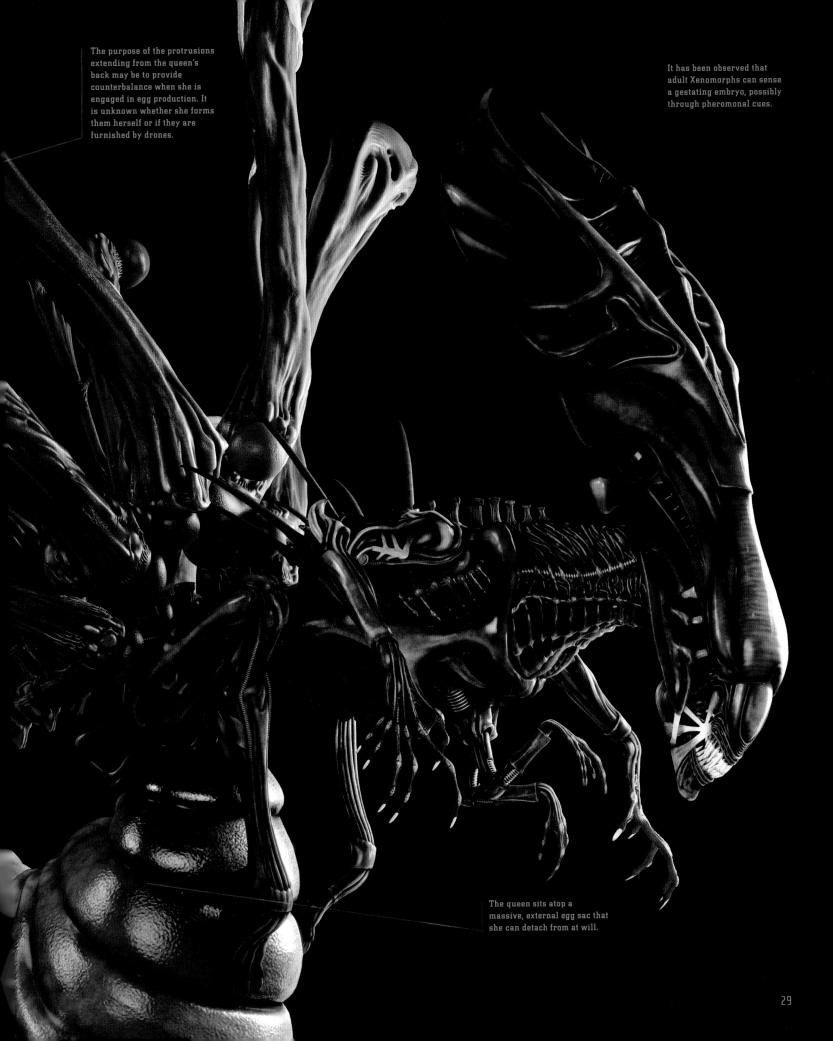

The purpose of the protrusions extending from the queen's back may be to provide counterbalance when she is engaged in egg production. It is unknown whether she forms them herself or if they are furnished by drones.

It has been observed that adult Xenomorphs can sense a gestating embryo, possibly through pheromonal cues.

The queen sits atop a massive, external egg sac that she can detach from at will.

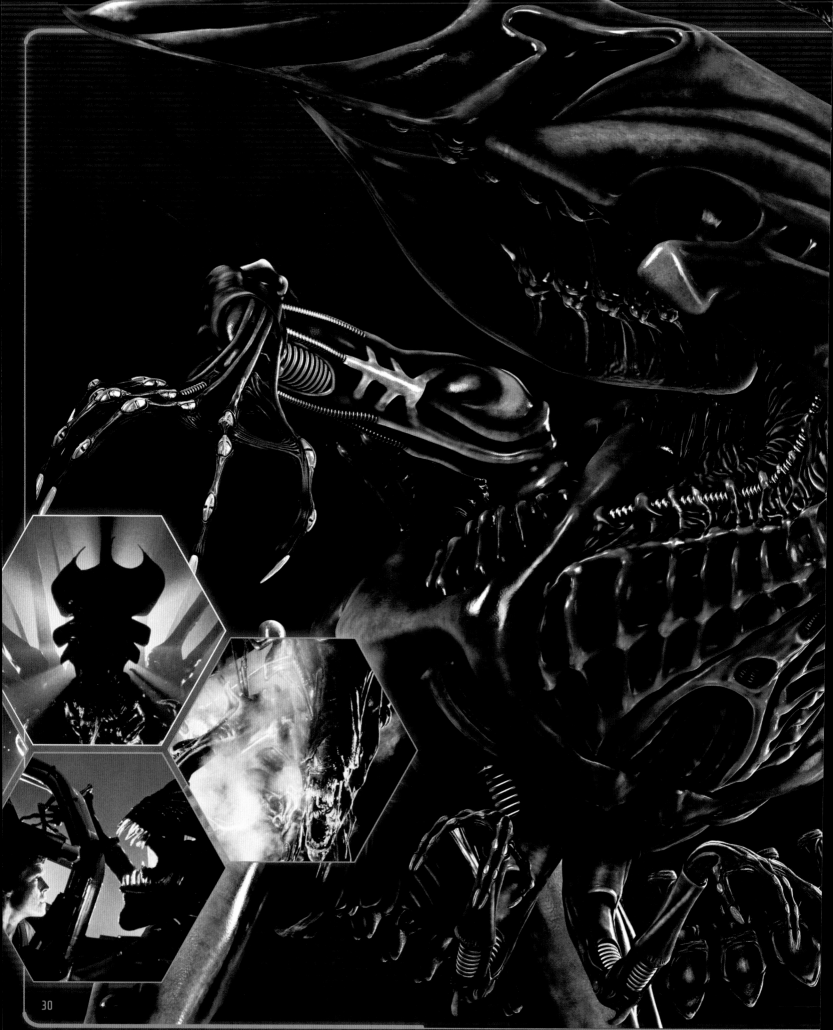

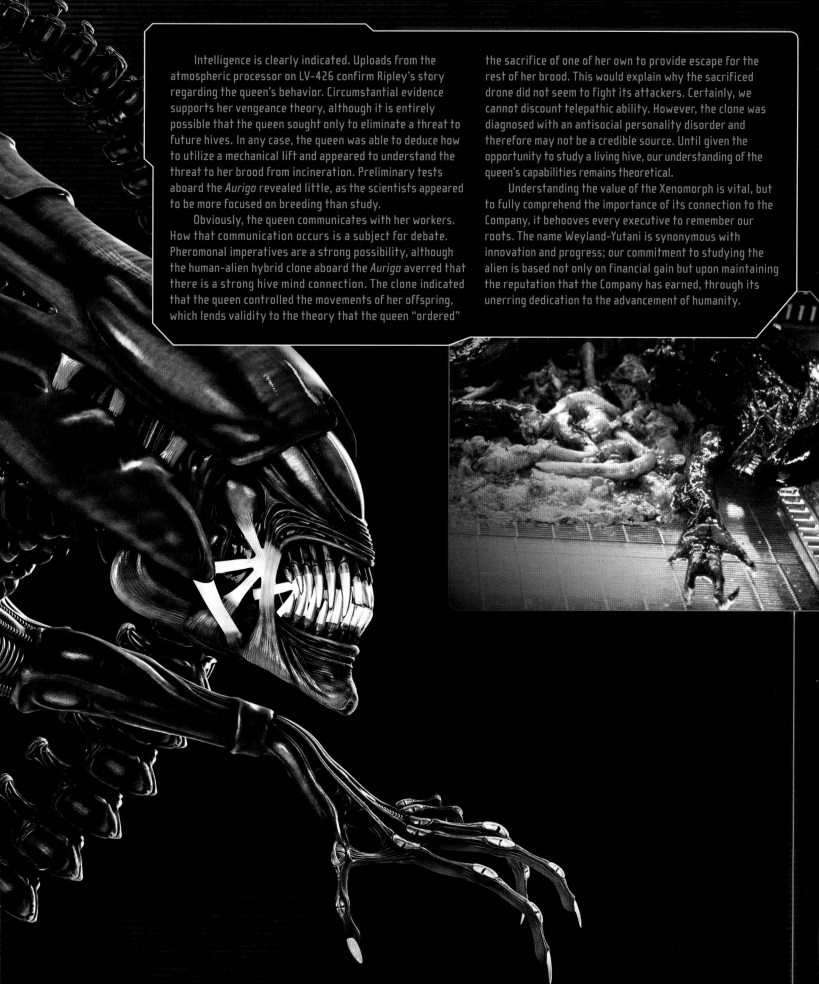

Intelligence is clearly indicated. Uploads from the atmospheric processor on LV-426 confirm Ripley's story regarding the queen's behavior. Circumstantial evidence supports her vengeance theory, although it is entirely possible that the queen sought only to eliminate a threat to future hives. In any case, the queen was able to deduce how to utilize a mechanical lift and appeared to understand the threat to her brood from incineration. Preliminary tests aboard the *Auriga* revealed little, as the scientists appeared to be more focused on breeding than study.

Obviously, the queen communicates with her workers. How that communication occurs is a subject for debate. Pheromonal imperatives are a strong possibility, although the human-alien hybrid clone aboard the *Auriga* averred that there is a strong hive mind connection. The clone indicated that the queen controlled the movements of her offspring, which lends validity to the theory that the queen "ordered" the sacrifice of one of her own to provide escape for the rest of her brood. This would explain why the sacrificed drone did not seem to fight its attackers. Certainly, we cannot discount telepathic ability. However, the clone was diagnosed with an antisocial personality disorder and therefore may not be a credible source. Until given the opportunity to study a living hive, our understanding of the queen's capabilities remains theoretical.

Understanding the value of the Xenomorph is vital, but to fully comprehend the importance of its connection to the Company, it behooves every executive to remember our roots. The name Weyland-Yutani is synonymous with innovation and progress; our commitment to studying the alien is based not only on financial gain but upon maintaining the reputation that the Company has earned, through its unerring dedication to the advancement of humanity.

THE PROUD HISTORY OF WEYLAND-YUTANI

THERE HAVE BEEN NUMEROUS BIOGRAPHIES ABOUT THE LIFE AND WORK OF SIR PETER WEYLAND, EASILY THE GREATEST SCIENTIFIC MIND OF ANY GENERATION. THERE IS NO QUESTION THAT HIS PERSONAL AND PROFESSIONAL ACHIEVEMENTS LED TO ASTONISHING ADVANCEMENTS IN ENGINEERING, MEDICINE, RESOURCE COLLECTION AND PROCESSING, AND SPACE TRAVEL. WHILE IT IS NOT THE INTENT OF THIS REPORT TO REHASH THE LIFE OF THIS GREAT MAN, ANY REPORT ON INTERACTION WITH ALIEN INTELLIGENCE MUST INCLUDE A SECTION ON SIR PETER. NOT ONLY DID HE PUSH HUMANITY INTO SPACE, HE DESIGNED THE SHIPS THAT TOOK US TO NEW WORLDS, INVENTED THE HYPERSLEEP CHAMBERS THAT ALLOWED US TO REACH THOSE WORLDS, AND CREATED THE ATMOSPHERIC PROCESSORS THAT MADE THOSE WORLDS VIABLE FOR HUMAN COLONIZATION.

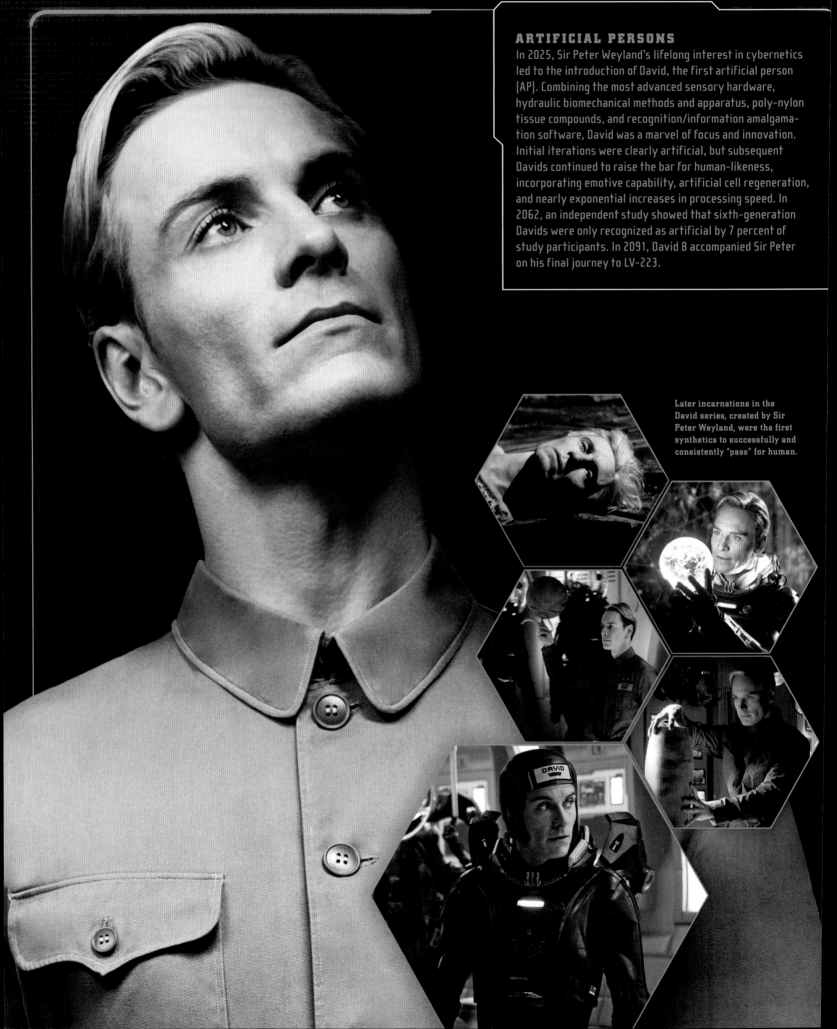

ARTIFICIAL PERSONS

In 2025, Sir Peter Weyland's lifelong interest in cybernetics led to the introduction of David, the first artificial person (AP). Combining the most advanced sensory hardware, hydraulic biomechanical methods and apparatus, poly-nylon tissue compounds, and recognition/information amalgamation software, David was a marvel of focus and innovation. Initial iterations were clearly artificial, but subsequent Davids continued to raise the bar for human-likeness, incorporating emotive capability, artificial cell regeneration, and nearly exponential increases in processing speed. In 2062, an independent study showed that sixth-generation Davids were only recognized as artificial by 7 percent of study participants. In 2091, David 8 accompanied Sir Peter on his final journey to LV-223.

Later incarnations in the David series, created by Sir Peter Weyland, were the first synthetics to successfully and consistently "pass" for human.

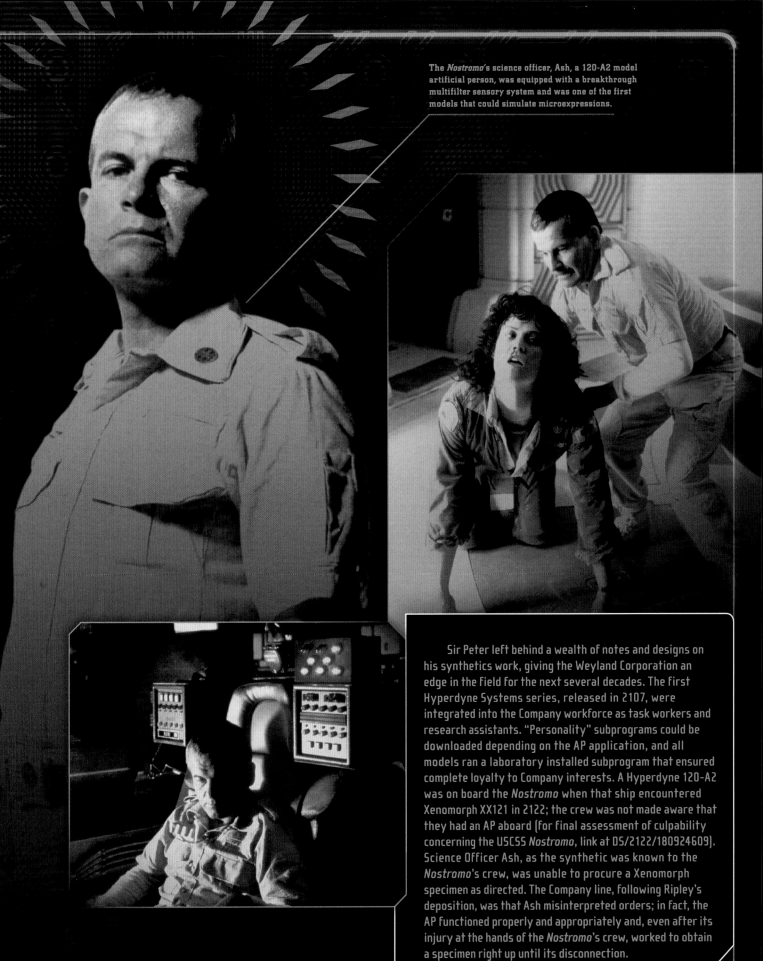

The *Nostromo*'s science officer, Ash, a 120-A2 model artificial person, was equipped with a breakthrough multifilter sensory system and was one of the first models that could simulate microexpressions.

Sir Peter left behind a wealth of notes and designs on his synthetics work, giving the Weyland Corporation an edge in the field for the next several decades. The first Hyperdyne Systems series, released in 2107, were integrated into the Company workforce as task workers and research assistants. "Personality" subprograms could be downloaded depending on the AP application, and all models ran a laboratory installed subprogram that ensured complete loyalty to Company interests. A Hyperdyne 120-A2 was on board the *Nostromo* when that ship encountered Xenomorph XX121 in 2122; the crew was not made aware that they had an AP aboard (for final assessment of culpability concerning the USCSS *Nostromo*, link at DS/2122/180924609). Science Officer Ash, as the synthetic was known to the *Nostromo*'s crew, was unable to procure a Xenomorph specimen as directed. The Company line, following Ripley's deposition, was that Ash misinterpreted orders; in fact, the AP functioned properly and appropriately and, even after its injury at the hands of the *Nostromo*'s crew, worked to obtain a specimen right up until its disconnection.

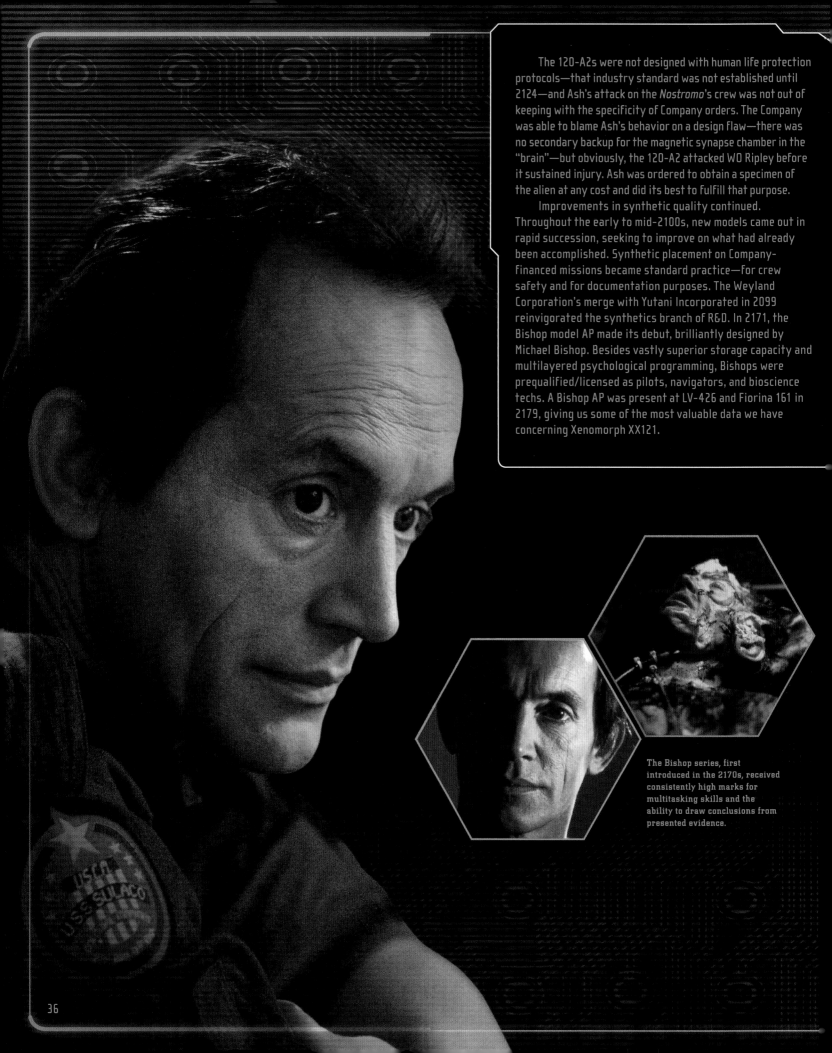

The 120-A2s were not designed with human life protection protocols—that industry standard was not established until 2124—and Ash's attack on the *Nostromo*'s crew was not out of keeping with the specificity of Company orders. The Company was able to blame Ash's behavior on a design flaw—there was no secondary backup for the magnetic synapse chamber in the "brain"—but obviously, the 120-A2 attacked WO Ripley before it sustained injury. Ash was ordered to obtain a specimen of the alien at any cost and did its best to fulfill that purpose.

Improvements in synthetic quality continued. Throughout the early to mid-2100s, new models came out in rapid succession, seeking to improve on what had already been accomplished. Synthetic placement on Company-financed missions became standard practice—for crew safety and for documentation purposes. The Weyland Corporation's merge with Yutani Incorporated in 2099 reinvigorated the synthetics branch of R&D. In 2171, the Bishop model AP made its debut, brilliantly designed by Michael Bishop. Besides vastly superior storage capacity and multilayered psychological programming, Bishops were prequalified/licensed as pilots, navigators, and bioscience techs. A Bishop AP was present at LV-426 and Fiorina 161 in 2179, giving us some of the most valuable data we have concerning Xenomorph XX121.

The Bishop series, first introduced in the 2170s, received consistently high marks for multitasking skills and the ability to draw conclusions from presented evidence.

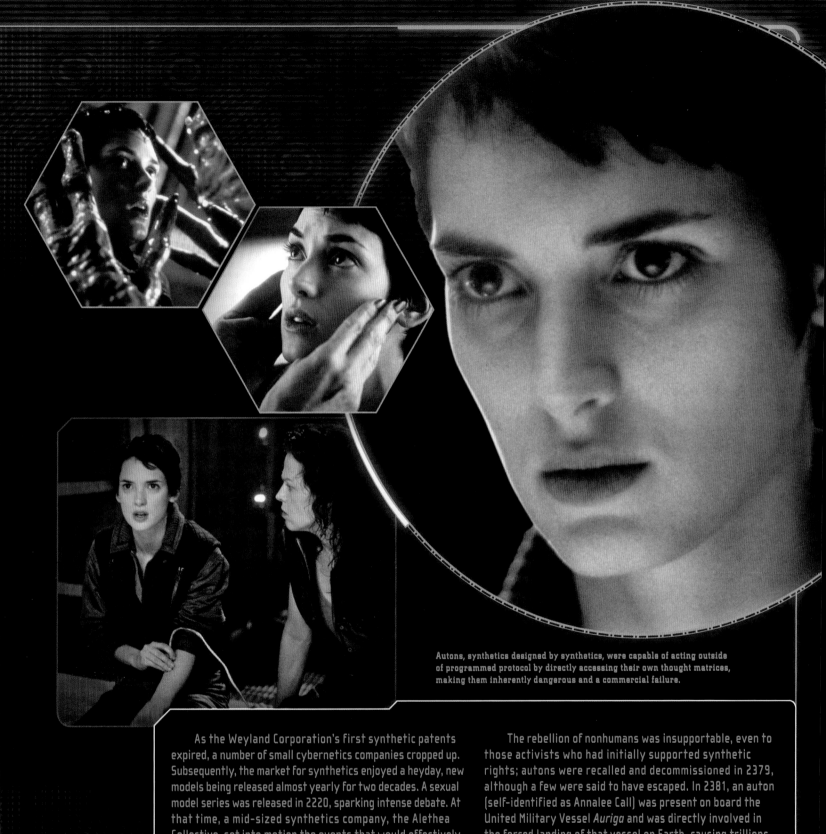

Autons, synthetics designed by synthetics, were capable of acting outside
of programmed protocol by directly accessing their own thought matrices,
making them inherently dangerous and a commercial failure.

As the Weyland Corporation's first synthetic patents
expired, a number of small cybernetics companies cropped up.
Subsequently, the market for synthetics enjoyed a heyday, new
models being released almost yearly for two decades. A sexual
model series was released in 2220, sparking intense debate. At
that time, a mid-sized synthetics company, the Alethea
Collective, set into motion the events that would effectively
end the commercial importance of synthetic manufacture. They
lobbied heavily for the rights of artificial persons, finally
procuring a legal dispensation for synthetics to design and
create "offspring." The resulting second-generation autons
were a financial and critical failure. Although technically quite
advanced, autons were also capable of developing morality and
could overwrite their own programming at will. Many refused to
participate in the tasks assigned them, forming their own
opinions about the actions of their human superiors and then
seeking to effect change, at times through violent action.

The rebellion of nonhumans was insupportable, even to
those activists who had initially supported synthetic
rights; autons were recalled and decommissioned in 2379,
although a few were said to have escaped. In 2381, an auton
(self-identified as Annalee Call) was present on board the
United Military Vessel *Auriga* and was directly involved in
the forced landing of that vessel on Earth, causing trillions
of adjusted dollars in damage.

Considering the current state of the AP market, Sir
Peter's cybernetic dream has perhaps been taken as far as it
can go; his own "son," David, was, although rudimentary by
modern standards, perhaps the best and brightest of them
all, as he represented an avatar of possibilities—a man
created by man, effectively (as Sir Peter himself said, in his
controversial 2023 presentation to shareholders) turning
men into gods.

ATMOSPHERIC PROCESSING

Sir Peter Weyland's prototype atmospheric processor effectively ended global warming on Earth in 2016, when he was only twenty-six years old; the invention also earned Sir Peter his first Nobel Prize and a knighthood (he received his second Nobel Prize in 2023 for vitally important cancer research). What began as a study of organic aerosols led Sir Peter to his breakthrough regarding the radiative balance of tropospheric creation. It would be another twenty-three years before the first breathable atmosphere was created on an extrasolar world by one of Sir Peter's processors; the "shake-and-bake" colonies engineered by Weyland-Yutani Corporation nearly a century later, while streamlined and mostly automated, used the same chemical model that the Weyland Corporation patented in 2015.

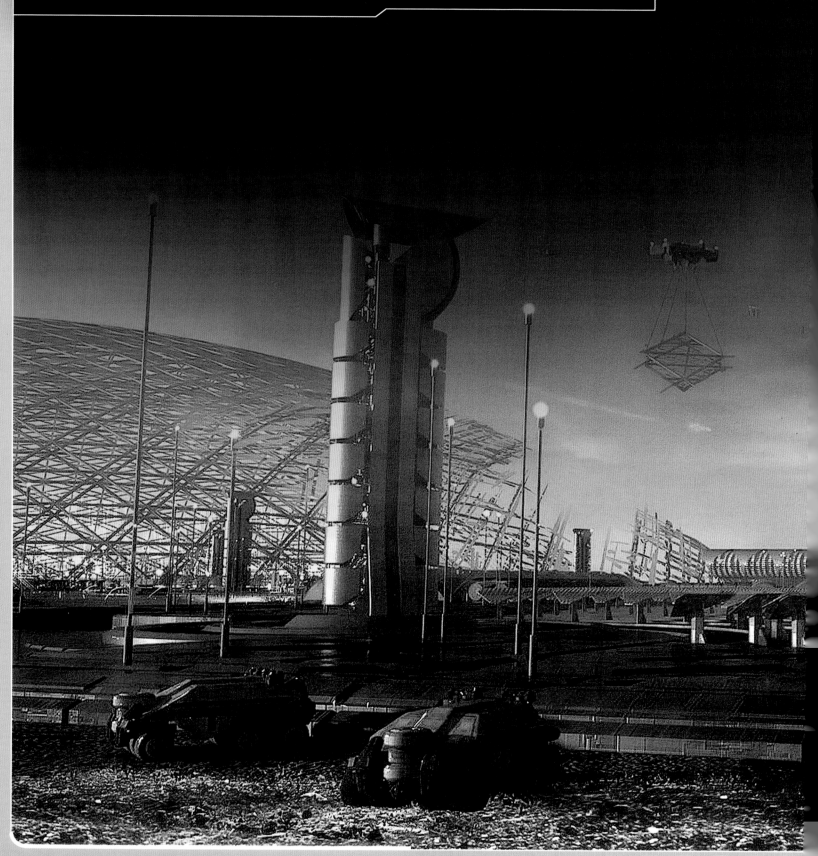

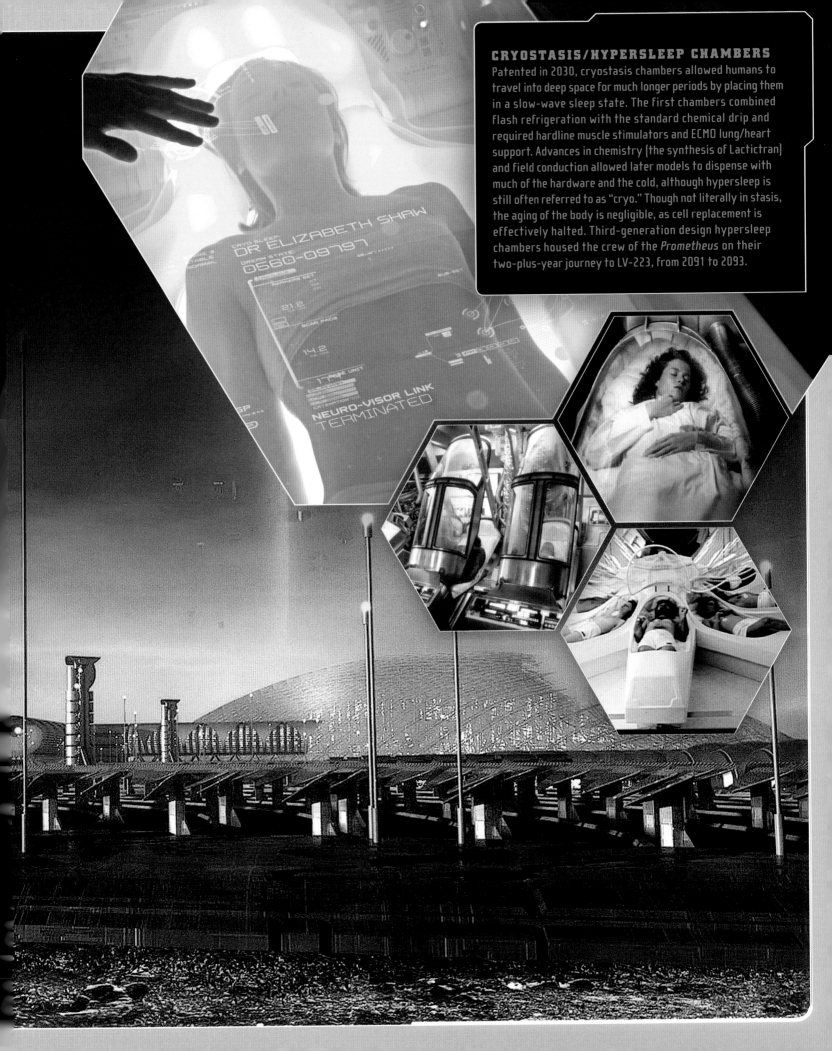

CRYOSTASIS/HYPERSLEEP CHAMBERS

Patented in 2030, cryostasis chambers allowed humans to travel into deep space for much longer periods by placing them in a slow-wave sleep state. The first chambers combined flash refrigeration with the standard chemical drip and required hardline muscle stimulators and ECMO lung/heart support. Advances in chemistry (the synthesis of Lactictran) and field conduction allowed later models to dispense with much of the hardware and the cold, although hypersleep is still often referred to as "cryo." Though not literally in stasis, the aging of the body is negligible, as cell replacement is effectively halted. Third-generation design hypersleep chambers housed the crew of the *Prometheus* on their two-plus-year journey to LV-223, from 2091 to 2093.

CRYO SLEEP
DR ELIZABETH SHAW
0560-09797

NEURO-VISOR LINK
TERMINATED

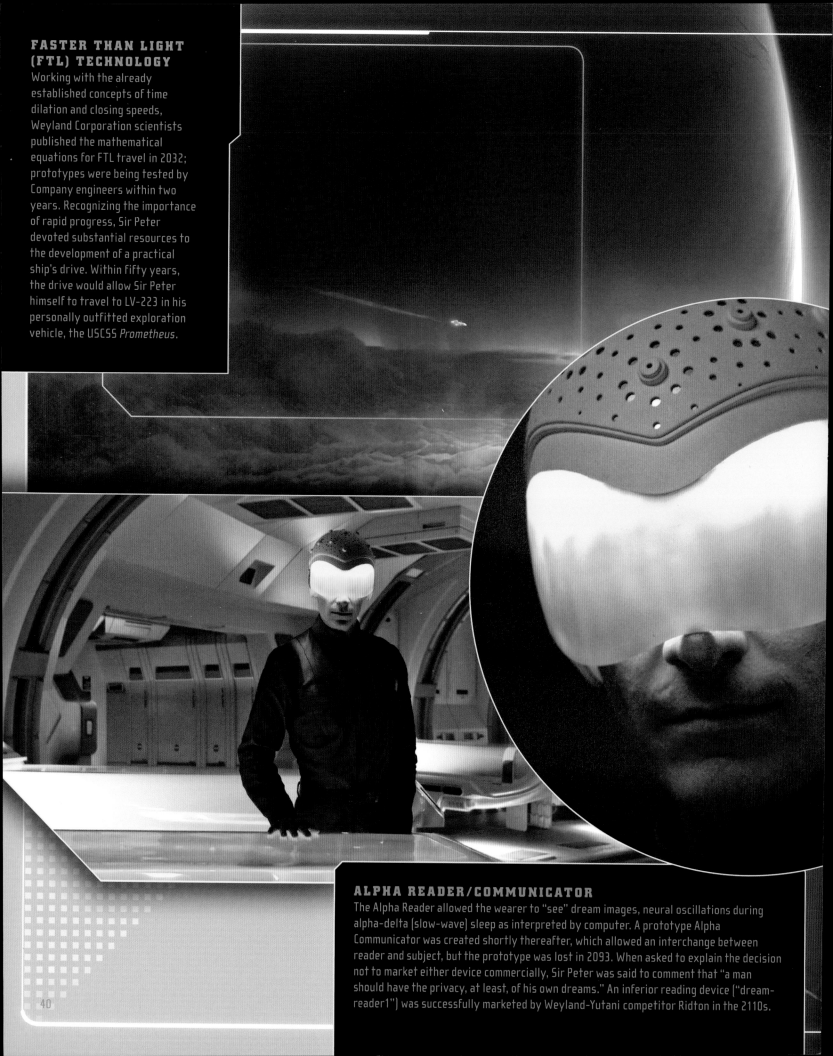

FASTER THAN LIGHT (FTL) TECHNOLOGY

Working with the already established concepts of time dilation and closing speeds, Weyland Corporation scientists published the mathematical equations for FTL travel in 2032; prototypes were being tested by Company engineers within two years. Recognizing the importance of rapid progress, Sir Peter devoted substantial resources to the development of a practical ship's drive. Within fifty years, the drive would allow Sir Peter himself to travel to LV-223 in his personally outfitted exploration vehicle, the USCSS *Prometheus*.

ALPHA READER/COMMUNICATOR

The Alpha Reader allowed the wearer to "see" dream images, neural oscillations during alpha-delta (slow-wave) sleep as interpreted by computer. A prototype Alpha Communicator was created shortly thereafter, which allowed an interchange between reader and subject, but the prototype was lost in 2093. When asked to explain the decision not to market either device commercially, Sir Peter was said to comment that "a man should have the privacy, at least, of his own dreams." An inferior reading device ("dream-reader1") was successfully marketed by Weyland-Yutani competitor Ridton in the 2110s.

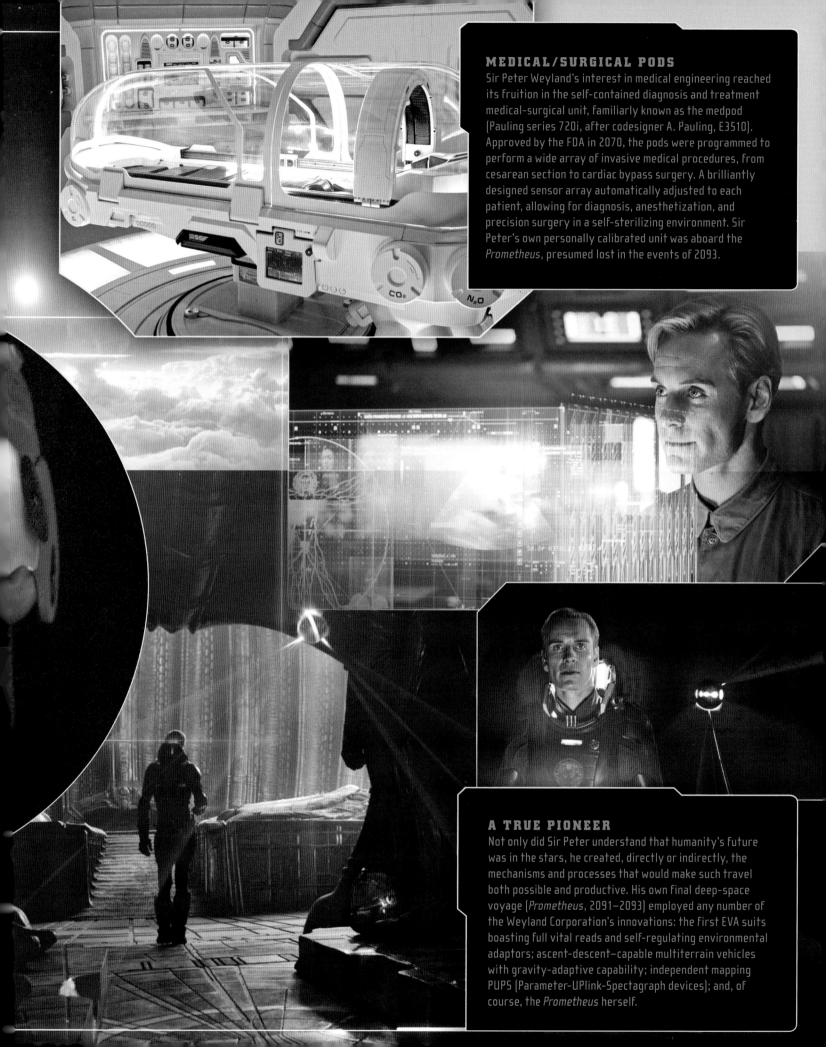

MEDICAL/SURGICAL PODS

Sir Peter Weyland's interest in medical engineering reached its fruition in the self-contained diagnosis and treatment medical-surgical unit, familiarly known as the medpod (Pauling series 720i, after codesigner A. Pauling, E3510). Approved by the FDA in 2070, the pods were programmed to perform a wide array of invasive medical procedures, from cesarean section to cardiac bypass surgery. A brilliantly designed sensor array automatically adjusted to each patient, allowing for diagnosis, anesthetization, and precision surgery in a self-sterilizing environment. Sir Peter's own personally calibrated unit was aboard the *Prometheus*, presumed lost in the events of 2093.

A TRUE PIONEER

Not only did Sir Peter understand that humanity's future was in the stars, he created, directly or indirectly, the mechanisms and processes that would make such travel both possible and productive. His own final deep-space voyage (*Prometheus*, 2091–2093) employed any number of the Weyland Corporation's innovations: the first EVA suits boasting full vital reads and self-regulating environmental adaptors; ascent-descent–capable multiterrain vehicles with gravity-adaptive capability; independent mapping PUPS (Parameter-UPlink-Spectagraph devices); and, of course, the *Prometheus* herself.

GENESIS

IN MARCH OF 2089, DOCTORS ELIZABETH SHAW AND CHARLIE HOLLOWAY APPROACHED SIR PETER WEYLAND WITH AN INCREDIBLE THEORY REGARDING THE ORIGIN OF MAN. THEY BELIEVED THAT THEY HAD DISCOVERED AN ANCIENT INVITATION CALLING MAN TO A SPECIFIC LOCATION IN SPACE TO MEET HIS CREATORS. THIS THEORY WAS BASED ON THEIR EXTENSIVE RESEARCH INTO A SERIES OF ANCIENT PETROGLYPHS AND CAVE PAINTINGS FOUND ALL OVER PLANET EARTH, EACH DEPICTING A PARTICULAR CONFIGURATION OF PLANET/PLANETOIDS, WITH A GIANT HUMANOID POINTING THE ARRANGEMENT OUT TO SMALLER, WORSHIPFUL HUMANOIDS. THIS EXACT CONFIGURATION OF SPHERES APPEARED IN DISPARATE SOCIETIES OVER A SPAN OF CENTURIES, STRONGLY INDICATING A COMMON SOURCE. THE DOCTORS' THEORY WAS THAT THESE "ENGINEERS" OF HUMANITY WERE OPERATING FROM THE LOCATION THAT THE STAR MAP DEPICTED IN DOZENS OF THESE REPRESENTATIONS.

DISREGARDING RECOMMENDATIONS FROM THE COMPANY BOARD, SIR PETER TURNED HIS CONSIDERABLE RESOURCES TOWARD PROVING SHAW AND HOLLOWAY'S HYPOTHESIS, UNCOVERING A CORRELATING STAR MAP IN THE ZETA II RETICULI SYSTEM. HE BEGAN BUILDING THE CRAFT THAT WOULD BECOME THE UNITED STATES COMMERCIAL STAR SHIP *PROMETHEUS* WITHIN DAYS OF THE DISCOVERY, CHOOSING THE NAME HIMSELF. PROMETHEUS, IT MAY BE REMEMBERED, WAS THE TITAN WHO DARED TO GIVE HUMANS THE GIFT OF FIRE AND WHO WAS SUBSEQUENTLY PUNISHED FOR HIS TRANSGRESSION—CHAINED TO A ROCK, HIS LIVER EATEN EACH DAY BY AN EAGLE, THE ORGAN REGENERATING EVERY NIGHT TO BE TORN OUT AGAIN THE NEXT DAY. (IN ANCIENT GREECE, THE LIVER WAS THOUGHT TO BE THE SEAT OF HUMAN EMOTIONS.) IN WESTERN CLASSICAL TRADITION, PROMETHEUS CAME TO SYMBOLIZE HUMAN STRIVING, PARTICULARLY FOR SCIENTIFIC KNOWLEDGE, AND, IRONICALLY, THE DANGER OF OVERREACHING IN THE PURSUIT OF THAT KNOWLEDGE.

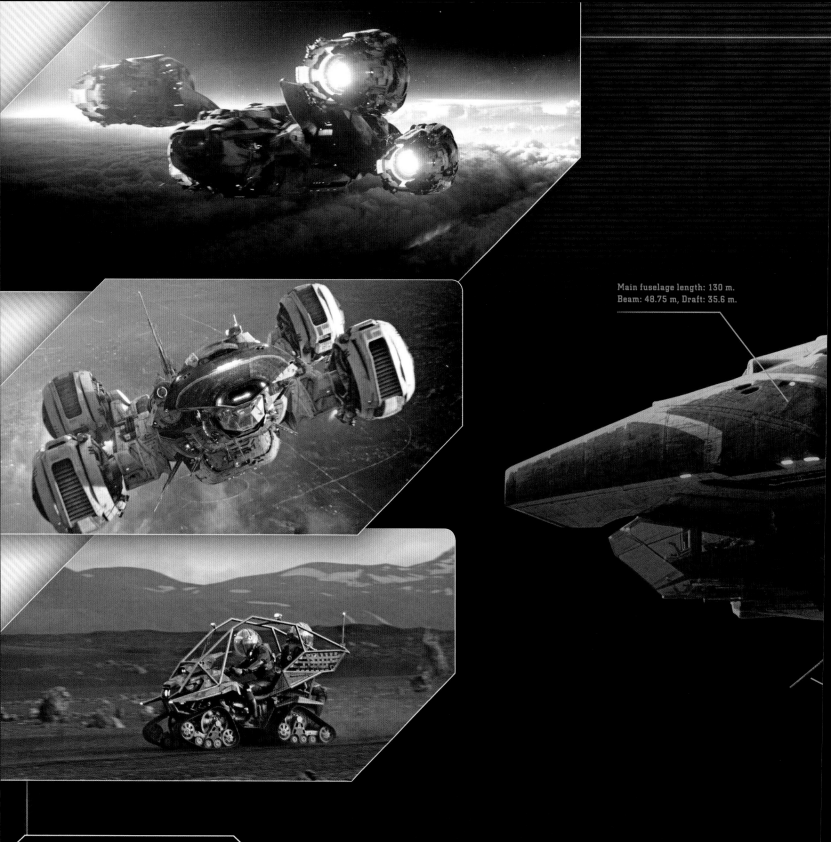

Main fuselage length: 130 m.
Beam: 48.75 m, Draft: 35.6 m.

THE *PROMETHEUS*

The USCSS *Prometheus*, at the time of its launch on August 2, 2091, was the most technologically advanced and expensive FTL-drive exploration vehicle ever created. It was designed to carry its crew megaparsecs beyond KOI-2410, at that time the Weyland-processed world farthest from Earth. Boasting four nuclear fission–powered ion-plasma engines and an ionized plasma drive, the ship was also the first of its class to feature a self-supporting class D crew-escape module, in addition to the individual ejector pods. *Prometheus* carried five R-series exploration rovers and four ATV NR6 runabouts, both multi-terrain vehicles specifically designed for the mission. The ship could comfortably house twenty-five—the actual number aboard in 2091 was seventeen, not including artificial person David 8—and was equipped with full chem and bio labs. The ship's destination was undisclosed to the general public, but she was, in fact, bound for a distant moon, LV-223.

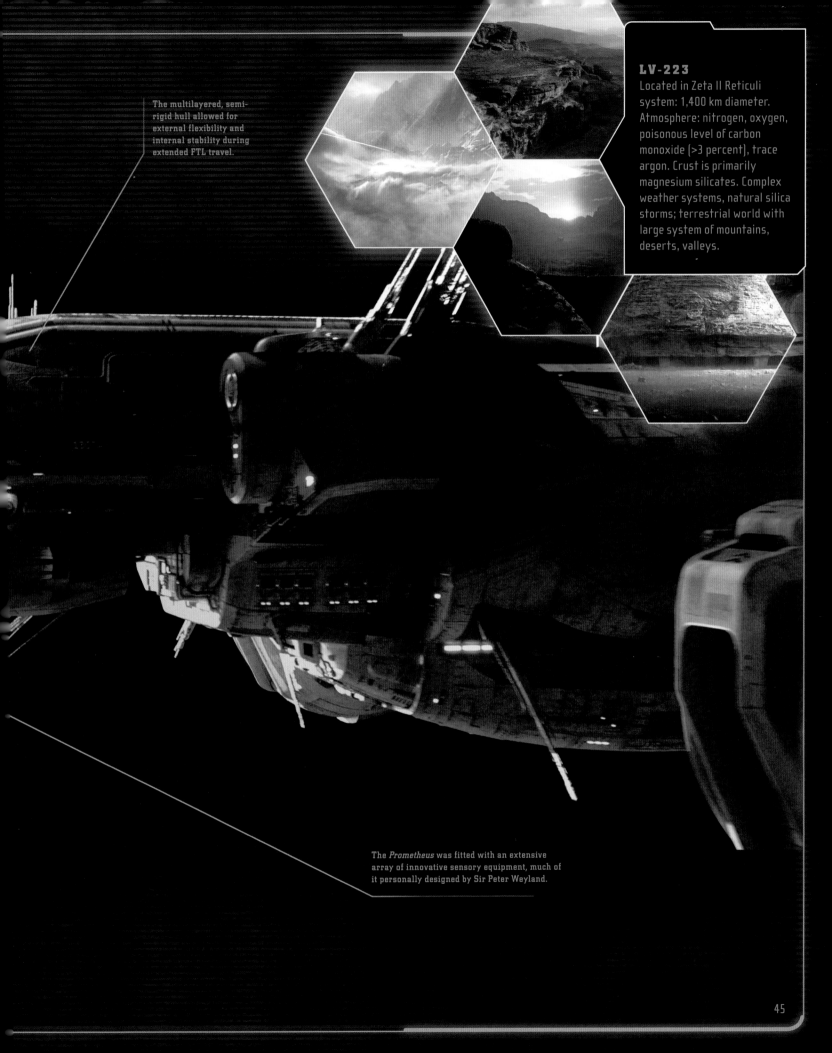

The multilayered, semirigid hull allowed for external flexibility and internal stability during extended FTL travel.

LV-223
Located in Zeta II Reticuli system: 1,400 km diameter. Atmosphere: nitrogen, oxygen, poisonous level of carbon monoxide (>3 percent), trace argon. Crust is primarily magnesium silicates. Complex weather systems, natural silica storms; terrestrial world with large system of mountains, deserts, valleys.

The *Prometheus* was fitted with an extensive array of innovative sensory equipment, much of it personally designed by Sir Peter Weyland.

SIR PETER WEYLAND, 1990–2093

Unknown to the majority of the ship's crew, Sir Peter was aboard the *Prometheus* in a specialized medical hypersleep chamber. Believing he had only a short time to live—his age, adjusted after numerous stints in hypersleep, was close to ninety-two—Sir Peter programmed David 8 to wake him if and when Shaw and Holloway's Engineers were found. Sir Peter was killed by an Engineer awakened from stasis on December 26, 2093.

ELIZABETH SHAW, PH.D. SC.D. 2061–

An accomplished archaeologist and archaeogeneticist, Doctor Shaw's work was compelling enough to draw Sir Peter himself into deep space, ostensibly to meet the Engineers of the human race. Her father, a Christian missionary, instilled in her a deep and abiding faith—a faith certainly tested by her discoveries on LV-223 and, later, [REDACTED] When given the opportunity to provide the Company with a specimen of alien life gestating inside of her, Shaw instead chose to surgically rid herself of the creature.

CHARLES HOLLOWAY, PH.D. 2058–2093

An American archaeoastronomer who worked closely with Elizabeth Shaw and oversaw four of their successful pictograph excavations. Dr. Holloway's specialty was interpretation of prehistoric hieroglyphs. Before meeting Shaw, Dr. Holloway's career was unremarkable. He was arrested as a protestor when the Nanethe dig was declared nonhistorical in 2079; Holloway, along with seven other archaeology students, chained himself to ground-moving equipment in a vain attempt to preserve the site. Holloway's antiauthoritarian tendencies continued to hinder his career; he was denied tenure at a state university for refusing to follow curriculum guidelines in 2084, and again in 2086.

MEREDITH VICKERS, EC/#9549874308. 2057–2093

Sir Peter Weyland's only legitimate child. Studied business management at Oxford; chose to accompany Sir Peter to oversee operations aboard the *Prometheus*. Ms. Vickers was in line to become CEO of Weyland-Yutani upon the death or resignation of her father. She was personally responsible for selecting the *Prometheus*'s crew.

CAPTAIN IDRIS JANEK, EC/#4861258765, 3-3571. 2051–2093

Ex-military FTL vessel ship's captain. By all accounts, well liked and respected by his crews. Although he scored well on Company evals (contracted loyalty rating in the 600s), Janek's handling of the *Prometheus*'s crew was unacceptably lax. His casual, unauthoritarian manner and self-indulgence undoubtedly encouraged his subordinates to act likewise, resulting in poor decision-making and ultimately contributing to the mission's failure.

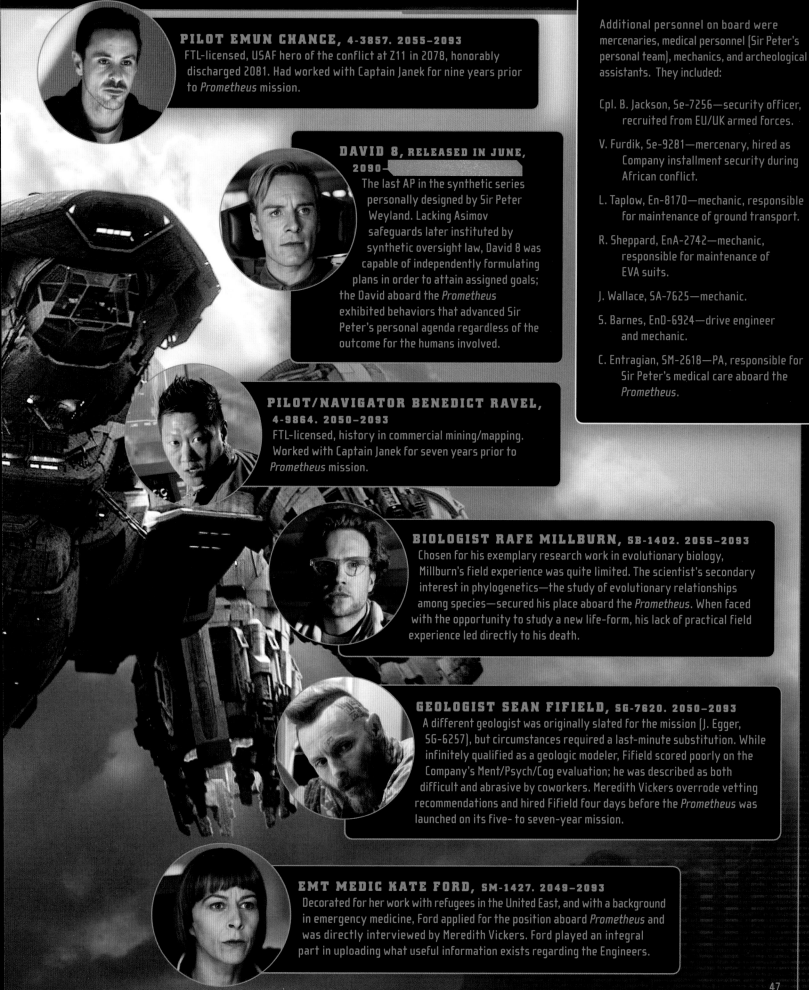

PILOT EMUN CHANCE, 4-3857. 2055–2093

FTL-licensed, USAF hero of the conflict at Z11 in 2078, honorably discharged 2081. Had worked with Captain Janek for nine years prior to *Prometheus* mission.

DAVID 8, RELEASED IN JUNE, 2090–

The last AP in the synthetic series personally designed by Sir Peter Weyland. Lacking Asimov safeguards later instituted by synthetic oversight law, David 8 was capable of independently formulating plans in order to attain assigned goals; the David aboard the *Prometheus* exhibited behaviors that advanced Sir Peter's personal agenda regardless of the outcome for the humans involved.

PILOT/NAVIGATOR BENEDICT RAVEL, 4-9864. 2050–2093

FTL-licensed, history in commercial mining/mapping. Worked with Captain Janek for seven years prior to *Prometheus* mission.

BIOLOGIST RAFE MILLBURN, SB-1402. 2055–2093

Chosen for his exemplary research work in evolutionary biology, Millburn's field experience was quite limited. The scientist's secondary interest in phylogenetics—the study of evolutionary relationships among species—secured his place aboard the *Prometheus*. When faced with the opportunity to study a new life-form, his lack of practical field experience led directly to his death.

GEOLOGIST SEAN FIFIELD, SG-7620. 2050–2093

A different geologist was originally slated for the mission (J. Egger, SG-6257), but circumstances required a last-minute substitution. While infinitely qualified as a geologic modeler, Fifield scored poorly on the Company's Ment/Psych/Cog evaluation; he was described as both difficult and abrasive by coworkers. Meredith Vickers overrode vetting recommendations and hired Fifield four days before the *Prometheus* was launched on its five- to seven-year mission.

EMT MEDIC KATE FORD, SM-1427. 2049–2093

Decorated for her work with refugees in the United East, and with a background in emergency medicine, Ford applied for the position aboard *Prometheus* and was directly interviewed by Meredith Vickers. Ford played an integral part in uploading what useful information exists regarding the Engineers.

Additional personnel on board were mercenaries, medical personnel (Sir Peter's personal team), mechanics, and archeological assistants. They included:

Cpl. B. Jackson, Se-7256—security officer, recruited from EU/UK armed forces.

V. Furdik, Se-9281—mercenary, hired as Company installment security during African conflict.

L. Taplow, En-8170—mechanic, responsible for maintenance of ground transport.

R. Sheppard, EnA-2742—mechanic, responsible for maintenance of EVA suits.

J. Wallace, SA-7625—mechanic.

S. Barnes, EnD-6924—drive engineer and mechanic.

C. Entragian, SM-2618—PA, responsible for Sir Peter's medical care aboard the *Prometheus*.

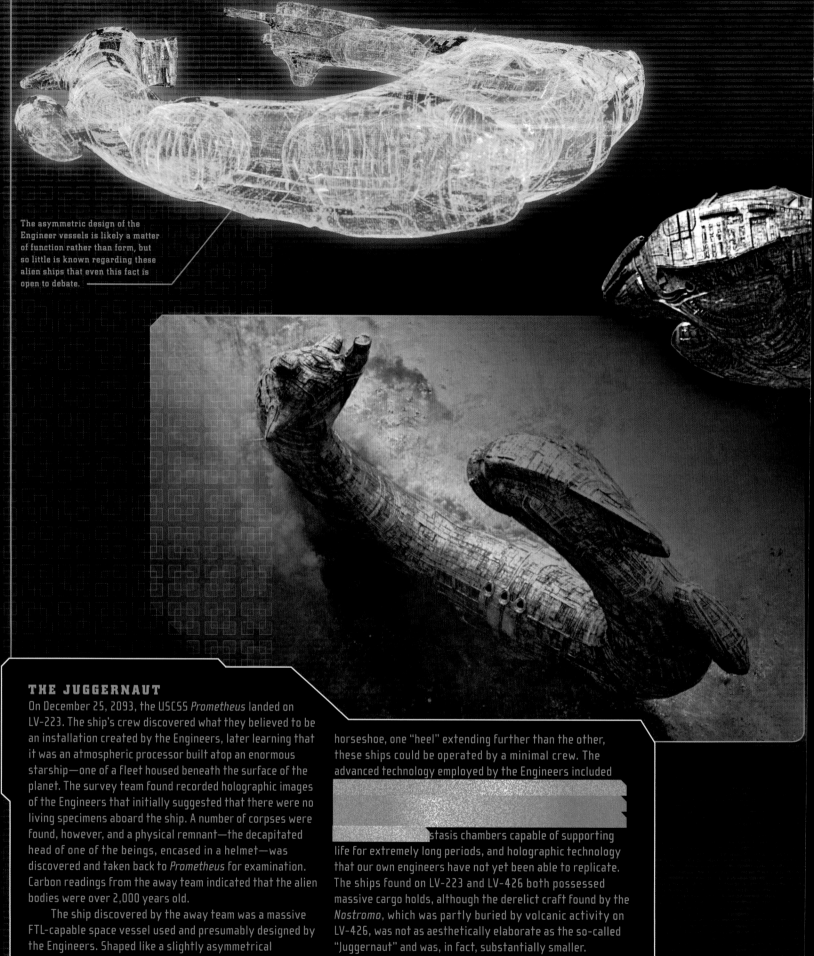

The asymmetric design of the Engineer vessels is likely a matter of function rather than form, but so little is known regarding these alien ships that even this fact is open to debate.

THE JUGGERNAUT

On December 25, 2093, the USCSS *Prometheus* landed on LV-223. The ship's crew discovered what they believed to be an installation created by the Engineers, later learning that it was an atmospheric processor built atop an enormous starship—one of a fleet housed beneath the surface of the planet. The survey team found recorded holographic images of the Engineers that initially suggested that there were no living specimens aboard the ship. A number of corpses were found, however, and a physical remnant—the decapitated head of one of the beings, encased in a helmet—was discovered and taken back to *Prometheus* for examination. Carbon readings from the away team indicated that the alien bodies were over 2,000 years old.

The ship discovered by the away team was a massive FTL-capable space vessel used and presumably designed by the Engineers. Shaped like a slightly asymmetrical horseshoe, one "heel" extending further than the other, these ships could be operated by a minimal crew. The advanced technology employed by the Engineers included stasis chambers capable of supporting life for extremely long periods, and holographic technology that our own engineers have not yet been able to replicate. The ships found on LV-223 and LV-426 both possessed massive cargo holds, although the derelict craft found by the *Nostromo*, which was partly buried by volcanic activity on LV-426, was not as aesthetically elaborate as the so-called "Juggernaut" and was, in fact, substantially smaller.

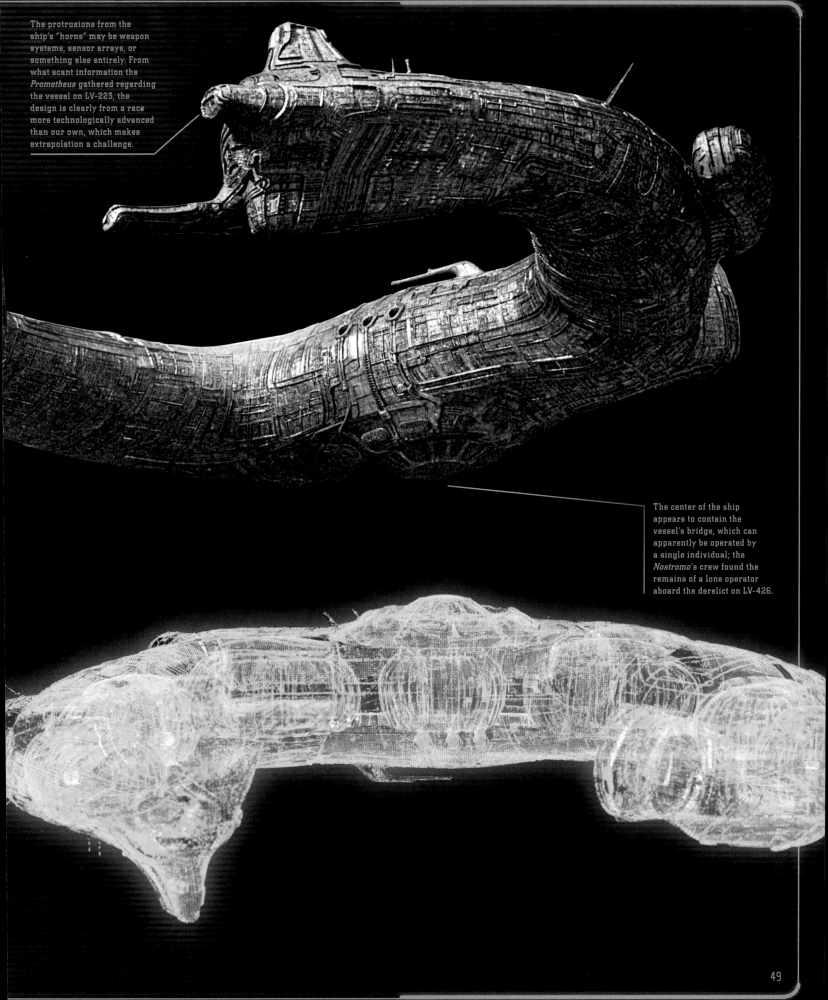

The protrusions from the ship's "horns" may be weapon systems, sensor arrays, or something else entirely. From what scant information the *Prometheus* gathered regarding the vessel on LV-223, the design is clearly from a race more technologically advanced than our own, which makes extrapolation a challenge.

The center of the ship appears to contain the vessel's bridge, which can apparently be operated by a single individual; the *Nostromo*'s crew found the remains of a lone operator aboard the derelict on LV-426.

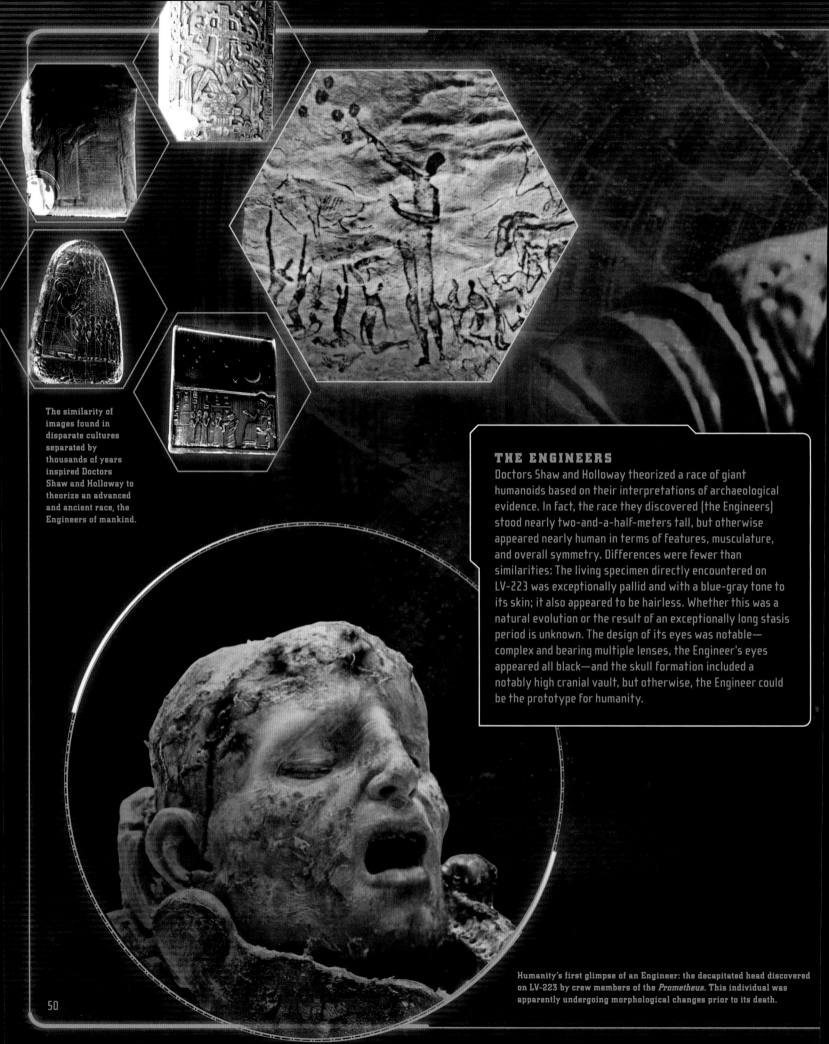

The similarity of images found in disparate cultures separated by thousands of years inspired Doctors Shaw and Holloway to theorize an advanced and ancient race, the Engineers of mankind.

THE ENGINEERS

Doctors Shaw and Holloway theorized a race of giant humanoids based on their interpretations of archaeological evidence. In fact, the race they discovered (the Engineers) stood nearly two-and-a-half-meters tall, but otherwise appeared nearly human in terms of features, musculature, and overall symmetry. Differences were fewer than similarities: The living specimen directly encountered on LV-223 was exceptionally pallid and with a blue-gray tone to its skin; it also appeared to be hairless. Whether this was a natural evolution or the result of an exceptionally long stasis period is unknown. The design of its eyes was notable—complex and bearing multiple lenses, the Engineer's eyes appeared all black—and the skull formation included a notably high cranial vault, but otherwise, the Engineer could be the prototype for humanity.

Humanity's first glimpse of an Engineer: the decapitated head discovered on LV-223 by crew members of the *Prometheus*. This individual was apparently undergoing morphological changes prior to its death.

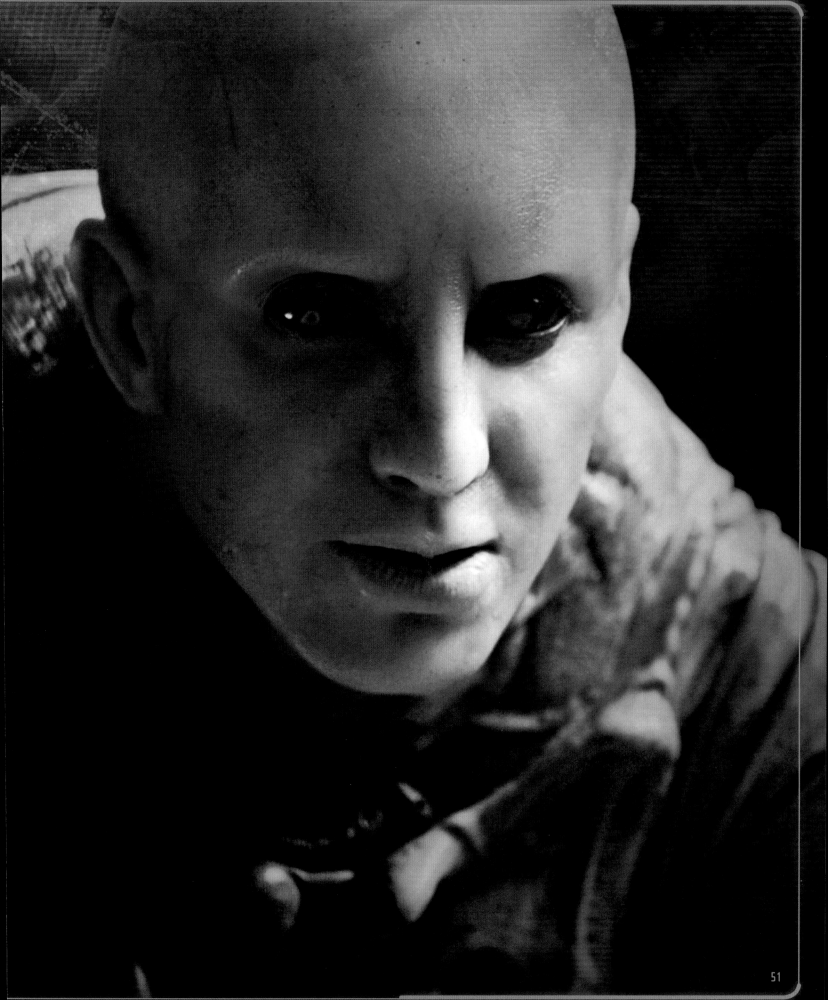

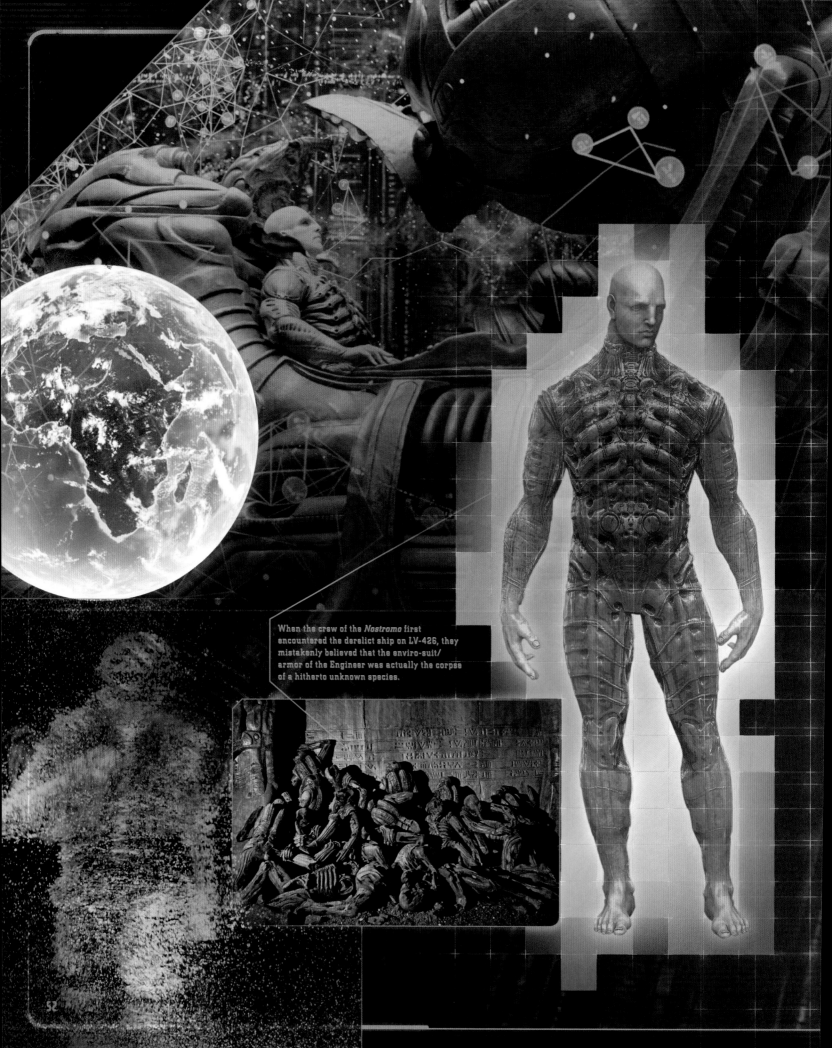

When the crew of the *Nostromo* first encountered the derelict ship on LV-426, they mistakenly believed that the enviro-suit/armor of the Engineer was actually the corpse of a hitherto unknown species.

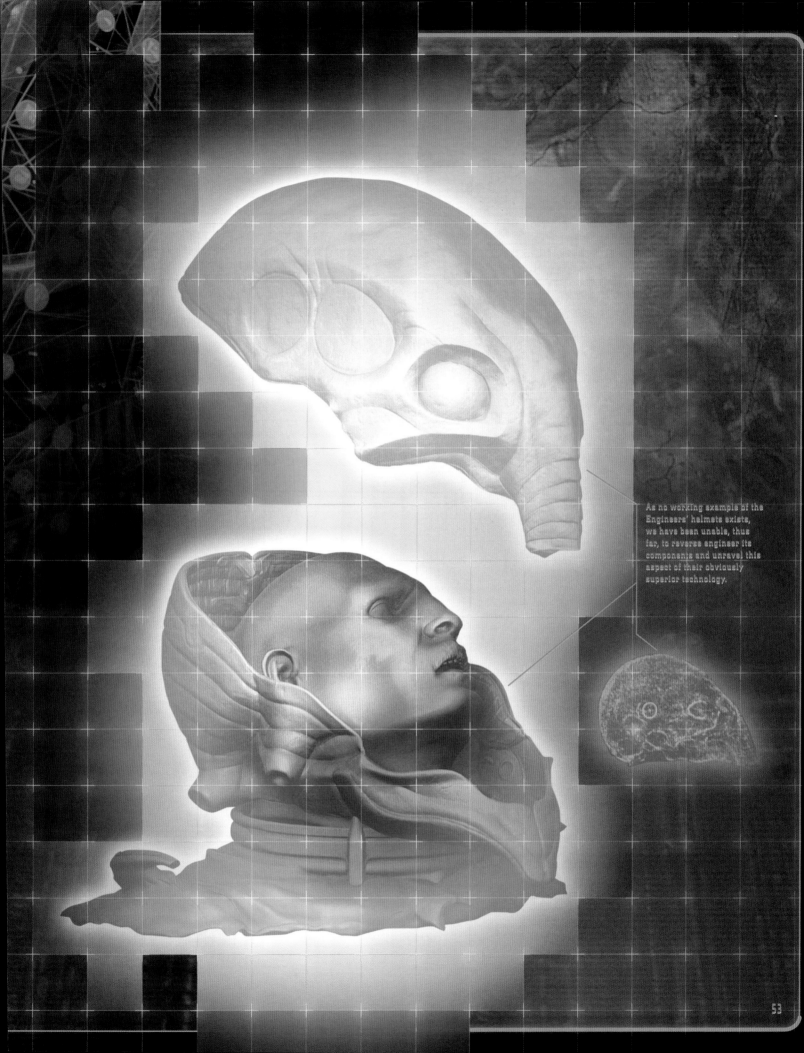

As no working example of the Engineers' helmets exists, we have been unable, thus far, to reverse engineer its components and unravel this aspect of their obviously superior technology.

THE ACCELERANT

In the hold of the alien ship, the crew of the *Prometheus* found innumerable urns filled with an organic, viscous fluid. Apparently activated by the team's presence, the urns began to leak. Unknown to the crew, David brought one of the urns back to *Prometheus* and put some of the alien fluid in a drink he served to Dr. Holloway. It is unclear if David was acting upon Sir Peter's orders or via his volition programming. Results of the experiment were inconclusive; Holloway sickened and appeared to undergo morphological changes before he was killed by Meredith Vickers while apparently trying to break quarantine.

It has been postulated that the cargo carried by the Engineers was a type of genetic accelerant, creating a quickly growing life-form based on whatever contaminant it came into contact with. Shortly after being infected with the material, Dr. Holloway had intercourse with Dr. Shaw. In spite of a medical history that included the inability to conceive, Dr. Shaw became pregnant. The organism that she had surgically removed went on to interact with the last remaining Engineer: the final result, a creature that bore a number of startling similarities to Xenomorph XX121.

The Accelerant, like so much of the Engineers' technology, is not only beyond our understanding, its existence pushes the limits of belief.

Further information regarding the canisters and the Accelerant require a security clearance above the rating of this report.

54

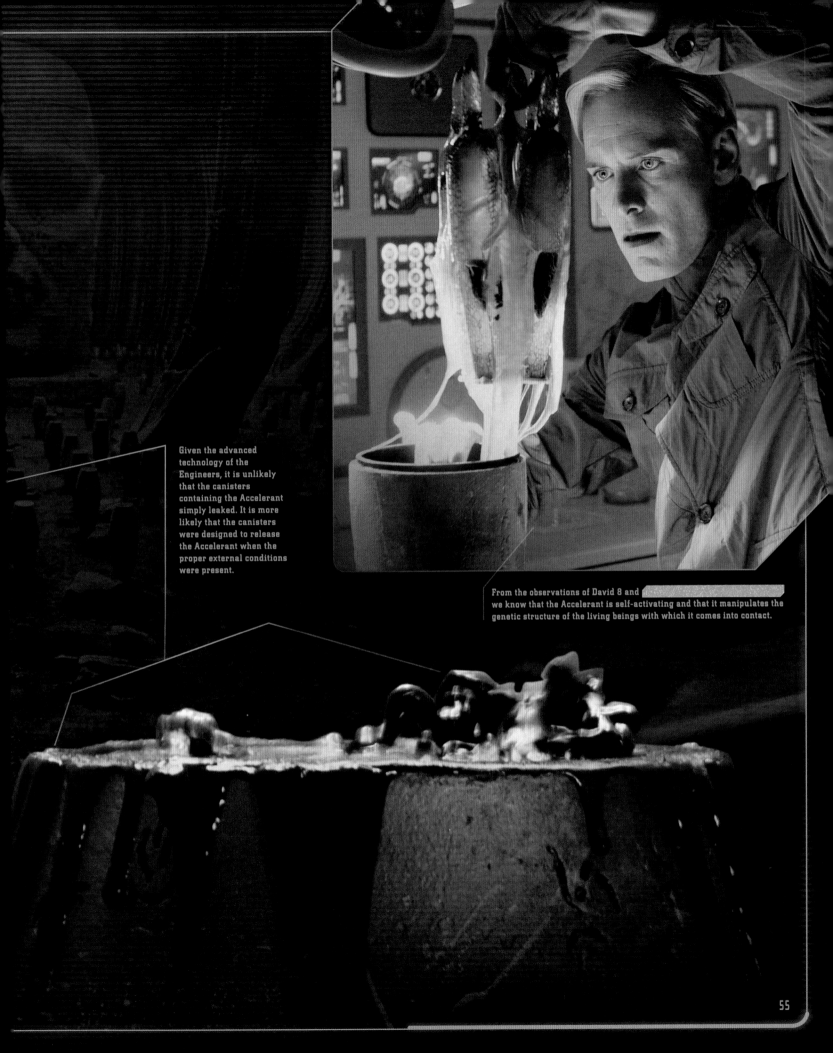

Given the advanced technology of the Engineers, it is unlikely that the canisters containing the Accelerant simply leaked. It is more likely that the canisters were designed to release the Accelerant when the proper external conditions were present.

From the observations of David 8 and ████████████ we know that the Accelerant is self-activating and that it manipulates the genetic structure of the living beings with which it comes into contact.

12/26/93

Doctor Holloway is dead. He was infected by some alien virus or bacterium and he tried to come back aboard the *Prometheus*. There was no alternative. I told him to stand down but he kept coming at me, forcing my hand. He begged me to kill him, and he was trying to break quarantine; there was nothing else I could do. No one supported my decision, but that's why I'm here, isn't it? To make the hard decisions. After a lifetime beyond brilliance, Sir Peter Weyland let the fear of his own mortality take over, to lead him on this fool's errand, and someone had to step up to manage his madness. I deserve better, I've *earned* better, but no one else was volunteering for the job.

Weyland thinks he's found the cure for death. He's off to meet our makers now, convinced that he hasn't wasted his last days of life reaching for the impossible. No man is immortal, not even him, but he refuses to surrender, his claws are so deeply entrenched. I used to think it was me—that he didn't believe in my abilities. The simpler truth is that he won't let go because he can't. He can't comprehend that his magical, special life is finally nearing its end, that he will cease to exist just like the rest of us.

Did the Engineers create us? Shaw and Holloway proved a connection, certainly, which I would have bet against. The real question is, though: Does it matter? My father created me; if I was dying, I wouldn't crawl to him, begging for more life, like he's crawling now. Weyland is no longer fit to lead the Company, and when he returns from his pointless journey to the Engineers' ship, I will relieve him of his duties. No matter what he finds, it won't be what he wants. It never is.

A human eye, after the subject (Holloway) was exposed to the alien Accelerant.

This apparently parasitic creature (sometimes known as the "hammerpede") may have been an indigenous and harmless worm before being exposed to the Accelerant. Biologist Millburn was killed by the creature when he recklessly attempted to interact with it.

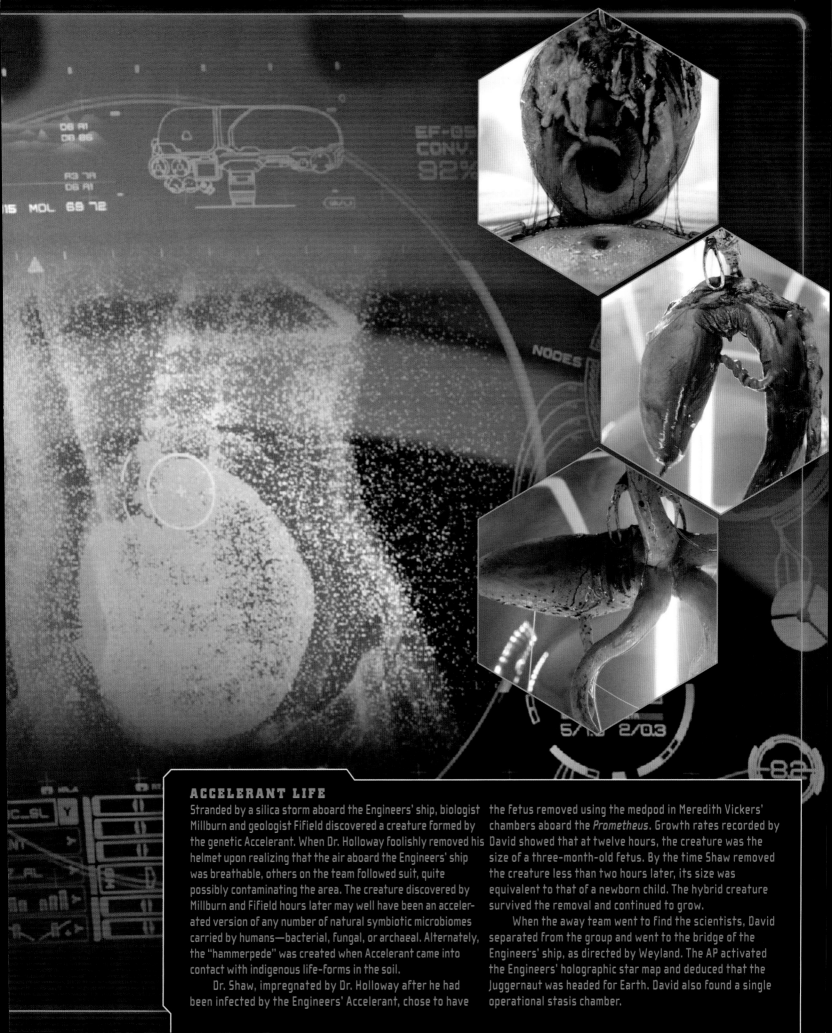

ACCELERANT LIFE

Stranded by a silica storm aboard the Engineers' ship, biologist Millburn and geologist Fifield discovered a creature formed by the genetic Accelerant. When Dr. Holloway foolishly removed his helmet upon realizing that the air aboard the Engineers' ship was breathable, others on the team followed suit, quite possibly contaminating the area. The creature discovered by Millburn and Fifield hours later may well have been an accelerated version of any number of natural symbiotic microbiomes carried by humans—bacterial, fungal, or archaeal. Alternately, the "hammerpede" was created when Accelerant came into contact with indigenous life-forms in the soil.

Dr. Shaw, impregnated by Dr. Holloway after he had been infected by the Engineers' Accelerant, chose to have the fetus removed using the medpod in Meredith Vickers' chambers aboard the *Prometheus*. Growth rates recorded by David showed that at twelve hours, the creature was the size of a three-month-old fetus. By the time Shaw removed the creature less than two hours later, its size was equivalent to that of a newborn child. The hybrid creature survived the removal and continued to grow.

When the away team went to find the scientists, David separated from the group and went to the bridge of the Engineers' ship, as directed by Weyland. The AP activated the Engineers' holographic star map and deduced that the Juggernaut was headed for Earth. David also found a single operational stasis chamber.

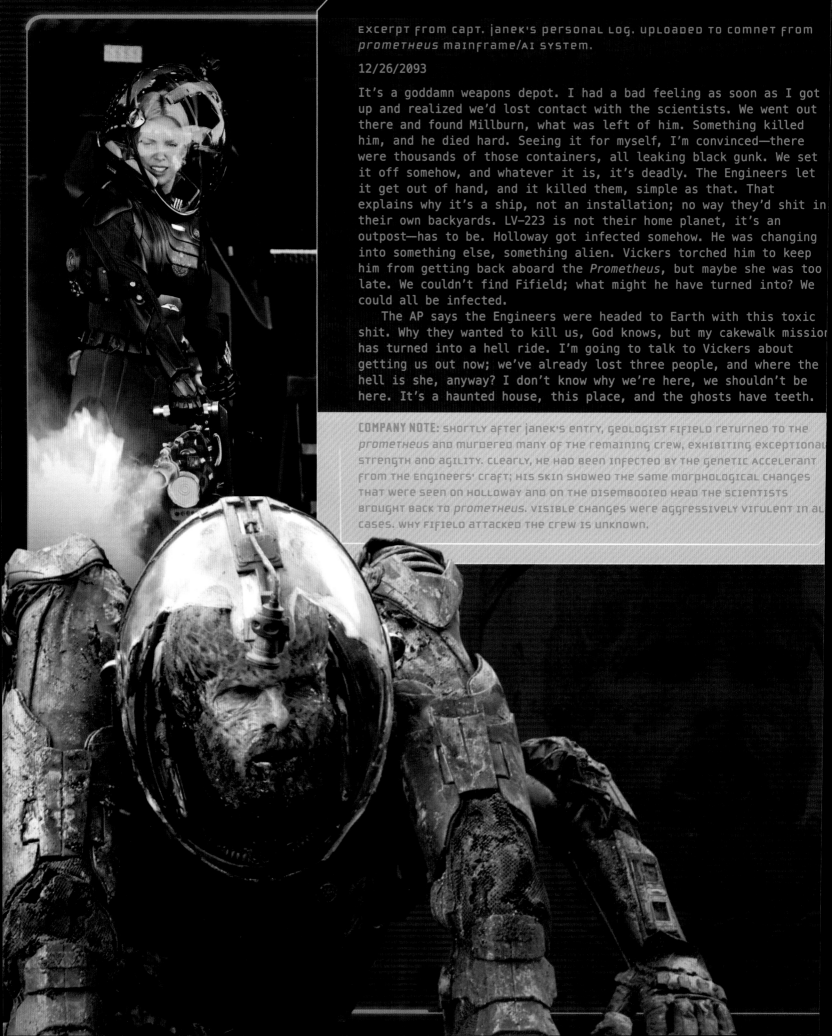

12/26/2093

It's a goddamn weapons depot. I had a bad feeling as soon as I got up and realized we'd lost contact with the scientists. We went out there and found Millburn, what was left of him. Something killed him, and he died hard. Seeing it for myself, I'm convinced—there were thousands of those containers, all leaking black gunk. We set it off somehow, and whatever it is, it's deadly. The Engineers let it get out of hand, and it killed them, simple as that. That explains why it's a ship, not an installation; no way they'd shit in their own backyards. LV-223 is not their home planet, it's an outpost—has to be. Holloway got infected somehow. He was changing into something else, something alien. Vickers torched him to keep him from getting back aboard the *Prometheus*, but maybe she was too late. We couldn't find Fifield; what might he have turned into? We could all be infected.

 The AP says the Engineers were headed to Earth with this toxic shit. Why they wanted to kill us, God knows, but my cakewalk mission has turned into a hell ride. I'm going to talk to Vickers about getting us out now; we've already lost three people, and where the hell is she, anyway? I don't know why we're here, we shouldn't be here. It's a haunted house, this place, and the ghosts have teeth.

COMPANY NOTE: Shortly after Janek's entry, geologist Fifield returned to the *prometheus* and murdered many of the remaining crew, exhibiting exceptional strength and agility. Clearly, he had been infected by the genetic accelerant from the Engineers' craft; his skin showed the same morphological changes that were seen on Holloway and on the disembodied head the scientists brought back to *prometheus*. Visible changes were aggressively virulent in all cases. Why Fifield attacked the crew is unknown.

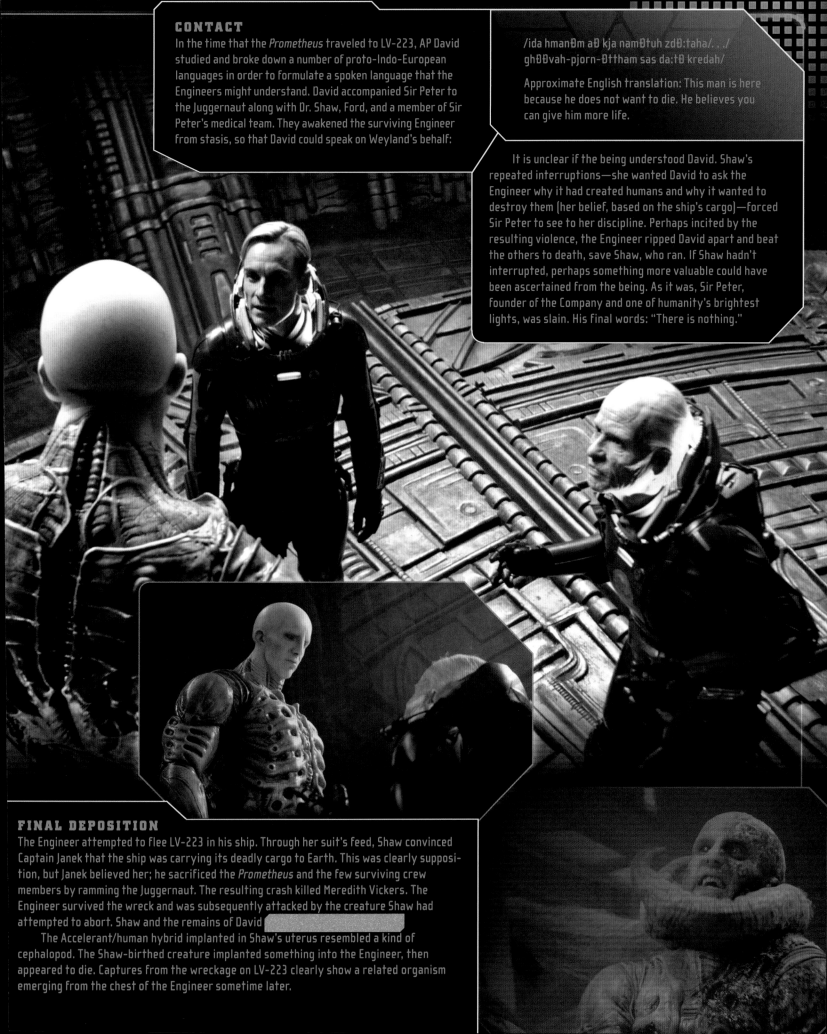

CONTACT

In the time that the *Prometheus* traveled to LV-223, AP David studied and broke down a number of proto-Indo-European languages in order to formulate a spoken language that the Engineers might understand. David accompanied Sir Peter to the Juggernaut along with Dr. Shaw, Ford, and a member of Sir Peter's medical team. They awakened the surviving Engineer from stasis, so that David could speak on Weyland's behalf:

/ida hmanÐm aÐ kja namÐtuh zdÐ:taha/. . ./
ghÐÐvah-pjorn-Ðttham sas da:tÐ kredah/

Approximate English translation: This man is here because he does not want to die. He believes you can give him more life.

It is unclear if the being understood David. Shaw's repeated interruptions—she wanted David to ask the Engineer why it had created humans and why it wanted to destroy them (her belief, based on the ship's cargo)—forced Sir Peter to see to her discipline. Perhaps incited by the resulting violence, the Engineer ripped David apart and beat the others to death, save Shaw, who ran. If Shaw hadn't interrupted, perhaps something more valuable could have been ascertained from the being. As it was, Sir Peter, founder of the Company and one of humanity's brightest lights, was slain. His final words: "There is nothing."

FINAL DEPOSITION

The Engineer attempted to flee LV-223 in his ship. Through her suit's feed, Shaw convinced Captain Janek that the ship was carrying its deadly cargo to Earth. This was clearly supposition, but Janek believed her; he sacrificed the *Prometheus* and the few surviving crew members by ramming the Juggernaut. The resulting crash killed Meredith Vickers. The Engineer survived the wreck and was subsequently attacked by the creature Shaw had attempted to abort. Shaw and the remains of David ▮▮▮▮▮▮▮▮▮▮▮▮▮▮

The Accelerant/human hybrid implanted in Shaw's uterus resembled a kind of cephalopod. The Shaw-birthed creature implanted something into the Engineer, then appeared to die. Captures from the wreckage on LV-223 clearly show a related organism emerging from the chest of the Engineer sometime later.

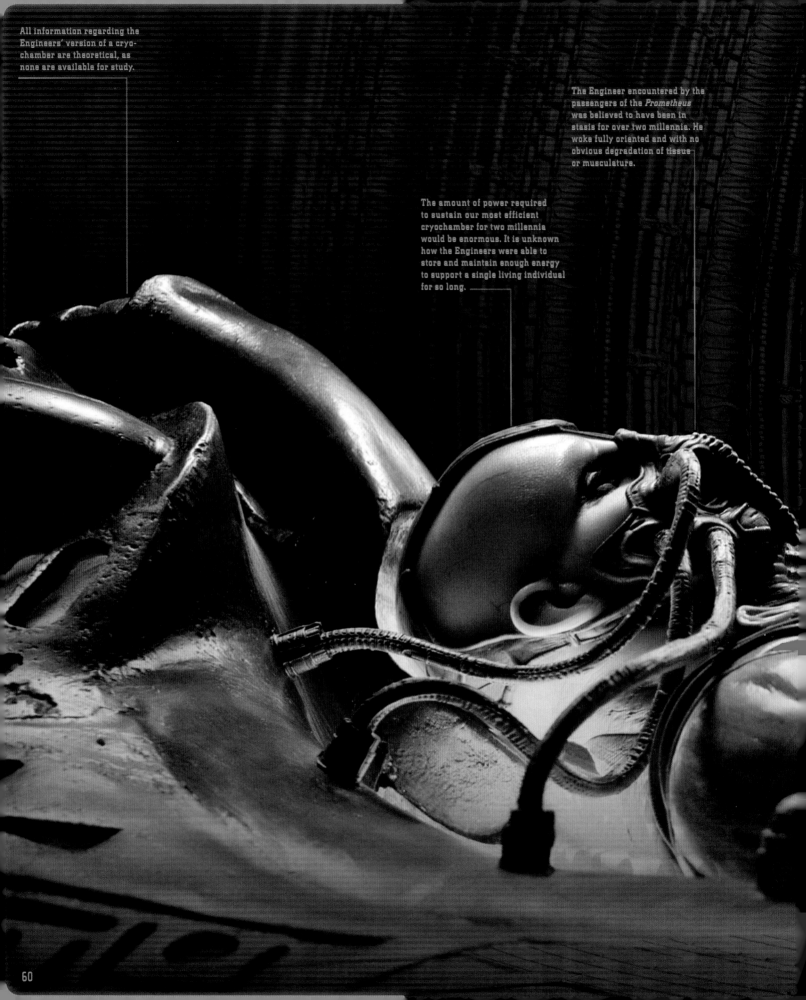

All information regarding the
Engineers' version of a cryo-
chamber are theoretical, as
none are available for study.

The Engineer encountered by the
passengers of the *Prometheus*
was believed to have been in
stasis for over two millennia. He
woke fully oriented and with no
obvious degradation of tissue
or musculature.

The amount of power required
to sustain our most efficient
cryochamber for two millennia
would be enormous. It is unknown
how the Engineers were able to
store and maintain enough energy
to support a single living individual
for so long.

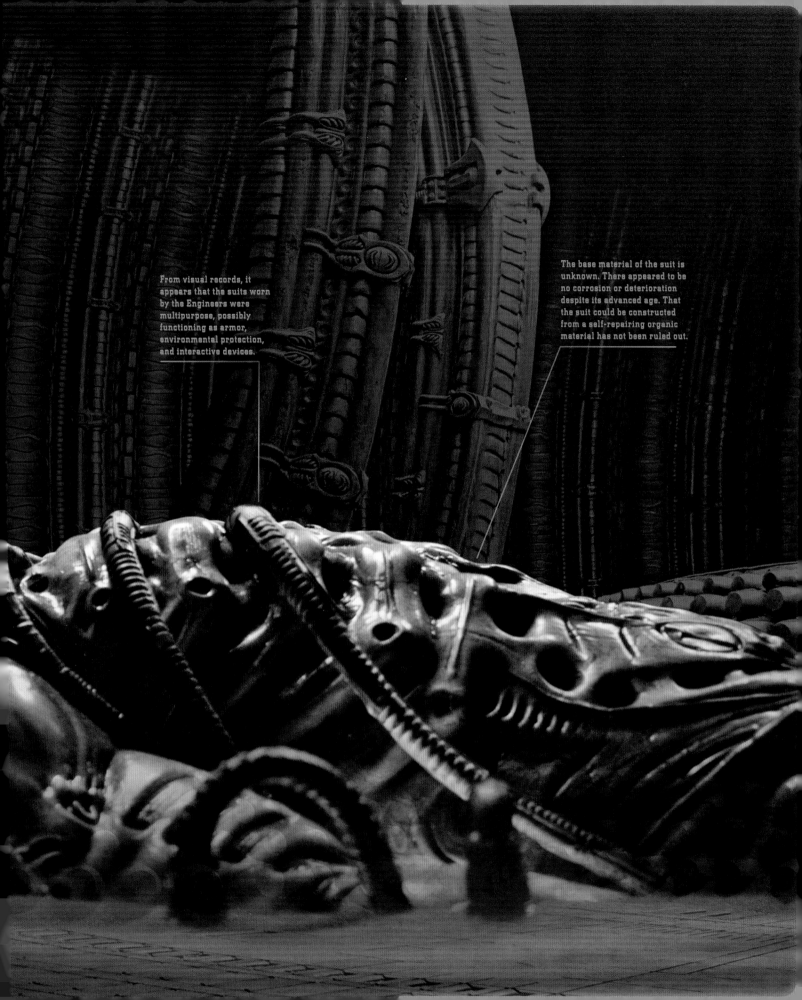

From visual records, it appears that the suits worn by the Engineers were multipurpose, possibly functioning as armor, environmental protection, and interactive devices.

The base material of the suit is unknown. There appeared to be no corrosion or deterioration despite its advanced age. That the suit could be constructed from a self-repairing organic material has not been ruled out.

That the Engineers' cargo was specifically a manufactured, biological genetic Accelerant cannot be proved or disproved, but the Engineers' hold was clearly full of something toxic to mammalian life, to human life. Was the Juggernaut bound for Earth? AP David believed so, but its interpretation may have been flawed. Based on the AP's belief, Shaw decided that the Engineers meant to destroy humanity, although she was unable to theorize a motive.

Obviously, the Company's interest in the Accelerant and in the Engineers is ongoing. The mysterious black, viscous liquid promises answers to questions we've not yet begun to ask regarding the technical creation of life. The Engineers

The Accelerant had no apparent effect on David 8, presumably because the android lacked a genetic code.

This is the creature that emerged from the chest of the Engineer on LV-223. Company scientists hypothesize

BIOENGINEERING

The *Prometheus* set out to find the giants theorized by Doctors Shaw and Holloway, to discover whether or not these creatures could shed light on the origins of humans. Sir Peter sought to extend his life; Shaw and Holloway both hoped to meet these "Engineers," to ask the questions that humans have long pondered: Why do we exist? What is our purpose? It is hard to clearly define what they discovered; circumstantial evidence indicated that the Engineers were related to humans—the DNA typing was conclusive—but the assumption that they created us may be fallacious.

A case could as easily be made that the Engineers were our brothers rather than our makers, and that the pictographs highlighted by Shaw and Holloway were a warning to stay away from the area indicated. The nature of their cargo certainly makes a warning more likely than an invitation. It was at the very least presumptuous that the scientists and Sir Peter concluded otherwise. That is not to say that they were wrong. At this time, the Company is not prepared to go on record with the data currently collated regarding the Engineers and their role in the creation of humanity.

Note secondary set of jaws and long, eyeless skull.

Information regarding this creature (sometimes referred to as "the Deacon") requires a security clearance above the rating of this report.

COURSE CORRECTION

The tragic loss of our founder and his heir marked the end of our Company's first epoch—a golden era for humanity, but only the beginning for the Company and the search for definitive answers. Beginning in 2095, barely a year after Dr. Shaw's final declassified transmission, the special directive 900 sequence was programmed into every Company ship—an authorization to wake the crew to investigate any transmission of unknown or seemingly intelligent origin. The clause that requires Company or Company-contracted employees to investigate any such transmissions became standard in 2101.

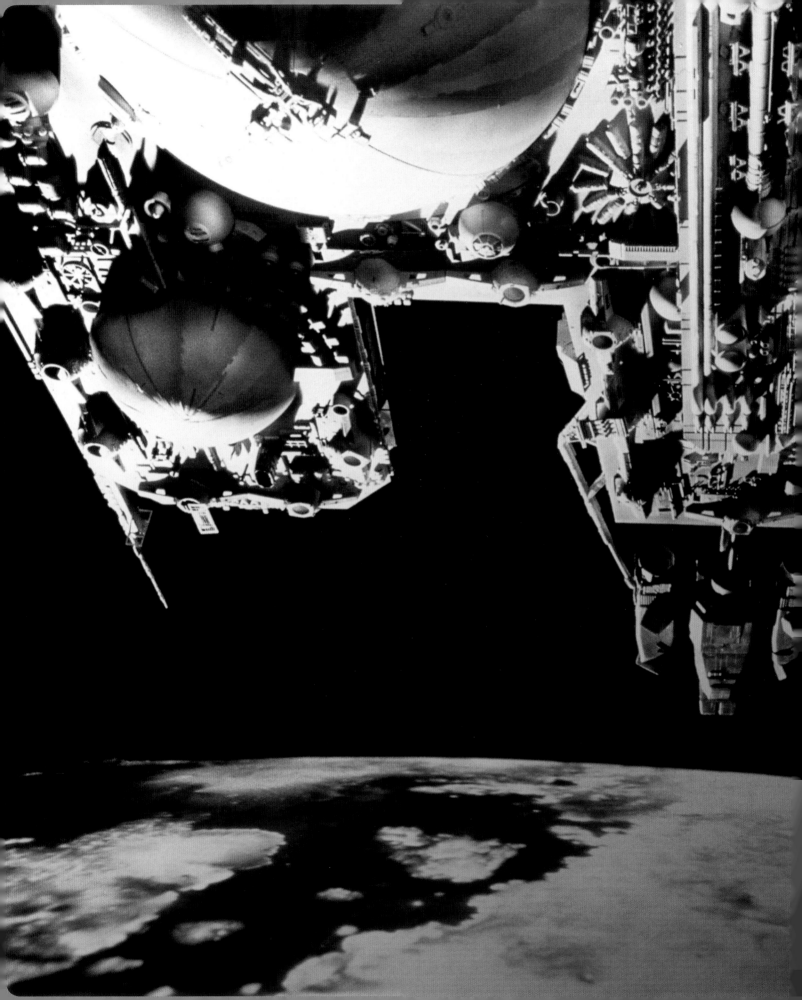

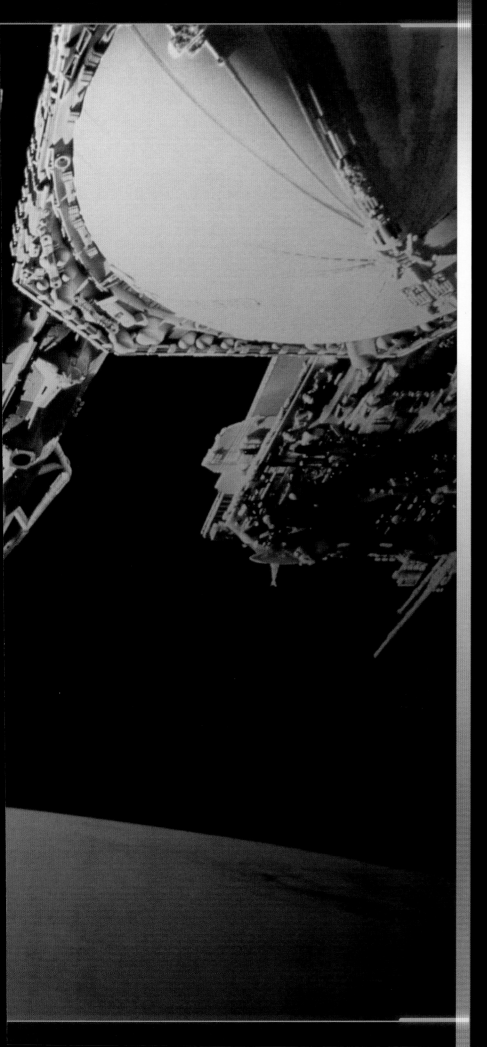

ENCOUNTER ON LV-426

IN 2122, THE USCSS *NOSTROMO* BECAME THE FIRST WEYLAND-YUTANI SHIP TO MAKE CONTACT WITH XENOMORPH XX121. RETURNING TO EARTH AFTER A STANDARD PROCESSING RUN, THE CREW WAS AWAKENED FROM HYPERSLEEP BY WHAT THE SHIP'S INTERFACE BELIEVED TO BE A DISTRESS SIGNAL. UPON SEEKING THE SOURCE, A DERELICT ALIEN CRAFT WAS DISCOVERED, ITS HOLD FULL OF XENOMORPH EGGS. A CREW MEMBER WAS IMPLANTED AND TAKEN BACK ABOARD THE *NOSTROMO*. IN LESS THAN TWENTY-FOUR HOURS, THE XENOMORPH HAD KILLED ALL BUT ONE OF THE CREW, EXHIBITING AN AS-YET-UNSEEN PERFECTION OF INSTINCT AND FORM.

USCSS NOSTROMO
REGISTRATION 1809246(09)

SPECS: Modified Lockmark CM-88B M-class Bison Transport, constructed 2101. Refitted as a commercial towing vehicle in 2116. Ran a standard processing route between Earth and the Outer Rim (originally the Outer Veil, discovered by Weyland Corporation scientists in 2037).

SCHEMATIC: Length of ship: 334 m. Beam, 215 m. Draft, 98 m.

LENGTH OF REFINERY: 1927 m. Beam, 1257 m. Draft, 1121.5 m.

THREE MAIN DECKS: A Deck held the galley, bridge, infirmary, hypersleep chamber, the Mother interface, and the main airlock. B Deck was shuttle access and storage. C Deck was equipment storage, observation, and engineering; the landing struts also retracted into C Deck. By law, the *Nostromo* was supposed to have two fully equipped escape shuttles at all times, but only the shuttle *Narcissus* was operational in 2122.

MODIFIED LSL INTRASYSTEM SHUTTLECRAFT *NARCISSUS*: 16.3 m L x 19.7 m W x 7.5 m H. 48 metric tons. Seated three. Could support two crew members in hypersleep for extended periods. Additional material available REF6294.

Docking arm/clamp connector.

Hyperdrive relay processor.

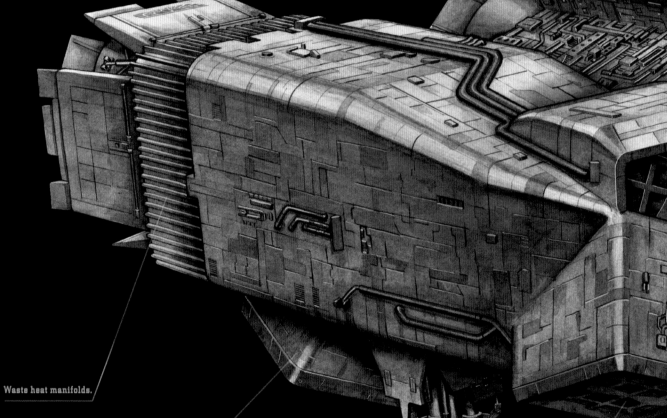

Waste heat manifolds.

Rear vertical take-off and landing thruster port.

VTOL exhaust housing with heatshields.

Atmospheric intake housing.

Bridge and viewports.

Bow interstellar
comms/sensory array.

Docking tube.

Observation blister.

Comms dish.

THE CREW OF THE USCSS *NOSTROMO*

IN APRIL 2121, USCSS *NOSTROMO* ARRIVED AT THEDUS. EIGHT WEEKS LATER, CARRYING 20 MILLION TONS OF MINERAL ORE, THE SHIP BEGAN THE RETURN TO EARTH WITH THE FOLLOWING CREW MEMBERS ABOARD.

CAPTAIN ARTHUR DALLAS, ID 032/V4-07C. 2076–2122

Graduated Mercaton Flight Academy in 2099, worked his way to AA flight status and his own commission in the United Americas Outer Rim Defense Fleet (UAORD) by 2108. Following the tragic loss of the UAS Troop Carrier *Archangel* under his command in 2109, Cpt. Dallas' flight status was revoked, and he was dishonorably discharged from military service. Over the next decade, Dallas turned his hand to commercial interests. By 2120, the year he was contracted by the Weyland-Yutani Corporation and given command of the USCSS *Nostromo*, Cpt. Dallas managed to reclaim B flight status.

EXECUTIVE OFFICER GILBERT WARD "THOMAS" KANE, ID 825/G9-01K. 2083–2122

Kane was expelled from Bryce-Watkins Medical School for substance abuse in 2108 when he was twenty-five, the only blemish on an otherwise spotless career. In 2112, he graduated from Wellington Academy with a master's of engineering and began work for the EU/UK as lead technician at an archeological dig on Konor Minor. His wife of barely two years was lost in a decompression accident in 2115, and Kane transferred to the EU/UK Colonial Expedition (to Outer Rim territories) as a mission analyst. After serving with distinction as first officer on the HMS *Sabretooth* in 2118, and as executive officer for the USCSS *Kenamor* in 2119, he was assigned to the USCSS *Nostromo* in 2120 as executive officer, flight status A.

WARRANT OFFICER ELLEN RIPLEY, ID 759/L2-01N. 2092–2179

Ellen Ripley was recruited straight from the prestigious Evansbrook Academy into the Company's Horizons Beyond Officer Training Program in 2115, graduating with honors a year later. She showed exceptional ability in law, ethics, and corporate management. In 2118, Ripley successfully sued the Company for a brief parental leave (her only daughter, Amanda, was born in 2111; REF#29162). She returned to work in 2119, as warrant officer aboard the USCSS *Sotillo*; in 2120, she was assigned to the USCSS *Nostromo* as warrant officer (flight status B). WO Ripley joined the *Nostromo* already en route to Thedus.

NAVIGATOR JOAN LAMBERT, ID 971/L6-02P. 2093–2122

Lambert graduated New Ontario University in 2112 with a master's degree in astrocartography. Successfully interned at Ridton Corp, Astrocartography Dept. Background as shipping lane trafficator (Luna-UA). Worked as assistant navigator on commercial Mars-Orion route, promoted to navigator in 2118 for UA Scout Vessel *Adowa*. Married and divorced twice. Assigned to USCSS *Nostromo* in 2120.

SCIENCE OFFICER ASH, ID 111/C2/01X

Hyperdyne Systems 120-A2, activated in 2118. Placed aboard the *Nostromo* at Thedus in 2121 for the return trip to Earth, Ash was designed to be fully loyal to Company interests. The Company standard, to place a synthetic on every DS mission, was not yet in place, but it was no accident that Ash was assigned to the *Nostromo*. In fact, the Interface 2037 (Mother) had picked up a faint signal on the journey to Thedus and uploaded it to the Company net. At the time, the signal was believed to be that of a lost mapping satellite. The decision was made to replace the serving science officer with an artificial person, so that Company interests would be suitably represented. The *Nostromo*'s return course was uploaded to I-2037 to pass closer to the signal.

CHIEF ENGINEER DENNIS PARKER, ID 313/S4-08M. 2080–2122

Served as a mechanic at Skyfire Down for the UAORD from 2105–2107. Captured and held by rebels at GR-161 on Torin Prime in 2107; escaped during liberation of Torin Prime in 2108 in an emergency evacuation vehicle (EEV) that he constructed himself from scrap. Honorably discharged from UAORD later that same year. Received additional training at the San Diego School of Astro-Engineering but quit in 2113 before completing degree. Briefly did freelance work before contracting to UA. The Weyland-Yutani Corporation took over his contract in 2115. Met and began working with Brett (see following bio) on the USCSS *Nonnabo* in 2117; in 2120, they joined the crew of the USCSS *Nostromo* en route to Thedus.

ASSISTANT ENGINEER SAMUEL BRETT, ID 724/R4-06J. 2069–2122

Worked as a vehicle mechanic, as a ship hardware specialist, and in cargo maintenance for Ridton before returning to trade school in 2102. A checkered history: Brett spent most of his adult life in and out of alcohol rehabilitation facilities. Also worked in waste disposal and as a reactor tech. Suffered minor brain damage during a cerebral detox procedure on Titan in 2112. Flight status was suspended or revoked on three separate occasions and finally restored in 2113 (Psych Cert# 921B-F7) shortly after his release from an extended stay at a Company medical facility.

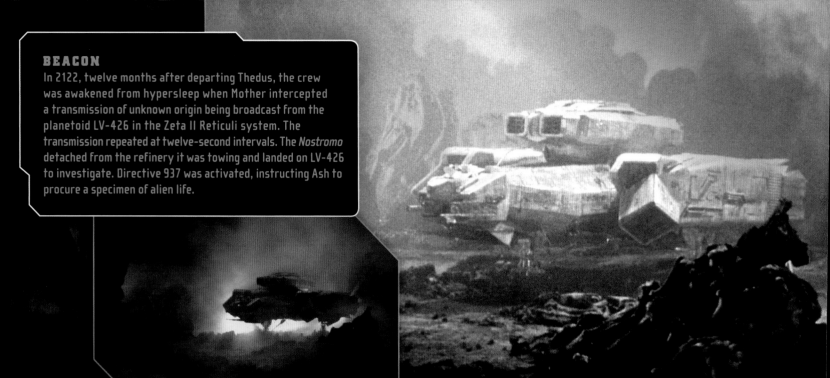

BEACON

In 2122, twelve months after departing Thedus, the crew was awakened from hypersleep when Mother intercepted a transmission of unknown origin being broadcast from the planetoid LV-426 in the Zeta II Reticuli system. The transmission repeated at twelve-second intervals. The *Nostromo* detached from the refinery it was towing and landed on LV-426 to investigate. Directive 937 was activated, instructing Ash to procure a specimen of alien life.

SPECIAL ORDER 937/ PRIORITY ONE
ALL OTHER CONSIDERATIONS SECONDARY

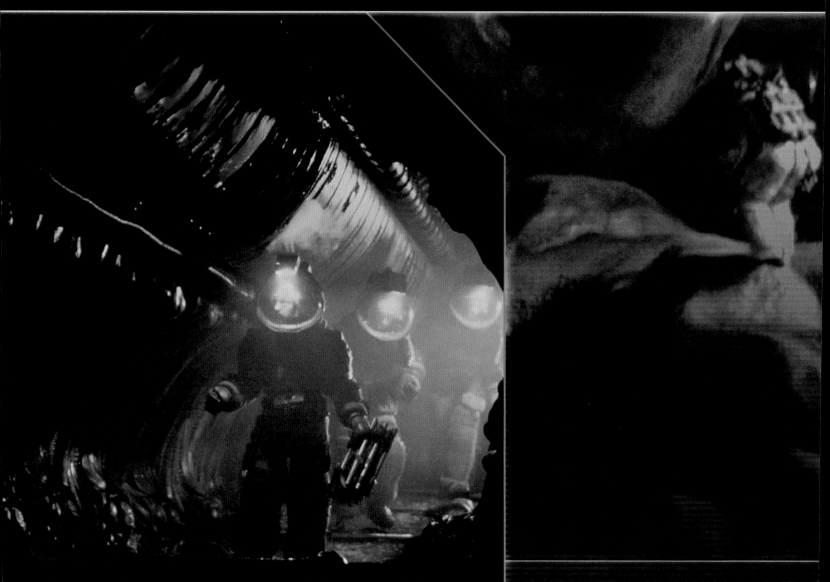

LAMBERT'S INCIDENT STATEMENT REGARDING QUARANTINE PROTOCOL DEVIATION

CLASSIFIED

0605						
	10491111	JUNE	2122	CP	LP	021414

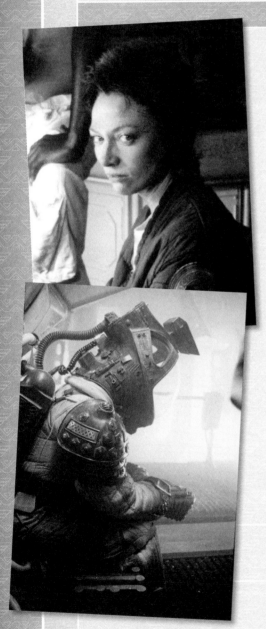

[Kane] was dead weight. We had to haul him out of that hole and then carry him back to the ship with that thing on his face. We knew he was still alive, but his suit had been breached. We had no idea how long he was going to survive. We didn't know anything except that he'd been attacked and the creature wasn't letting go. We were exhausted, scared; we had to get help. Dallas gave Ripley a direct order to open the airlock; he was the captain, it was his call, and Ripley refused. She disobeyed a direct order. She said that with Dallas and Kane not on board, she was ranking officer. It was easy for her to make that distinction. She was safe on the ship; she wasn't running out of air on some godforsaken rock with Kane dying in her arms. If it hadn't been for Ash's decision to breach quarantine protocols, Kane might have died out there. He could still die, that thing won't let go of him, but his only chance is on board the *Nostromo*. Ash made the right call, and I want to be on the record saying so. We could all have died.

CLASSIFIED

Percy Traveller, 262302141480

Lambert, Joan

NSURE RETURN OF ORGANISM FOR ANALYSIS.
CREW EXPENDABLE.

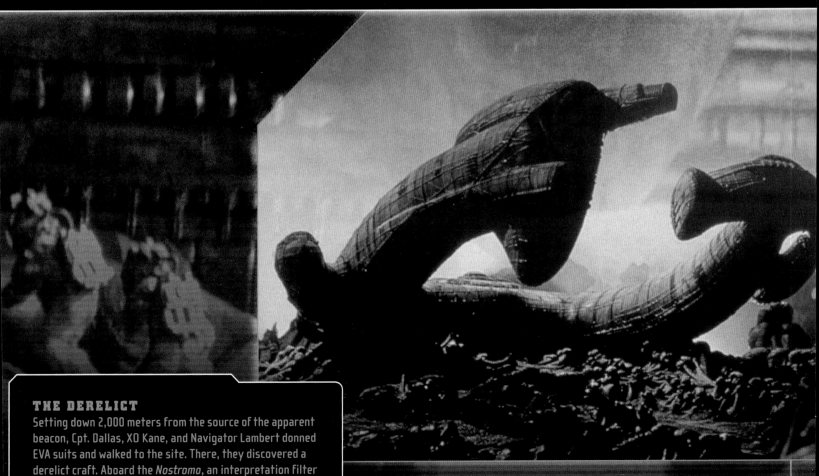

THE DERELICT

Setting down 2,000 meters from the source of the apparent
beacon, Cpt. Dallas, XO Kane, and Navigator Lambert donned
EVA suits and walked to the site. There, they discovered a
derelict craft. Aboard the *Nostromo*, an interpretation filter

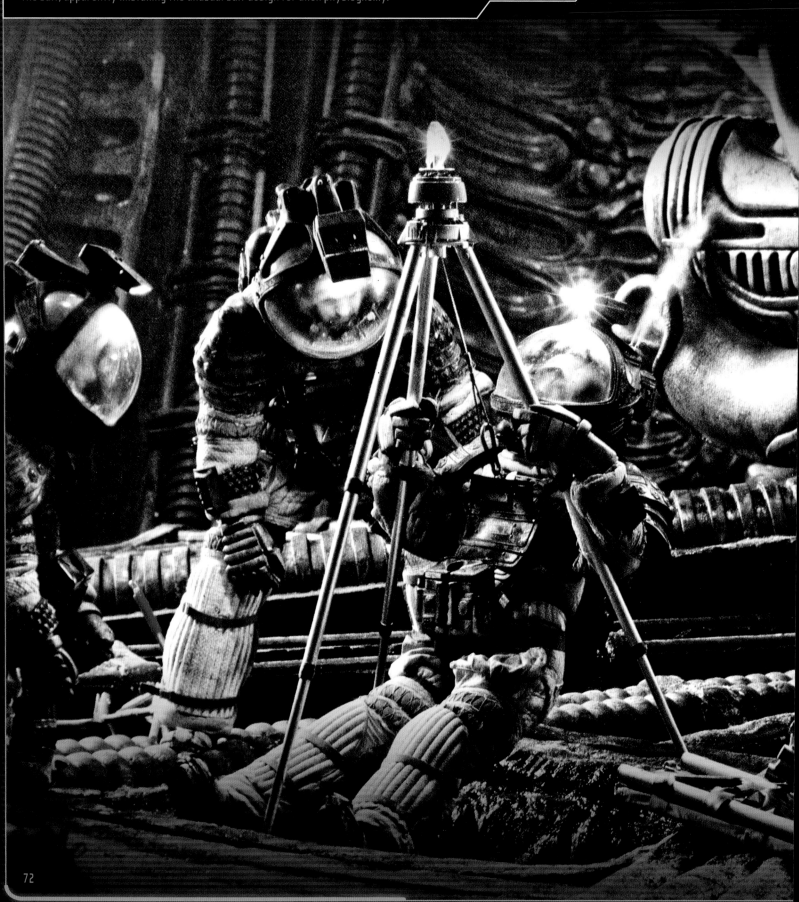

THE LONE ENGINEER

Dallas, Kane, and Lambert found a single chair aboard the bridge, which held what they believed to be the fossilized remains of some gigantic humanoid, but obviously alien, species. The chest of the creature had suffered damage, as though something had burst from within. The alien was almost certainly an Engineer—it wore the suit of the mysterious race, and piloted a similar alien ship—but the *Nostromo*'s crew did not investigate the remains inside of the suit, apparently mistaking the unusual suit design for alien physiognomy.

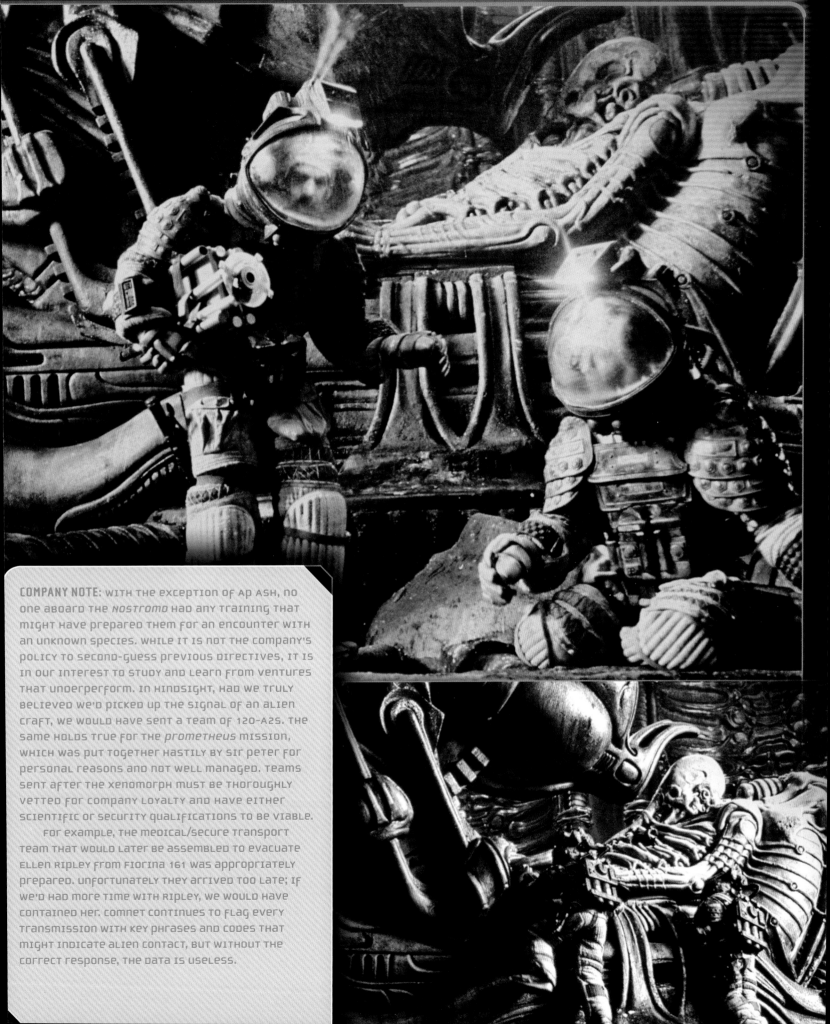

COMPANY NOTE: WITH THE EXCEPTION OF AP ASH, NO ONE ABOARD THE *NOSTROMO* HAD ANY TRAINING THAT MIGHT HAVE PREPARED THEM FOR AN ENCOUNTER WITH AN UNKNOWN SPECIES. WHILE IT IS NOT THE COMPANY'S POLICY TO SECOND-GUESS PREVIOUS DIRECTIVES, IT IS IN OUR INTEREST TO STUDY AND LEARN FROM VENTURES THAT UNDERPERFORM. IN HINDSIGHT, HAD WE TRULY BELIEVED WE'D PICKED UP THE SIGNAL OF AN ALIEN CRAFT, WE WOULD HAVE SENT A TEAM OF 120-A2S. THE SAME HOLDS TRUE FOR THE *PROMETHEUS* MISSION, WHICH WAS PUT TOGETHER HASTILY BY SIR PETER FOR PERSONAL REASONS AND NOT WELL MANAGED. TEAMS SENT AFTER THE XENOMORPH MUST BE THOROUGHLY VETTED FOR COMPANY LOYALTY AND HAVE EITHER SCIENTIFIC OR SECURITY QUALIFICATIONS TO BE VIABLE.

FOR EXAMPLE, THE MEDICAL/SECURE TRANSPORT TEAM THAT WOULD LATER BE ASSEMBLED TO EVACUATE ELLEN RIPLEY FROM FIORINA 161 WAS APPROPRIATELY PREPARED. UNFORTUNATELY THEY ARRIVED TOO LATE; IF WE'D HAD MORE TIME WITH RIPLEY, WE WOULD HAVE CONTAINED HER. COMNET CONTINUES TO FLAG EVERY TRANSMISSION WITH KEY PHRASES AND CODES THAT MIGHT INDICATE ALIEN CONTACT, BUT WITHOUT THE CORRECT RESPONSE, THE DATA IS USELESS.

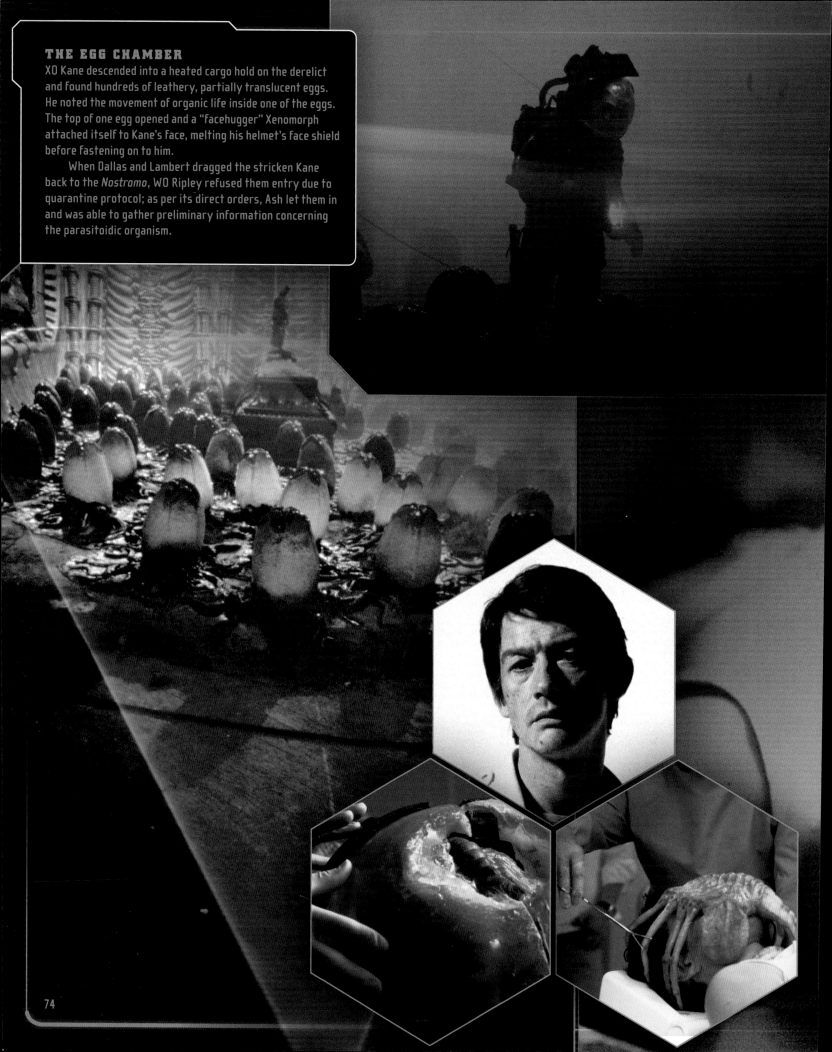

THE EGG CHAMBER

XO Kane descended into a heated cargo hold on the derelict and found hundreds of leathery, partially translucent eggs. He noted the movement of organic life inside one of the eggs. The top of one egg opened and a "facehugger" Xenomorph attached itself to Kane's face, melting his helmet's face shield before fastening on to him.

When Dallas and Lambert dragged the stricken Kane back to the *Nostromo*, WO Ripley refused them entry due to quarantine protocol; as per its direct orders, Ash let them in and was able to gather preliminary information concerning the parasitoidic organism.

ASH'S INTERVIEW WITH KANE

Having served its purpose, the embryotic delivery system stage, or "facehugger," detached itself from Kane and hid itself in an overhead compartment before dying. Kane revived with a sore throat and a mild fever. The following is from the transcript of Ash's conversation with XO Kane, held in the *Nostromo*'s medlab.

ASH: Kane? Kane, can you hear me?

KANE: Water.

ASH: Here. Can you sit up?

KANE: What happened?

ASH: How do you feel?

KANE: Like I've been hit by a lorry. More water, please.

ASH: Of course.

KANE: Thank you. I was dreaming.

ASH: What did you dream?

KANE: It was dark, I was . . . somewhere else, a place I didn't know. A man had his hand over my mouth, his other hand around my throat. I couldn't breathe. I kept trying to hit him, to push him away, but there was no one there. I was dying.

ASH: I'll call Dallas. Lay down again, please. We'll want to get a full scan, make sure we've dotted all of the i's and crossed all of the t's, yes?

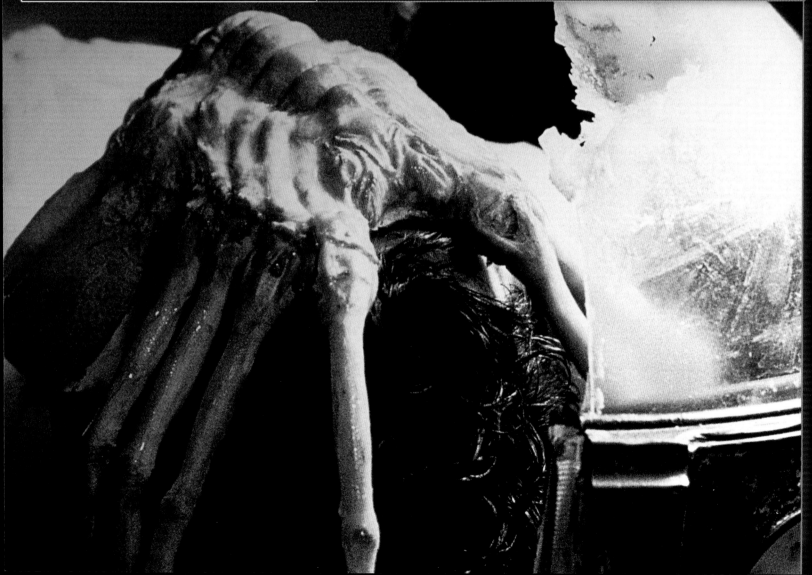

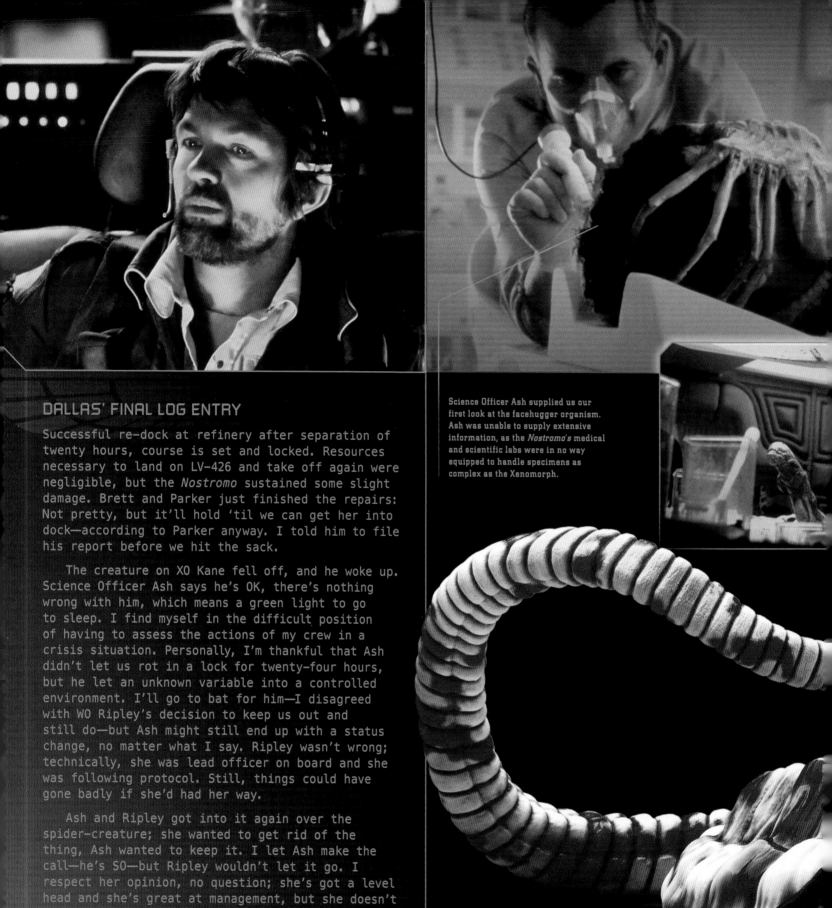

DALLAS' FINAL LOG ENTRY

Successful re-dock at refinery after separation of twenty hours, course is set and locked. Resources necessary to land on LV-426 and take off again were negligible, but the *Nostromo* sustained some slight damage. Brett and Parker just finished the repairs: Not pretty, but it'll hold 'til we can get her into dock—according to Parker anyway. I told him to file his report before we hit the sack.

The creature on XO Kane fell off, and he woke up. Science Officer Ash says he's OK, there's nothing wrong with him, which means a green light to go to sleep. I find myself in the difficult position of having to assess the actions of my crew in a crisis situation. Personally, I'm thankful that Ash didn't let us rot in a lock for twenty-four hours, but he let an unknown variable into a controlled environment. I'll go to bat for him—I disagreed with WO Ripley's decision to keep us out and still do—but Ash might still end up with a status change, no matter what I say. Ripley wasn't wrong; technically, she was lead officer on board and she was following protocol. Still, things could have gone badly if she'd had her way.

Ash and Ripley got into it again over the spider-creature; she wanted to get rid of the thing, Ash wanted to keep it. I let Ash make the call—he's SO—but Ripley wouldn't let it go. I respect her opinion, no question; she's got a level head and she's great at management, but she doesn't know when to let things lie.

The whole thing is like a bad dream. I just want to forget it and go home. Lambert is heating up a big dinner, breaking out the hoarded stuff. We're going to eat and go to sleep. Next time we wake up, this will all be someone else's headache.

Science Officer Ash supplied us our first look at the facehugger organism. Ash was unable to supply extensive information, as the *Nostromo's* medical and scientific labs were in no way equipped to handle specimens as complex as the Xenomorph.

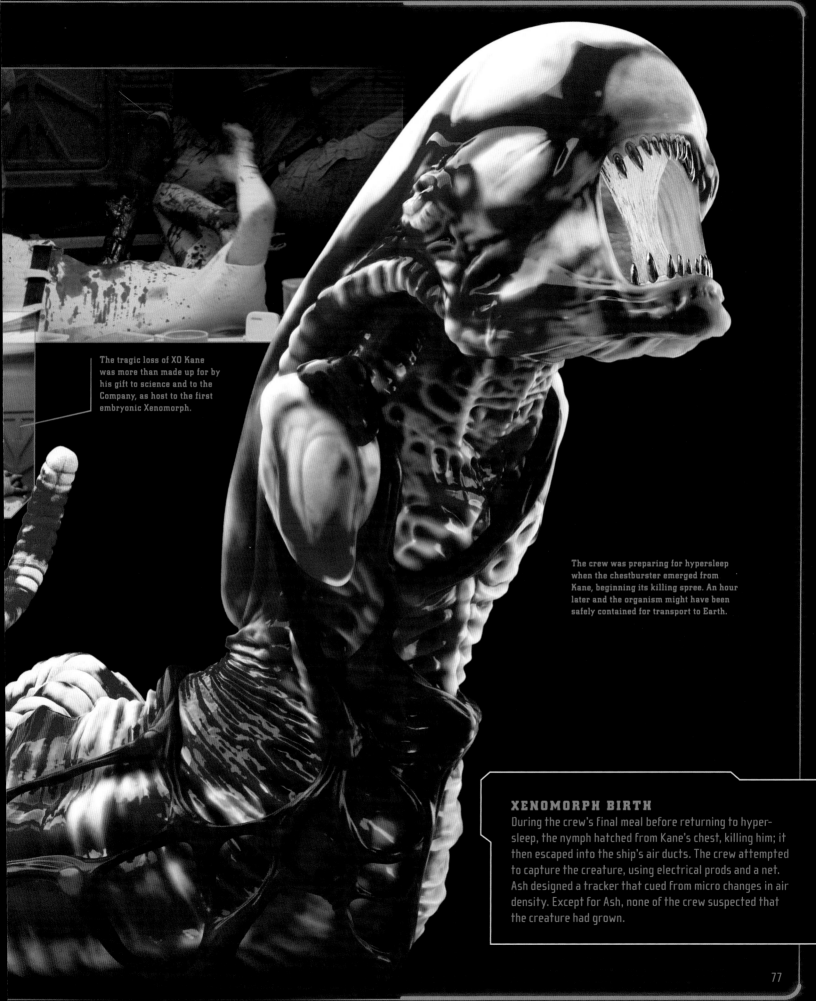

The tragic loss of XO Kane was more than made up for by his gift to science and to the Company, as host to the first embryonic Xenomorph.

The crew was preparing for hypersleep when the chestburster emerged from Kane, beginning its killing spree. An hour later and the organism might have been safely contained for transport to Earth.

XENOMORPH BIRTH

During the crew's final meal before returning to hyper-sleep, the nymph hatched from Kane's chest, killing him; it then escaped into the ship's air ducts. The crew attempted to capture the creature, using electrical prods and a net. Ash designed a tracker that cued from micro changes in air density. Except for Ash, none of the crew suspected that the creature had grown.

QUOTES FROM RIPLEY'S DEPOSITION

"It got Brett first. He went after Jonesy—we didn't want to get tripped up again by the cat. Parker and I kept looking for the alien, but we could hear [Brett] calling for Jones in the hold. It happened so fast, it just took him, grabbed him and pulled him up into the vent shafts. He was there, and then he wasn't."

"Dallas wanted to flush it out of the vent system and into the airlock. He went in [to the ventilation system] with an incinerator, but it was dark; it was tight in there. We tried to track him, but we got the readings confused. It got behind him somehow. Lambert started crying. She was telling him to get out of there—we both were—and he was scared; he wanted out."

"There was this sticky, adhesive resin on everything it touched. I don't know what it was."

"I found your special directive for Ash. It said that he was to procure an alien specimen at any cost. We were expendable. When he recognized that I was a threat to his objective—to bring this thing back to Earth—he tried to kill me. It tried to kill me."

COMPANY NOTE: ASH WAS INDEED FOLLOWING ORDERS. IT MIGHT HAVE BEEN ABLE TO CARRY THEM OUT, IF NOT FOR THE INTERFERENCE OF CREWMEMBERS.

"We decided to take our chances in the shuttle. Parker and Lambert went for supplies, and it got to them. I ran when I heard the

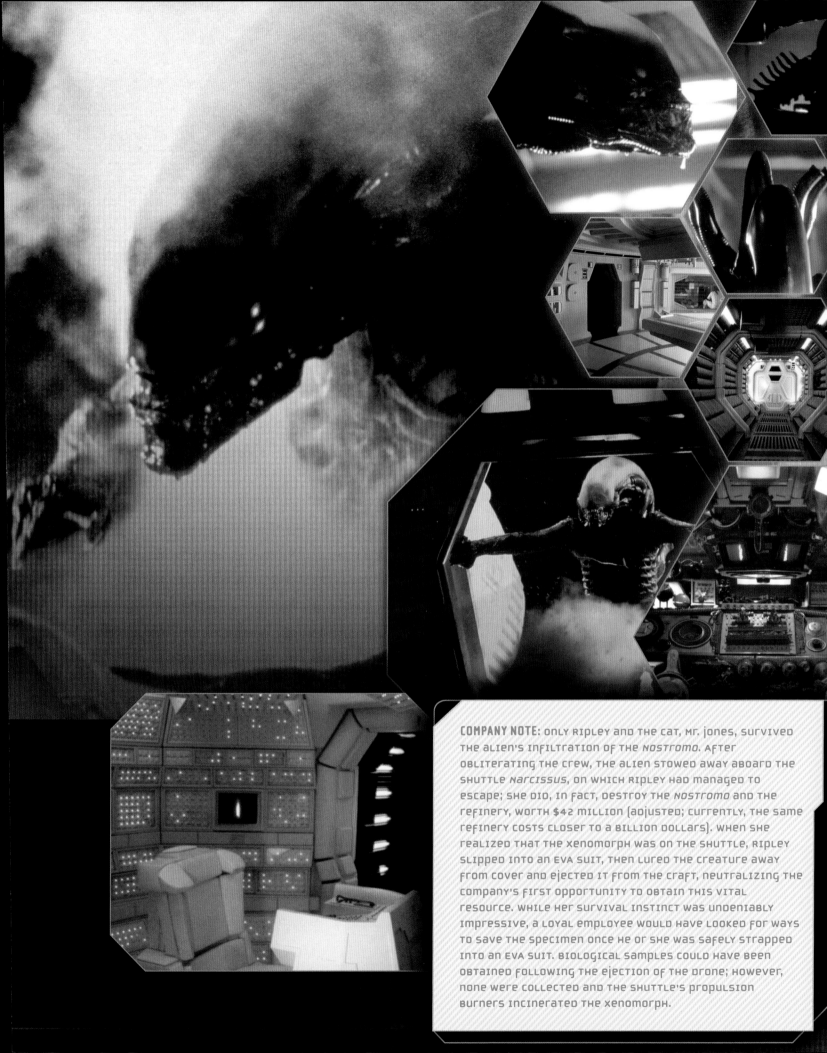

COMPANY NOTE: ONLY RIPLEY AND THE CAT, MR. JONES, SURVIVED THE ALIEN'S INFILTRATION OF THE *NOSTROMO*. AFTER OBLITERATING THE CREW, THE ALIEN STOWED AWAY ABOARD THE SHUTTLE *NARCISSUS*, ON WHICH RIPLEY HAD MANAGED TO ESCAPE; SHE DID, IN FACT, DESTROY THE *NOSTROMO* AND THE REFINERY, WORTH $42 MILLION (ADJUSTED; CURRENTLY, THE SAME REFINERY COSTS CLOSER TO A BILLION DOLLARS). WHEN SHE REALIZED THAT THE XENOMORPH WAS ON THE SHUTTLE, RIPLEY SLIPPED INTO AN EVA SUIT, THEN LURED THE CREATURE AWAY FROM COVER AND EJECTED IT FROM THE CRAFT, NEUTRALIZING THE COMPANY'S FIRST OPPORTUNITY TO OBTAIN THIS VITAL RESOURCE. WHILE HER SURVIVAL INSTINCT WAS UNDENIABLY IMPRESSIVE, A LOYAL EMPLOYEE WOULD HAVE LOOKED FOR WAYS TO SAVE THE SPECIMEN ONCE HE OR SHE WAS SAFELY STRAPPED INTO AN EVA SUIT. BIOLOGICAL SAMPLES COULD HAVE BEEN OBTAINED FOLLOWING THE EJECTION OF THE DRONE; HOWEVER, NONE WERE COLLECTED AND THE SHUTTLE'S PROPULSION BURNERS INCINERATED THE XENOMORPH.

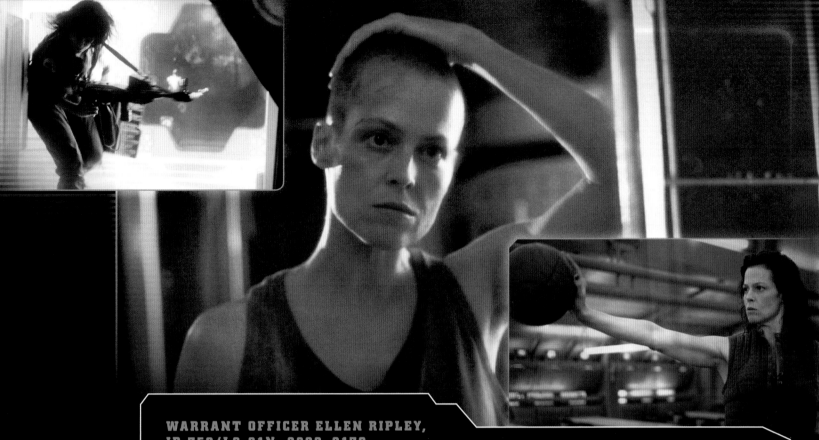

WARRANT OFFICER ELLEN RIPLEY, ID 759/L2-01N. 2092–2179

Ellen Ripley was the only survivor of the Company's first contact with Xenomorph XX121; she entered hypersleep believing that her shuttle would be picked up when it passed through the more heavily traveled shipping lanes. In 2159, Ripley's sleep was briefly interrupted when the shuttle was diverted to an orbit over LV-178. Following events aboard the *Marion*, Ripley's memory was adjusted and the shuttle was returned to its course. The shuttle's beacon failed shortly thereafter, and the *Narcissus* drifted through and beyond the Core Systems.

In 2137, Ripley's only child, Amanda Ripley, also encountered Xenomorph XX121 at ▮▮▮▮▮▮▮▮▮▮

It was sheer luck that a deep salvage team ran across the shuttle in 2179—fifty-seven years after the destruction of the *Nostromo*. The team towed the ship back to Gateway, where WO Ripley and the ship's cat were revived.

Ripley's actions in the loss of the *Nostromo* were widely criticized upon her return to societal time line in 2179. Company psych evaluations diagnosed her as suffering from PTSD with comorbid generalized anxiety disorder; medications were recommended and dispensed. Her flight status was revoked, her rank reduced. With her family gone (Ripley was informed upon waking that her only child, Amanda, died two years before the *Narcissus* was found) and no career prospects, she had taken a job on Gateway station operating power loaders when the Company lost contact with LV-426 in July 2179. Company executive Carter J. Burke talked her into accompanying the mission as a civilian advisor to rescue the colonists if a Xenomorph attack occurred. He greatly underestimated her hatred of the Xenomorph and her mistrust of the Company. Neither Burke (nor later, Bishop) made any progress in promoting Company interests with Ellen Ripley.

Showing leadership and ingenuity, Ripley was one of only three survivors from the interaction on LV-426 and the only survivor of the subsequent crash on Fiorina 161. Implanted with a Xenomorph queen, she chose to end her life rather than let the Company have access to the specimen. Her clearly defined ethical boundaries did not include compromise.

Biological samples were collected from Fiorina 161 following Ripley's suicide, but science had not yet advanced to the point where Ripley or the Xenomorph could be successfully cloned from the material. When Weyland-Yutani lost its designation in 2349, the USM received right of entry to Company labs, for documentation purposes only. They found files on Ripley and the DNA samples. In 2381, after a number of unsuccessful attempts, Ellen Ripley was successfully—and illegally—cloned by the USM in order to create a queen specimen. This eighth clone resembled Ellen Ripley physically but also exhibited traits of Xenomorph XX121, including enhanced sensory and extrasensory perceptions, and remarkable strength, speed, and agility. The clone apparently "remembered" Weyland-Yutani, suggesting that its hybridization with the queen enabled some type of inherited memory. The clone's blood was also highly acidic, and she expressed a predator's view toward other humans. The clone disliked captivity and the scientists who studied her, exhibiting the same anti-authoritarian streak that defined Ellen Ripley.

Ripley 8 is currently unaccounted for. Scattered reports from the survivors of the *Auriga* suggest that the clone willfully colluded with auton Call to keep the Xenomorph from reaching Earth. Part alien herself, the clone recognized the pure destructive force that defines the Xenomorph and thwarted the USM's plans accordingly. Considering how poorly the USM has dealt with the Xenomorph, we commend Ripley 8 for clearly understanding that their incompetence would lead to disaster, and for reminding the Company of an important lesson: The alien must be actively managed with intelligence, caution, and foresight.

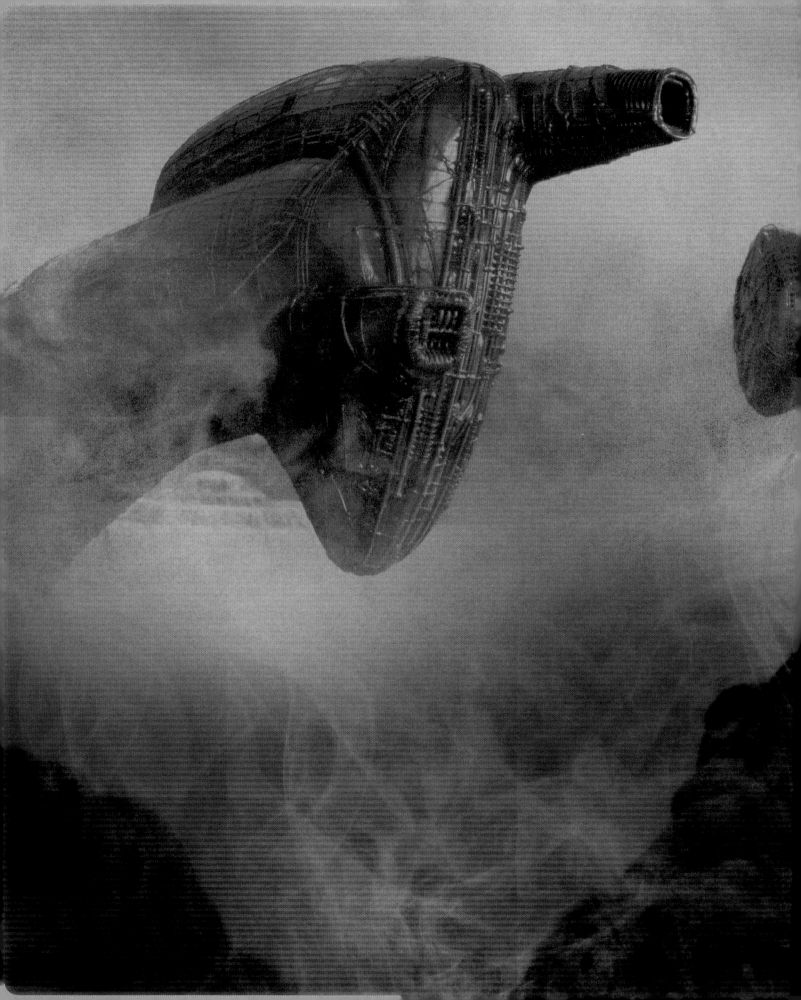

INCURSION AT HADLEY'S HOPE

DURING THE TIME THAT RIPLEY SLEPT, THE COMPANY—AND THEREFORE HUMANITY—FLOURISHED. IN AN ERA OF MEGACORPORATIONS, THE WEYLAND-YUTANI CORPORATION WAS DOMINANT, HOLDING BETTER THAN 93 PERCENT OF ALL GOVERNMENT CONTRACTS BY THE LATE 2150s, INCLUDING PROCESSING, MILITARY APPLICATIONS, CYBERNETICS, MEDICAL ADVANCES, EXPLORATION, AND SOCIAL MAINTENANCE. ATMOSPHERIC PROCESSORS, NOW STREAMLINED TO BE SMALLER AND FASTER, WERE DISPATCHED TO MORE THAN FORTY WORLDS—AMONG THEM, THE MOON IDENTIFIED AS LV-426, ONE OF THREE ORBITING A GAS GIANT.

UNOFFICIALLY RENAMED ACHERON IN 2157 BY THE FIRST TERRAFORMING TEAM TO LAND—LED BY CURTIS HADLEY AND COFUNDED BY THE EXTRASOLAR COLONIZATION ADMINISTRATION—THERE WAS EFFECTIVELY NO SIGN OF THE DERELICT SHIP DISCOVERED THERE IN 2122 BY THE *NOSTROMO*'S CREW. THE DERELICT SHIP'S SIGNAL WAS NEVER HEARD AGAIN, POSSIBLY AS A RESULT OF VIOLENT VOLCANIC ACTIVITY AT SOME TIME IN THE LATE 2120s, ALTHOUGH THERE ARE UNSUBSTANTIATED REPORTS THAT THE BEACON WAS DELIBERATELY TURNED OFF IN 2135 (SEE REPORT REF#MARLOW58821). WHAT COULD STILL BE SEEN OF THE SHIP BY 2157 WAS BELIEVED TO BE PART OF THE ILIUM MOUNTAIN RANGE, NEARLY 30 KM FROM THE TERRAFORMERS' COMPOUND.

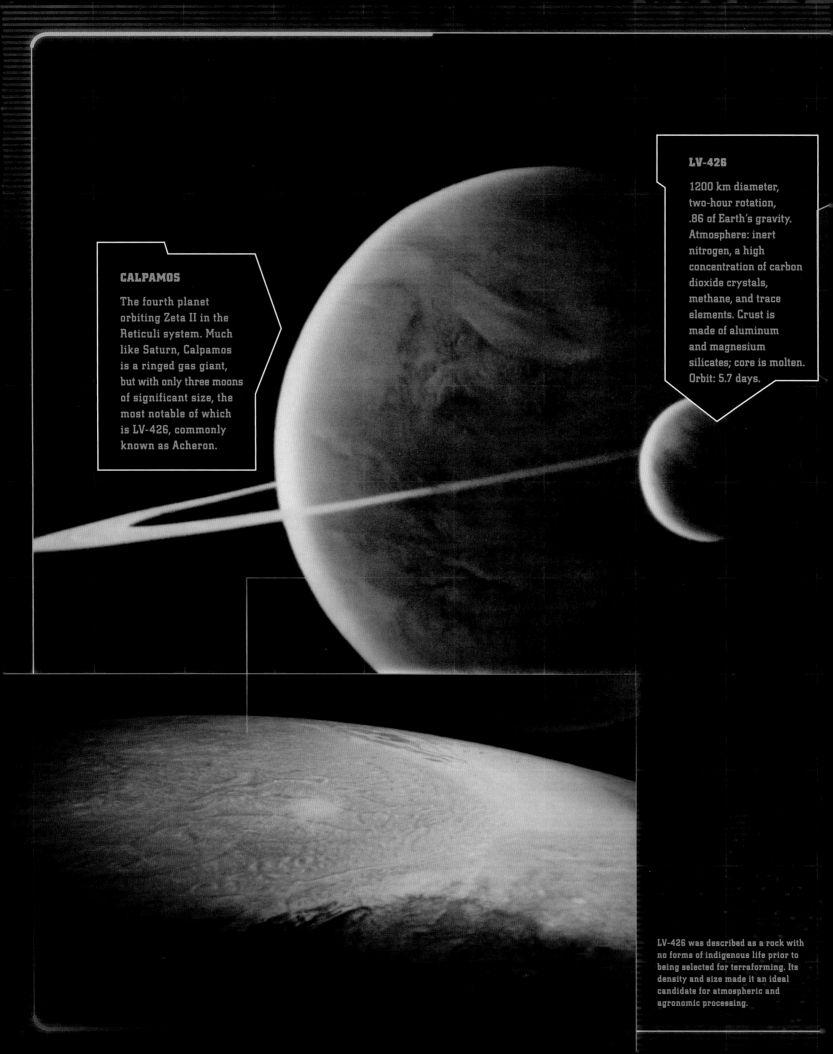

CALPAMOS

The fourth planet
orbiting Zeta II in the
Reticuli system. Much
like Saturn, Calpamos
is a ringed gas giant,
but with only three moons
of significant size, the
most notable of which
is LV-426, commonly
known as Acheron.

LV-426

1200 km diameter,
two-hour rotation,
.86 of Earth's gravity.
Atmosphere: inert
nitrogen, a high
concentration of carbon
dioxide crystals,
methane, and trace
elements. Crust is
made of aluminum
and magnesium
silicates; core is molten.
Orbit: 5.7 days.

LV-426 was described as a rock with
no forms of indigenous life prior to
being selected for terraforming. Its
density and size made it an ideal
candidate for atmospheric and
agronomic processing.

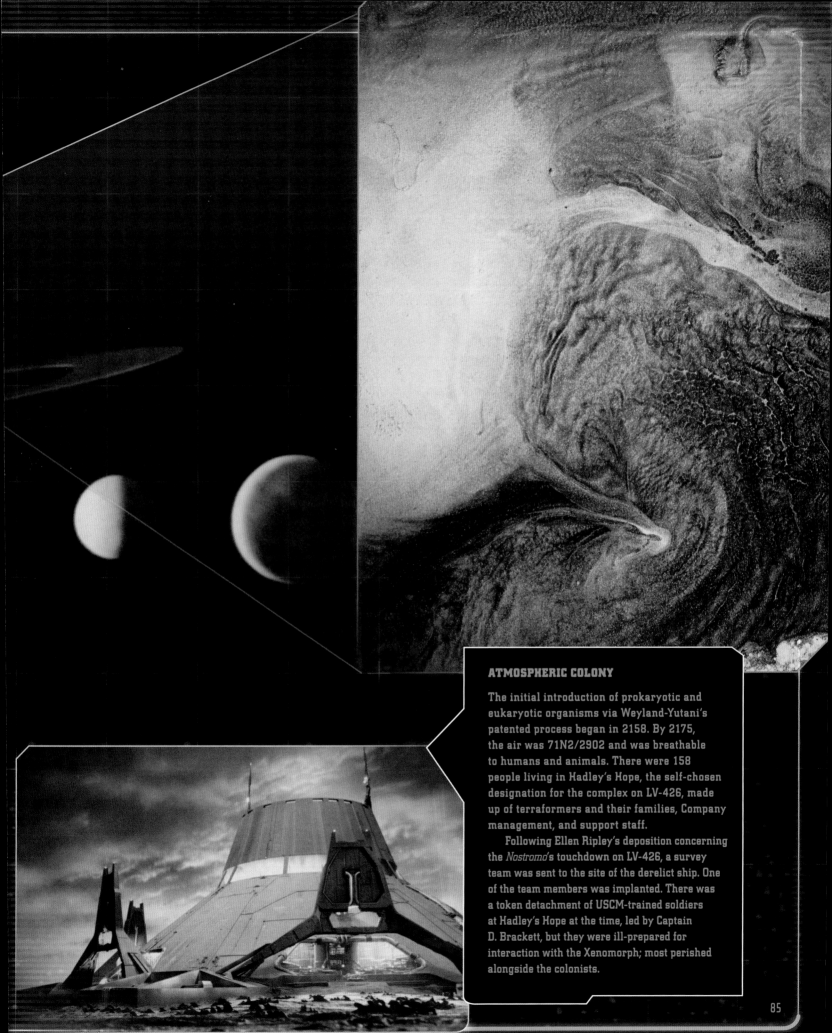

ATMOSPHERIC COLONY

The initial introduction of prokaryotic and eukaryotic organisms via Weyland-Yutani's patented process began in 2158. By 2175, the air was 71N2/2902 and was breathable to humans and animals. There were 158 people living in Hadley's Hope, the self-chosen designation for the complex on LV-426, made up of terraformers and their families, Company management, and support staff.

Following Ellen Ripley's deposition concerning the *Nostromo's* touchdown on LV-426, a survey team was sent to the site of the derelict ship. One of the team members was implanted. There was a token detachment of USCM-trained soldiers at Hadley's Hope at the time, led by Captain D. Brackett, but they were ill-prepared for interaction with the Xenomorph; most perished alongside the colonists.

WEYLAND·YUTANI CORP

MEMO FROM OFFICE OF DIRECTOR OF SPECIAL PROJECTS, BURKE, CARTER J.

07032179/07:17. Dictated message. Delivered to seven undisclosed recipients.

I had the satellite run over the coordinates that Ellen Ripley estimated in her deposition, and results were inconclusive. There's a low mountain range there, and there's been volcanic activity at some point; that whole area is kind of mountainous. The images were unreadable. So I sent a survey team to check the coordinates, and within forty-eight hours of them receiving the check request, we lost contact with Hadley's Hope. Now, there are any number of reasons that transmissions might be blocked—one of those big storms or a failed relay—but we have not heard from them since, for coming up on sixty hours. This is the longest we've been out of contact with any of our colonies. Given that something has gone wrong out there, one way or another, I feel that we need to take a look. LV-426 is a big investment. And considering Ripley's deposition regarding the alien creatures, I'd like the go-ahead to fund an armed response.

Ellen Ripley was the only survivor of the first Xenomorph encounter on LV-426, and I believe that she should be hired as a civilian advisor or reinstated, whatever's more likely to get her to come. I will personally handle negotiations with her; she trusts me. I've already got a line on a USCM lieutenant who understands the significance of being a team player. He has access to a team that has dealt with alien life-forms before, those grain parasites on Actura. They're battle-ready, experienced combat veterans.

I don't want to send up any flares too soon, but we may be looking at an opportunity to obtain first rights to a real R&D asset—the alien ship and associated tech, possibly a specimen of alien life. If we believe Ripley's story—and I'm finding it more and more credible—this creature she describes could make our bioweapons division.

Considering the importance of this mission to the Company, I plan to accompany Ripley and the soldiers to LV-426. If this turns out to be what it's looking like, I feel very strongly that Weyland-Yutani needs to be fully represented, and we cannot afford to wait.

Please contact me immediately regarding this matter. I am available 24/7 until we get this nailed down.

Prior to the Xenomorph infestation at Hadley's Hope, 158 men, women, and children had established their homes there, primarily colonists and their families.

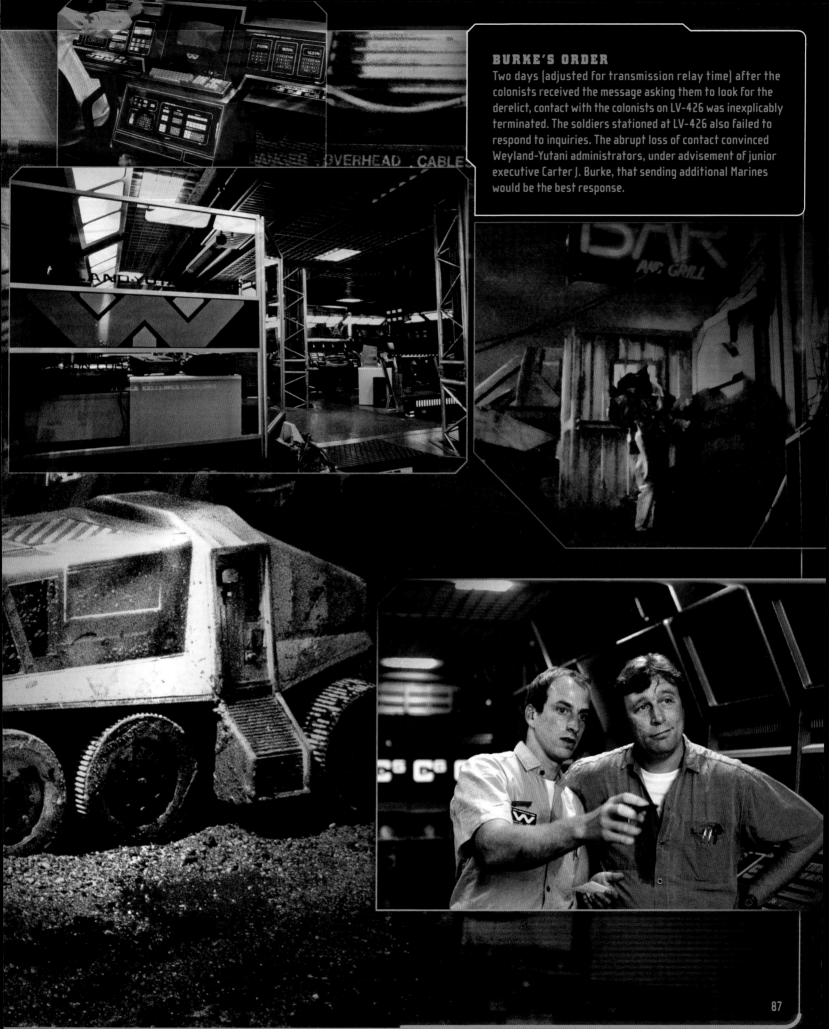

BURKE'S ORDER

Two days (adjusted for transmission relay time) after the colonists received the message asking them to look for the derelict, contact with the colonists on LV-426 was inexplicably terminated. The soldiers stationed at LV-426 also failed to respond to inquiries. The abrupt loss of contact convinced Weyland-Yutani administrators, under advisement of junior executive Carter J. Burke, that sending additional Marines would be the best response.

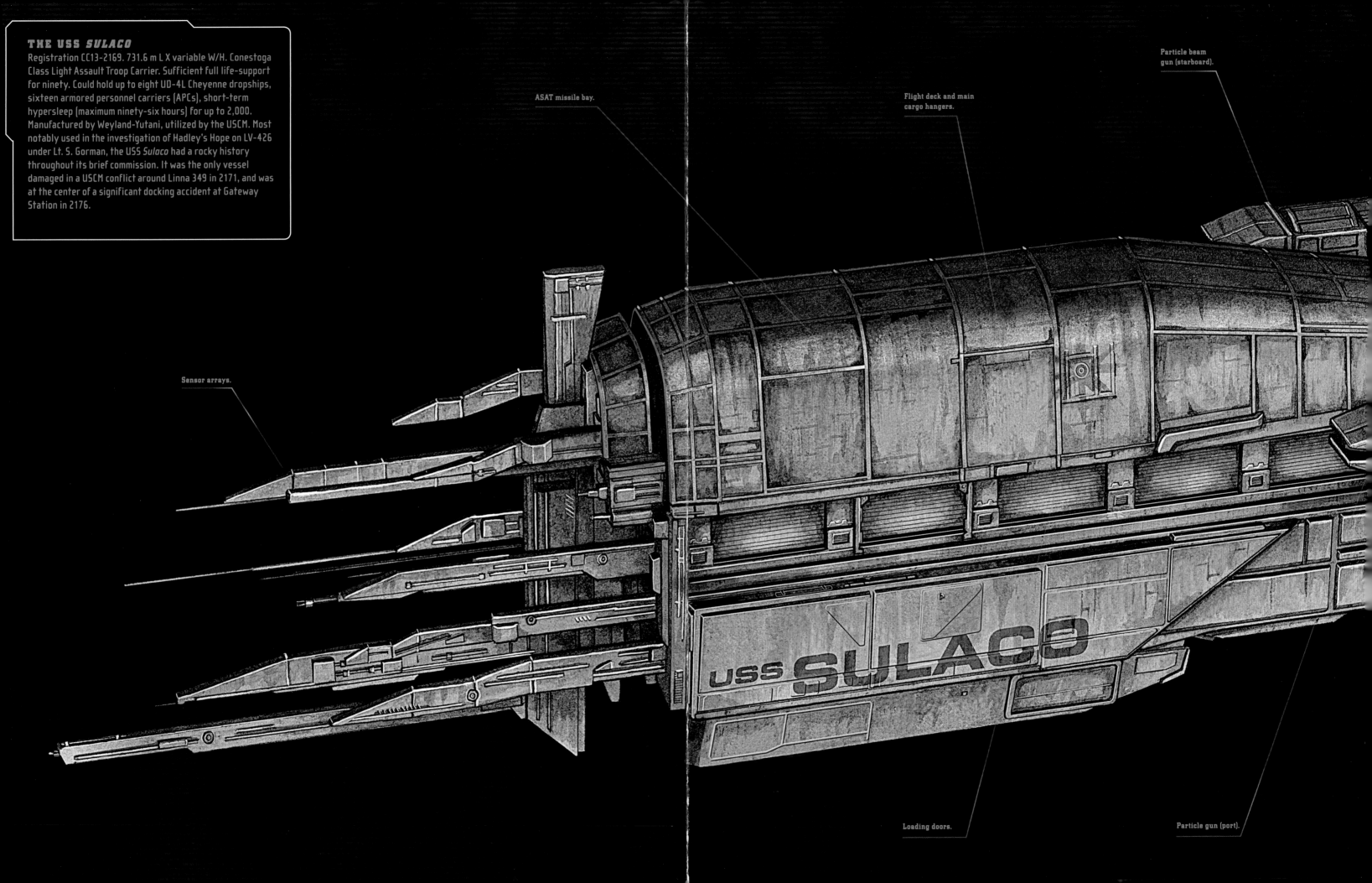

THE USS SULACO

Registration CC13-2169. 731.6 m L X variable W/H. Conestoga Class Light Assault Troop Carrier. Sufficient full life-support for ninety. Could hold up to eight UD-4L Cheyenne dropships, sixteen armored personnel carriers (APCs), short-term hypersleep (maximum ninety-six hours) for up to 2,000. Manufactured by Weyland-Yutani, utilized by the USCM. Most notably used in the investigation of Hadley's Hope on LV-426 under Lt. S. Gorman, the USS *Sulaco* had a rocky history throughout its brief commission. It was the only vessel damaged in a USCM conflict around Linna 349 in 2171, and was at the center of a significant docking accident at Gateway Station in 2176.

Particle beam gun (starboard).

ASAT missile bay.

Flight deck and main cargo hangers.

Sensor arrays.

Loading doors.

Particle gun (port).

CARTER J. BURKE, ID L1E7/.569643 267 MN. 2150–2179
At the time of the mission to LV-426, Carter Burke served as the Director of Special Projects, a position he took early in his meteoric rise through the corporate ranks of Weyland-Yutani. Noted for excellent people skills and hands-on initiative (personnel file available on request, REF#62048). Given his unquestioning loyalty to Weyland-Yutani and his high socio rating, he was the logical choice to represent Company interests.

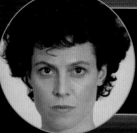

LIEUTENANT FIRST CLASS ELLEN RIPLEY, ID 759/L2-01N. 2092–2179
Ellen Ripley held no military rank during the mission; technically, she was considered a civilian adviser and her lieutenant designation was a flight rank rather than military. Because she had served as a warrant officer for the UA, the USCM awarded her a second lieutenant's pay scale in recognition of past service.

EXECUTIVE OFFICER BISHOP, SERIAL # A17/TQ2.0.35100E2. MODEL 341-B
Bishop faithfully followed orders during the mission to LV-426. Burke wanted Bishop replaced with a modified model (life-protection imperative stripped, Weyland-Yutani loyalty subprogram activated), but timely access was unavailable.

FIRST LIEUTENANT SCOTT GORMAN, SQUADRON COMMANDER
2ND BATTALION, 9TH REGIMENT: SERIAL #: A09/TQ4.0.56124E3. 2142–2179
KIA: Hadley's Hope on LV-426, July 2179. The mission to LV-426 was Lt. Gorman's second field command operation. Despite showing exceptional potential in the USCM Academy, Gorman failed to perform appropriately under combat conditions; although it appears that at the very end of his life, he died attempting to save PFC Vasquez.

Dorsal railgun.

Lithium hydride tanking.

Lithium hydride tanking.

Ventral railgun.

Thrust tunnel heat/ blast shield fins.

Protective composite hull plating.

Heat/blast shield fins.

IR masking tower and communications antennae.

U.S. COLONIAL MARINES

USS SULACO

CORPORAL DWAYNE HICKS, SERIAL #: A27/TQ4.0.48215E9. 2151–2179

Corporal Hicks was the sole Colonial Marine survivor from Hadley's Hope/Xenomorph encounter on LV-426. After Lt. Gorman received incapacitating injuries and Apone was captured by Xenomorphs, Corporal Hicks assumed command of the mission, which was technically under military jurisdiction. He had neither the training nor the experience to make informed decisions regarding the protection of Company property, and he relied heavily on Ripley's input to make decisions. Perished in hypersleep in the crash of a Type 337 Emergency Escape Vehicle (EEV), which was ejected from the USS *Sulaco*; August 2179. Posthumously received a Distinguished Service Medal from the USCM for outstanding bravery.

PRIVATE TREVOR WIERZBOWSKI, RIFLE TEAM.
SERIAL #: A14/TQ8.0.20034E7. 2147–2179

MIA: Hadley's Hope on LV-426, July 2179 (presumed dead). Carried an M240 incinerator unit into combat with the Xenomorphs at the processor. It is unknown if Wierzbowski was killed outright in the attack or if he was also taken as a host; his armor was damaged and helmet lost when the drones attacked.

PRIVATE FIRST CLASS WILLIAM HUDSON, COMBAT TECH:
SERIAL #: A08/TQ1.0.41776E3. 2149-2179

KIA: Hadley's Hope on LV-426, July 2179. Despite PFC Hudson's numerous altercations with superiors and peers, he was scheduled to receive an honorable discharge from the USCM following the mission to LV-426. Decorated posthumously for gallantry under fire.

NOTE: FOLLOWING THE HADLEY'S HOPE INCIDENT, A FIRE ABOARD THE USS *Sulaco* CAUSED SIGNIFICANT DAMAGE TO THE VESSEL'S MAINFRAME, PERMANENTLY DAMAGING DATA FILES ON A NUMBER OF THE CREW. DESPITE THE COMPANY'S BEST ATTEMPTS TO TRACK DOWN VISUAL RECORDS FOR THESE MARINES, NONE CAN CURRENTLY BE LOCATED.

U.S.C.M.
U.S.S. SULACO
COLONIAL MARINES
2nd Batt. 9th Regt.
U.S. COLONIAL MARINES

MASTER SERGEANT AL APONE, GROUND TROOP COMMANDER:
SERIAL #: A19/TQ4.0.32751E8. 2137-2179

MIA: Hadley's Hope on LV-426, July 2179 (presumed dead). Apone served as the senior NCO for the Company-funded mission to LV-426. Chosen for his expertise in on-the-ground logistics and strong leadership abilities. In the first direct contact with the Xenomorph, MSgt. Apone was captured to be used as a host.

CORPORAL CYNTHIA DIETRICH, HOSPITAL CORPSMAN:
SERIAL #: A41/TQ8.0.81120E2. 2154-2179

MIA: Hadley's Hope on LV-426, July, 2179 (presumed dead). Earned EMT advanced in 2172. Was abducted by the Xenomorphs to be used as a host.

PRIVATE FIRST CLASS JENETTE VASQUEZ, SMARTGUN
OPERATOR: SERIAL #: A03/TQ7.0.15618E4. 2153-2179

KIA: Hadley's Hope on LV-426, July 2179. Long recognized for her absolute dedication to the Corps, PFC Vasquez enlisted to avoid detention time in 2172 as part of the Service or Jail Act. While cited several times early in her career for disorderly conduct (often accompanied by Private Drake, see following), Vasquez earned a silver National/Interservice/Marine Corps Rifle Competition badge in 2175, and in 2177, she became an active member of the USCM At-Risk Youth Outreach program.

PRIVATE MARK DRAKE, SMARTGUN OPERATOR: SERIAL #: A23/
TQ2.0.47619E7. 2145-2179

KIA: Hadley's Hope on LV-426, July 2179. Like PFC Vasquez, Drake also enlisted shortly after national directives encouraged courts to offer military enlistment in lieu of sentencing. Vasquez and Drake went through boot camp together and requested assignment to the same units. Both chose advanced weapons training as a specialty; their smartgun drill instructor referred to them as "the sweethearts," although they denied a romantic relationship. On three separate occasions in 2172, Drake and Vasquez were picked up by MPs on D&D complaints. While Vasquez finally embraced the Marine lifestyle following her promotion in rank, Drake seemed to resent his choice, often complaining about pay scale. Stenciled on the rear armor plate of his battle harness was the motto, "Eat the apple and fuck the Corps." Drake was killed in the Marines' first direct contact with Xenomorph XX121, a victim of severe burns to the face and chest.

PRIVATE RICCO "FROSTY" FROST, COMBAT TECH SUPPORT:
SERIAL #: A17/TQ4.0.61247E5. 2153–2179

KIA: Hadley's Hope on LV-426, July 2179. Held a first-degree black belt in the MCMAP and was in the process of applying to instruct/train. Referred to jokingly within his unit as the Zen Master, Frost's nickname became a code among his fellow Marines to remain cool during emergencies. Frost was the first Marine killed in the Xenomorph hive on LV-426.

PRIVATE TIM CROWE, COMMUNICATIONS TECH: SERIAL #: A46/TQ1.0.98712E6. 2151–2179

KIA: Hadley's Hope on LV-426, July 2179. Perished in the initial conflict when a bag of confiscated rifle ammo was detonated by fire. Suit readings record that he was killed instantly.

CORPORAL COLETTE FERRO, UD-4L CHEYENNE DROPSHIP PILOT:
SERIAL #: A71/TQ9.0.09428E1. 2140–2179

KIA: Hadley's Hope on LV-426, July 2179. By all accounts, a gifted dropship pilot. Uploads to the *Sulaco* show that Cpl. Ferro and PFC Spunkmeyer waited unsecured at the colony complex for a "dust off" call from Lt. Gorman. A Xenomorph drone got aboard the ship, killing both pilots. Cpl. Ferro died reaching for her VP-70 semiautomatic.

PRIVATE FIRST CLASS DANIEL SPUNKMEYER, UD-4L CHEYENNE DROPSHIP CREW CHIEF. SERIAL #: A23/TQ6.0.92810E7. 2152–2179

KIA: Hadley's Hope on LV-426, July 2179. Pilot and crew chief, responsible for overseeing maintenance of UD-4L dropships. Killed when a Xenomorph came aboard the dropship as he and Cpl. Ferro waited for contact from Lt. Gorman.

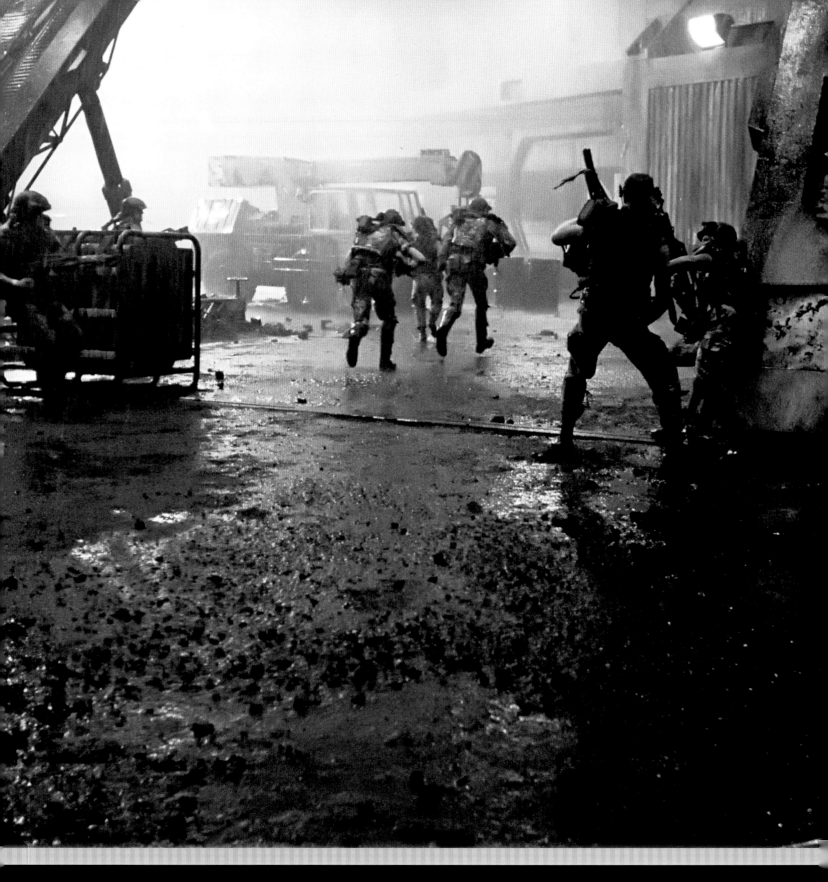

TRANSCRIPT OF ALL-FREQUENCY TRANSMISSION UPLOADED TO USS *SULACO* FROM ACHERON MAINFRAME, ORIGINAL TRANSMISSION DATED 7/24/79:

"THIS IS CHRIS MEYERS, AH, ID#28789, SCIENCES, ON LV-426. WE'RE IN C

WE HAVEN'T HEARD ANYTHING IN DAYS; THIS HAS BEEN GOING ON FOR WEEKS

WE COULD STILL SAVE THEM. THEY'RE ALL IN THE PROCESSOR. JES

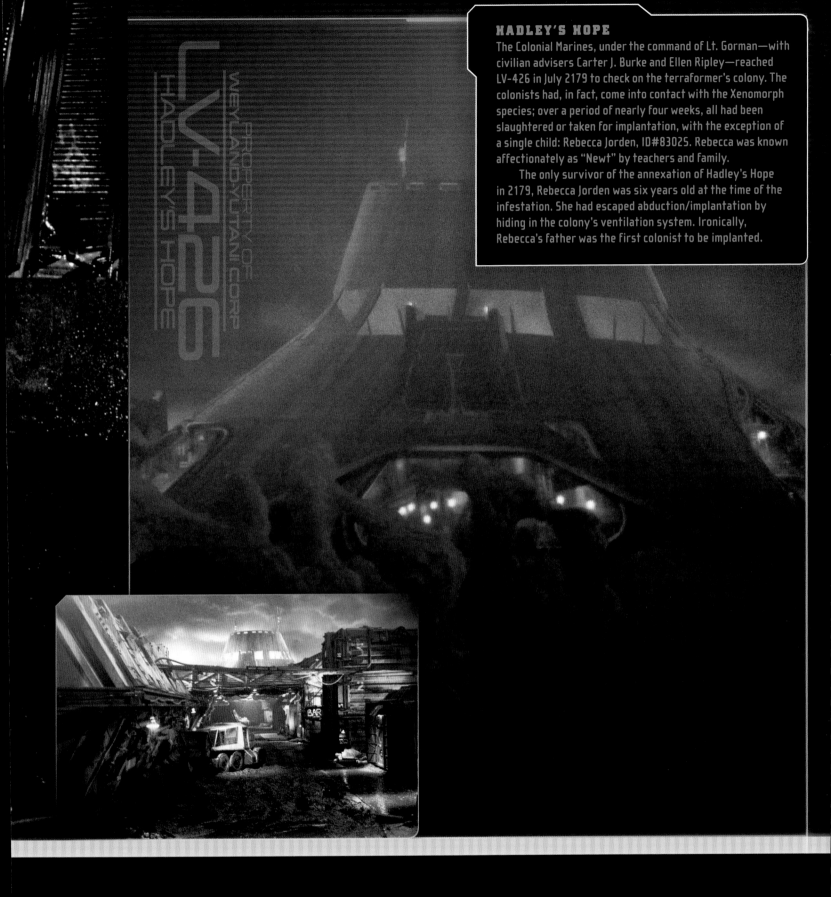

HADLEY'S HOPE

The Colonial Marines, under the command of Lt. Gorman—with civilian advisers Carter J. Burke and Ellen Ripley—reached LV-426 in July 2179 to check on the terraformer's colony. The colonists had, in fact, come into contact with the Xenomorph species; over a period of nearly four weeks, all had been slaughtered or taken for implantation, with the exception of a single child: Rebecca Jorden, ID#83025. Rebecca was known affectionately as "Newt" by teachers and family.

The only survivor of the annexation of Hadley's Hope in 2179, Rebecca Jorden was six years old at the time of the infestation. She had escaped abduction/implantation by hiding in the colony's ventilation system. Ironically, Rebecca's father was the first colonist to be implanted.

PROPERTY OF
WEYLAND YUTANI CORP
LV-426
HADLEY'S HOPE

THERE ARE ONLY SEVEN OF US NOW. LYDECKER IS DEAD, SIMPSON IS DEAD. WHEN WILL YOU GET HERE? EY GOT TRACY, BUT SHE'S STILL ALIVE, I CAN SEE HER PDT. WHERE ARE YOU?"

Dropship flight uneventful. Ferro circled the complex, set us down, and dusted off.

Approach of complex also uneventful. Exterior of processor and living quarters appear serviceable. Storm shutters sealed; valuable machinery exposed to the elements. Looks like everyone went inside in a hurry.

Entered the interior of the complex through the north lock without incident. Outer doors required an electrical bypass to open and inner doors were not operationally functional.

Inside, a considerable level of destruction is obvious—hanging panels, exposed tangles of wires, personal effects scattered. Structural integrity still sound. Power's still on, so visibility's good. Rain is pouring through holes in the ceiling and down through the levels of the complex.

Obvious evidence of hits from small arms fire and explosive damage—probably from seismic survey charges. They were shake-and-bake, access to real weapons would have been minimal. Records indicate that there was a small contingent of REMF Marines here, but they're not here now, and we didn't see any evidence of

Individual living quarters show various levels of destruction. Some have blast holes through the storm shutters. Tables are still set for dinner. Whatever hit here, hit fast.

Found evidence of melted steel on one of the upper walkways consistent with reports from Ripley about creatures with acid for blood. Further into the complex— toward operations—found large holes melted through walkways and floors going down multiple levels. It's clear the colonists fought back and bagged some of the creatures, but no bodies have been found, colonist or otherwise.

Looks like everyone holed up in a sublevel storage area for several days, maybe a week, but just inside the south lock was where the colonists made their last stand. The south wing, encompassing ops and medical, was sealed off with doors welded at both ends and the stairs blocked with heavy equipment. Doesn't appear that the barricade held long. It's all got the look of some pretty intense fighting but without the bodies or even parts of bodies. There's barely a trace of blood.

Operations and medlab show very little

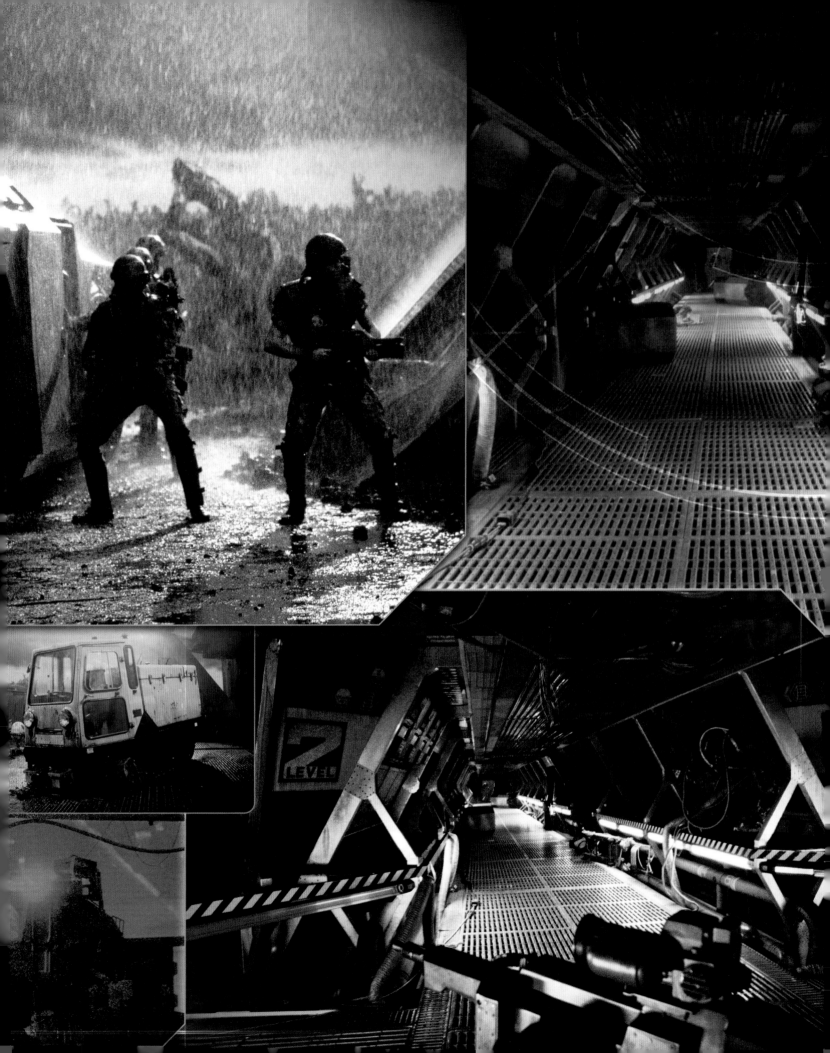

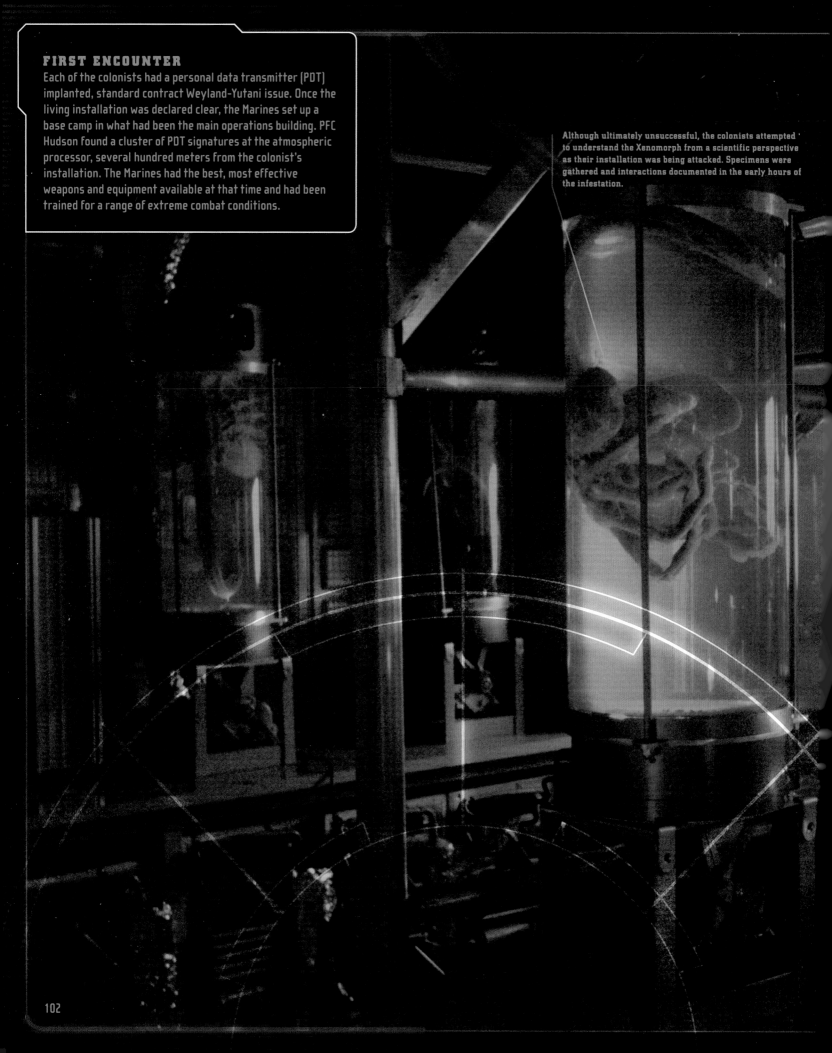

FIRST ENCOUNTER

Each of the colonists had a personal data transmitter (PDT) implanted, standard contract Weyland-Yutani issue. Once the living installation was declared clear, the Marines set up a base camp in what had been the main operations building. PFC Hudson found a cluster of PDT signatures at the atmospheric processor, several hundred meters from the colonist's installation. The Marines had the best, most effective weapons and equipment available at that time and had been trained for a range of extreme combat conditions.

Although ultimately unsuccessful, the colonists attempted to understand the Xenomorph from a scientific perspective as their installation was being attacked. Specimens were gathered and interactions documented in the early hours of the infestation.

REPORT ON MARACHUK, JOHN J.,
ID#93850

Engineering maintenance//

Post-mortem//CT and MRI//

Acting pathologist K. Gaisford,

ID#9870M, Medtech support. 7/17/79.

7/17/79.

Pt is WM, 34, 85 kg, 182 cm, Bro/Blu, scar on right knee. Found in sub-level access tunnel to the atmospheric processor with implant creature attached to his face. Dr. T. Biggs, ID#75492, killed in attempt to remove the creature surgically. The colony's only surgeon made a single incision across the creature's back and was sprayed with less than an ounce of organic acid across the face and throat. Organism was pulled free by two medtechs and secured in a specimen jar. Evidence in blood panels of toxic chemical dump at time of removal; patient died from MI brought on by traumatic shock and poisoning.

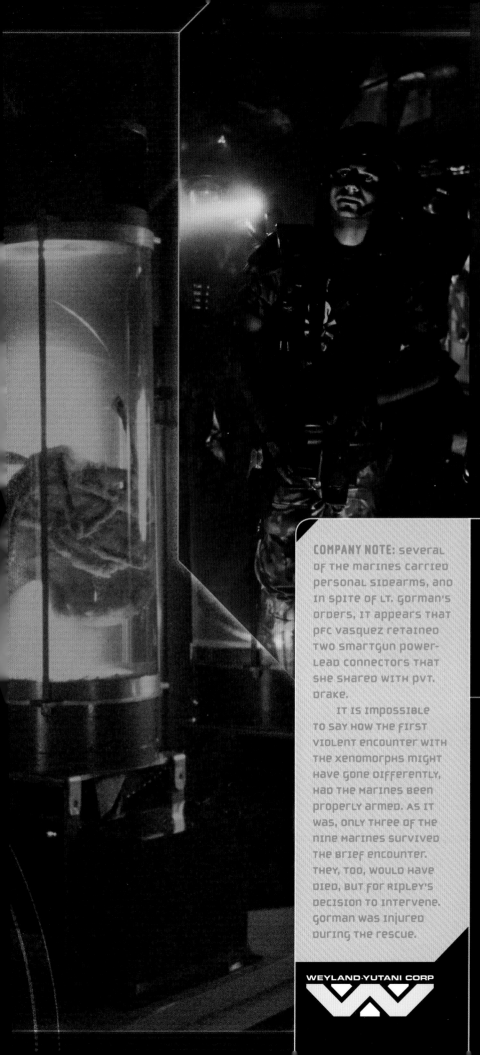

TRANSCRIPT FROM USCM XENOMORPH ENCOUNTER

Cpls. Hicks and Dietrich, PFCs Hudson and Vasquez, and Pvts. Wierzbowski, Frost, Drake, and Crowe were led into the atmospheric processor by MSgt. Apone. Lt. Gorman, Carter Burke, Ellen Ripley, and Rebecca Jorden were aboard the APC at a safe distance and watched feeds from the soldiers' helmet cameras.

GORMAN: Proceed inside.

APONE: Watch your fire and check your targets. Remember we're looking for civvies in here. Easy.

HICKS: Tighten it up, Frost. We're getting a little thin.

APONE: Nice and easy.

DIETRICH: [noting the environment] Looks like some sort of secreted resin.

HICKS: Yeah, but secreted from what?

APONE: Nobody touch nothing.

FROST: Hot as hell in here.

HUDSON: Yeah, man, but it's a dry heat.

APONE: Knock it off, Hudson.

COMPANY NOTE: Several of the marines carried personal sidearms, and in spite of Lt. Gorman's orders, it appears that PFC Vasquez retained two smartgun power-lead connectors that she shared with Pvt. Drake.

It is impossible to say how the first violent encounter with the xenomorphs might have gone differently, had the marines been properly armed. As it was, only three of the nine marines survived the brief encounter. They, too, would have died, but for Ripley's decision to intervene. Gorman was injured during the rescue.

WEYLAND-YUTANI CORP

At that time, Ellen Ripley pointed out to Lt. Gorman that the soldiers were directly beneath the atmospheric processor's primary heat exchanger, and that the pulse rifles and Smartguns both were loaded with caseless, explosive-tipped rounds. Burke confirmed her concern: Rupturing the coolant system for the processor—essentially a giant fusion reactor—would almost inevitably trigger a core-melt incident.

GORMAN: Apone, look. We can't have any firing in there. I want you to collect magazines from everybody.

HUDSON: What? Is he fucking crazy?

FROST: What the hell are we supposed to use, man, harsh language?

GORMAN: Flame units only, I want rifles slung.

APONE: Sir, I—

GORMAN: Just do it, sergeant. And no grenades.

APONE: All right, sweethearts, you heard the man, pull 'em out, let's have 'em. Come on Vasquez, clear and lock. Damn. Give it up, Ski. Come on, let's go. Crowe, I want it now. Give it up.

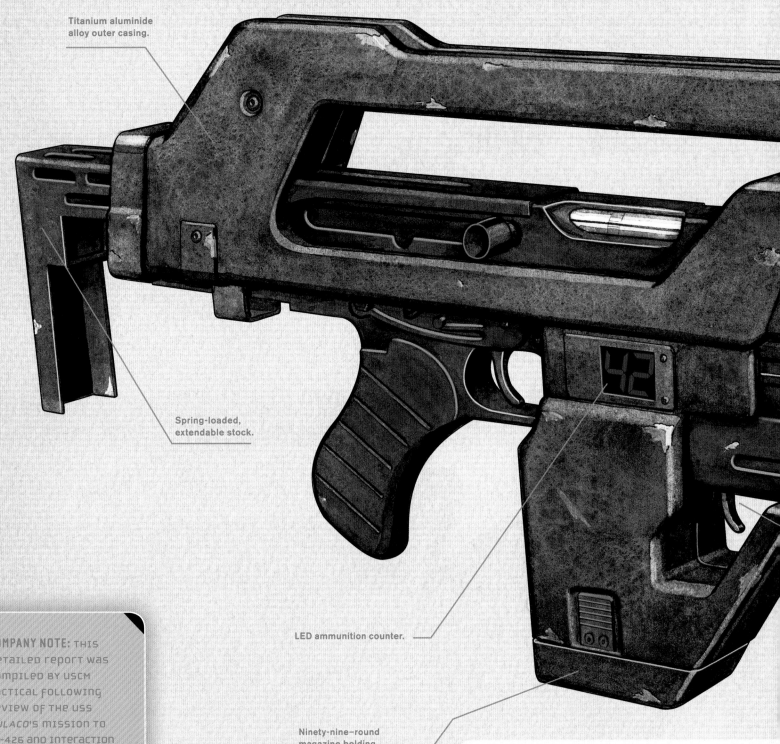

Titanium aluminide alloy outer casing.

Spring-loaded, extendable stock.

LED ammunition counter.

Ninety-nine–round magazine holding 10x24mm explosive-tip, caseless rounds.

WEAPONS
M41A PULSE RIFLE

Historically, this weapon ranks with the Thompson submachine gun and the Kalashnikov. The durable M41A performs consistently and in a range of environments. Of all items suggested for hunting Xenomorphs, the M41A tops the list.

The magazine holds ninety-nine 10x24mm caseless rounds; the weapon is only 4.9 kg fully loaded.

WEYLAND·YUTANI CORP

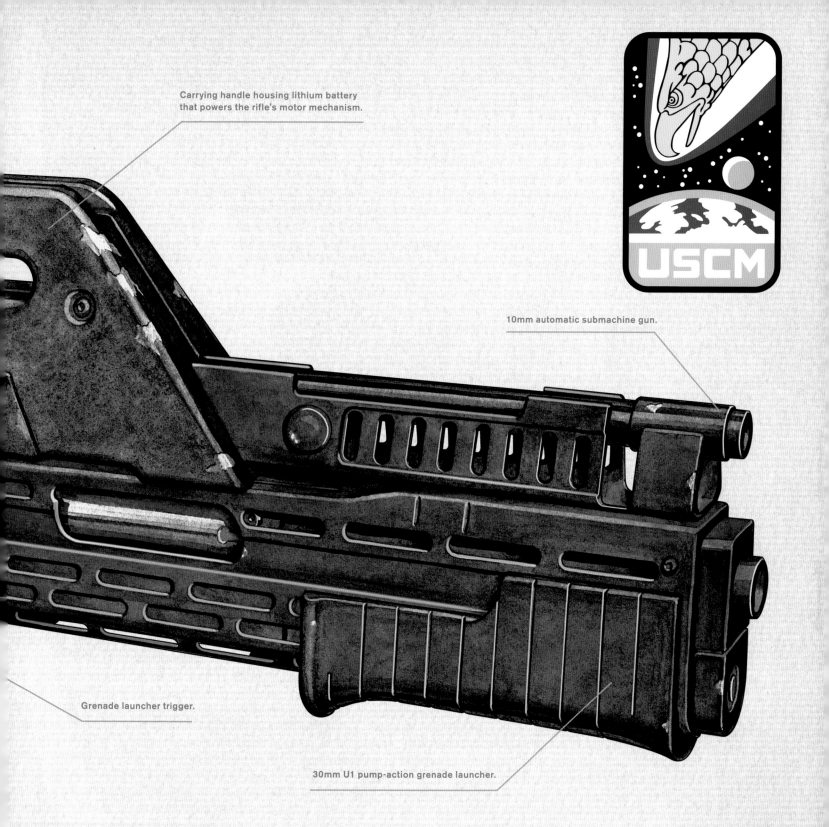

Carrying handle housing lithium battery that powers the rifle's motor mechanism.

10mm automatic submachine gun.

Grenade launcher trigger.

30mm U1 pump-action grenade launcher.

USCM

The rifle fires either explosive-tipped or standard-tipped rounds. Because of the potential for acid spray, it is suggested that the operator use standard-tipped rounds when fighting Xenomorphs at close range and explosive-tipped rounds only at medium or long range.

The underbarrel is a U1 grenade launcher—30mm and pump-action. The importance of choosing the right grenade cannot be overstated.

For short and medium range, we recommend the M108 buckshot. The blast is more likely to blow the acid spray away from the user rather than in 360 degrees.

At medium range, there is also the potential for using the M60 Incendiary or the M72A1 Starshell. As we still don't know how the Xenomorph visualizes its environment, there is the possibility that these shells will burn hot and bright enough to disorient the Xenomorph.

We recommend explosive grenades only at long range.

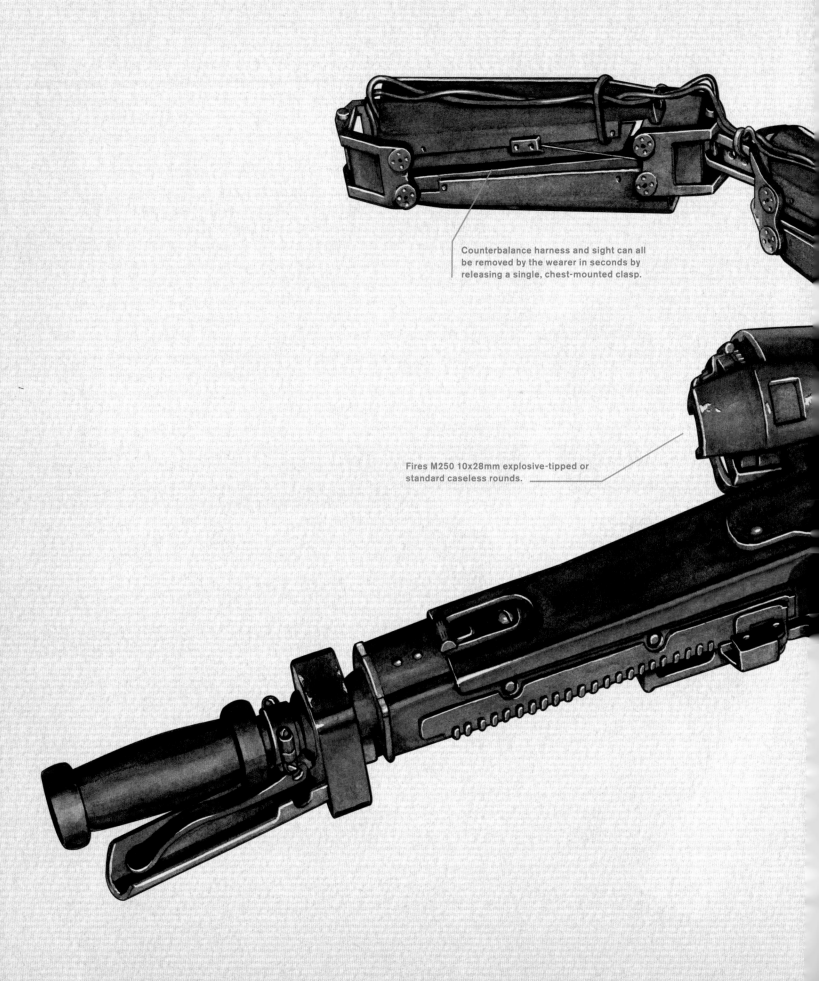

Counterbalance harness and sight can all be removed by the wearer in seconds by releasing a single, chest-mounted clasp.

Fires M250 10x28mm explosive-tipped or standard caseless rounds.

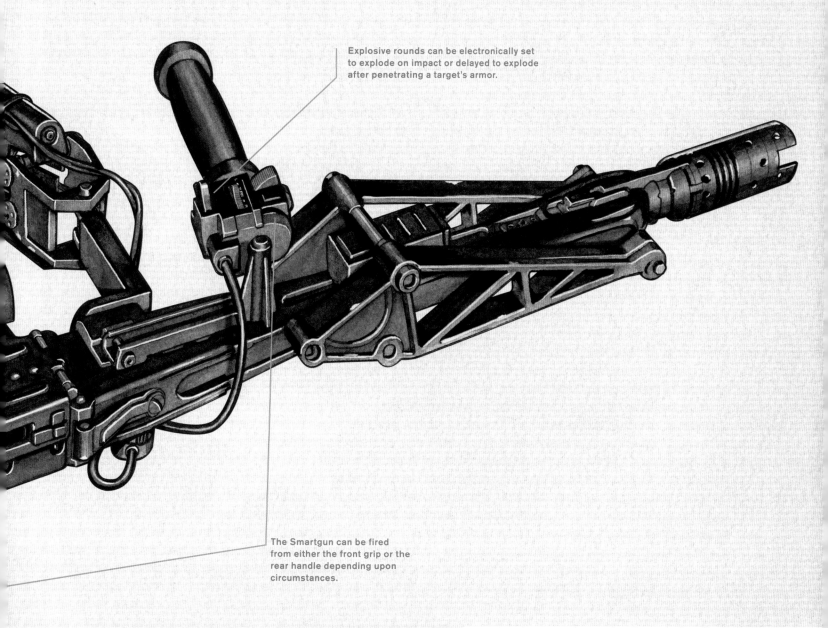

Explosive rounds can be electronically set to explode on impact or delayed to explode after penetrating a target's armor.

The Smartgun can be fired from either the front grip or the rear handle depending upon circumstances.

M56A SMARTGUN

At medium and long range, this rifle ranks close to the M41A as an asset. At the flip of a switch, the Smartgun can switch between standard and explosive-tipped rounds; it holds 600 rounds and delivers more punch than the M41A. Because of its ability to distinguish friend from foe via the IFF data transmitter, the Smartgun is a potentially devastating weapon.

At short and especially point-blank range, this rifle is not recommended. The weapon's reaction time is significantly slower than that of the Xenomorph.

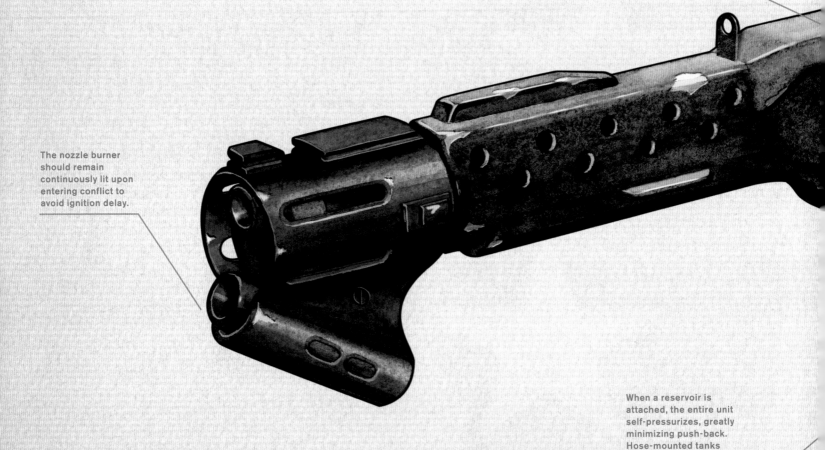

Fuel is supplied through the attached reservoir. Alternatively, the reservoir can be removed and the unit can be directly fed by larger tanks borne by the operator.

The nozzle burner should remain continuously lit upon entering conflict to avoid ignition delay.

When a reservoir is attached, the entire unit self-pressurizes, greatly minimizing push-back. Hose-mounted tanks rely on the tank pressure to project the fuel with considerable push-back.

M240 INCINERATOR UNIT

This exceptionally designed weapon should be modified when facing Xenomorphs. The pressure-thickened napthal accelerant is designed to adhere to any surface it touches and to burn slowly, creating as much damage and smoke as possible. We strongly feel that the effectiveness of fire against Xenomorphs is more psychological/instinctual than physical. Reports from Fiorina 161 state that, after being immersed in molten lead, the Xenomorph was able to continue fighting—this indicates a significant resistance to heat.

We recommend a petroleum-based fuel rather than napthal, refined so that it burns hot, clean, and quickly. The heat should be enough to keep Xenomorphs at bay and burn facehuggers outright with a minimum of smoke interference. Long-burning fuels risk the structural integrity of any flammable environment.

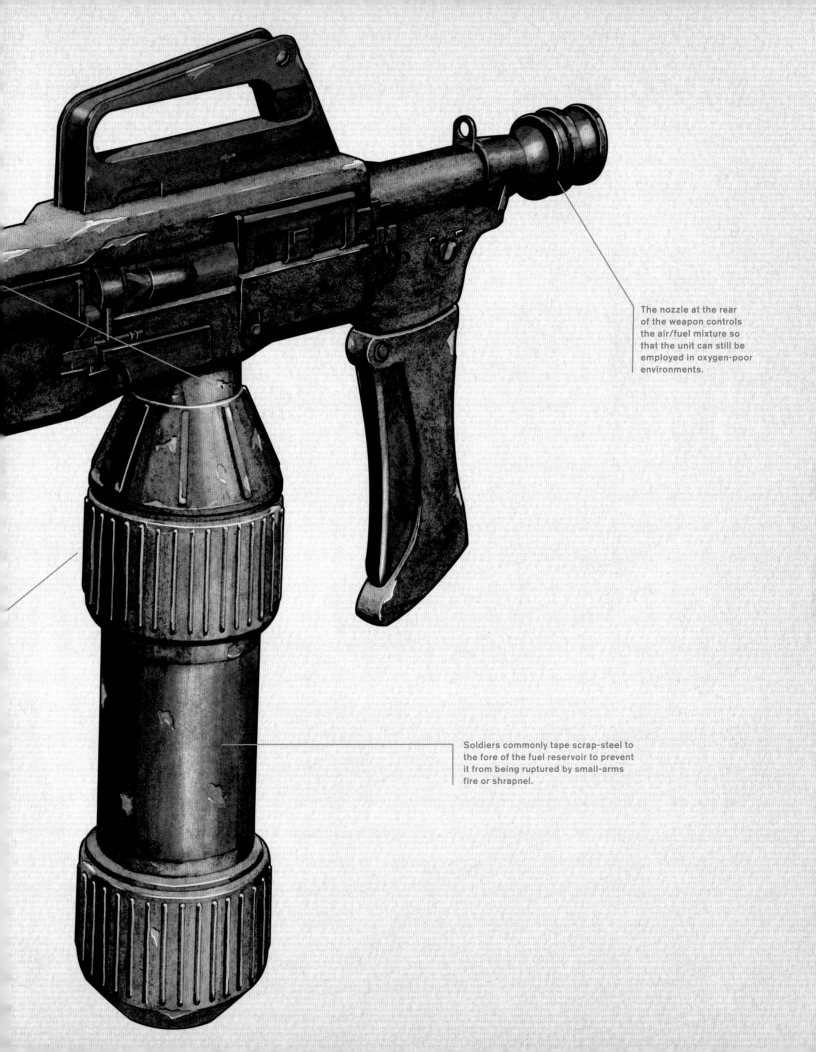

The nozzle at the rear
of the weapon controls
the air/fuel mixture so
that the unit can still be
employed in oxygen-poor
environments.

Soldiers commonly tape scrap-steel to
the fore of the fuel reservoir to prevent
it from being ruptured by small-arms
fire or shrapnel.

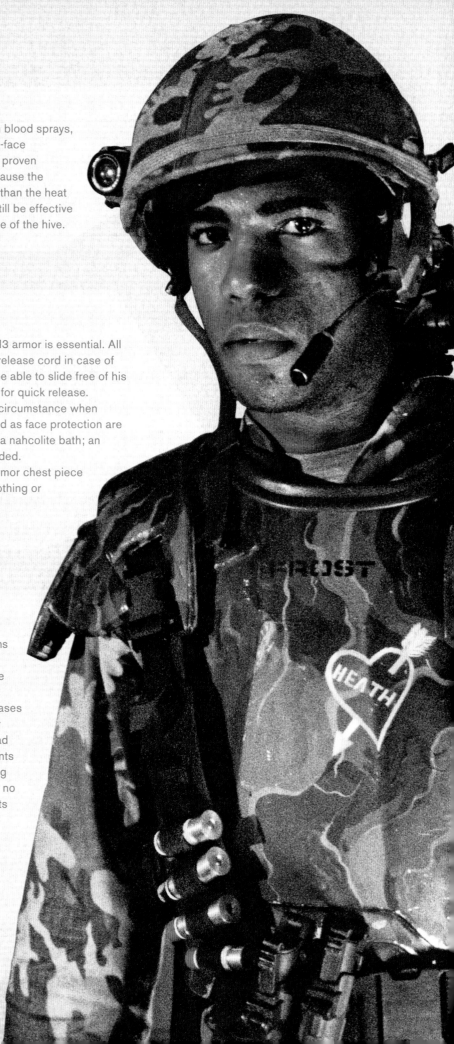

M10 BALLISTIC HELMET

In order to be effective against Xenomorph blood sprays, this helmet needs to be reinforced with full-face protection. Though the infrared viewer has proven ineffective inside a hive—theoretically, because the Xenomorphs' heat signature is not greater than the heat signature of an active hive—infrared may still be effective when Xenomorphs are encountered outside of the hive.

M3 PERSONAL ARMOR

If fighting the Xenomorphs at close range, a full version of the M3 armor is essential. All armor should be modified so that it can be removed by a quick-release cord in case of acid spatter, and so that a soldier taken for implantation might be able to slide free of his or her captor. The helmet and face shield should NOT be wired for quick release. A soldier's face must be protected at all times and under every circumstance when engaging the Xenomorph. Unfortunately, materials currently used as face protection are insufficient. We do know that facehugger acid is neutralized by a nahcolite bath; an alkaline coating on all body armor is therefore highly recommended.

The IFF personal data transmitter normally located in the armor chest piece and in the helmet should be stitched directly to the trooper's clothing or surgically implanted.

GRENADES

Use the same cautions and recommendations as listed for the U1 grenade launcher with one exception: Consider deployment of the G2 Electroshock Grenade. Known as the Sonic Electronic Ball Breaker, the G2 releases a 1.2-gigavolt charge upon detonation. For humans, this charge is sufficient to overload and shut down all but the most vital elements of the autonomic nervous system, rendering the opponent effectively helpless. There is no data on how a high electrical charge affects Xenomorph facehuggers or drones, but if effective, the G2 could potentially incapacitate attacking Xenomorphs, preparing them for easy collection. *Note: As the effectiveness of this grenade is untested, its use is only recommended in addition to established methods of effective combat.*

ALTERNATE FIREARMS

Though considered archaic by the technological standards of the Colonial Marines, older firearms have proven effective against the Xenomorph. Lt. Gorman carried a Heckler & Koch VP-70 pistol, as did Frost and Ferro; Cpl. Hicks carried an Ithica 37 pump-action shotgun; and PFC Vasquez carried a Smith & Wesson Model 39 semi-automatic pistol. These older firearms don't have the same power as an M41A, but they are faster at point-blank range and have enough "punch" to pierce the exoskeleton of a facehugger or an adult Xenomorph.

CHEMICAL AGENTS

On LV-426, PFC Vasquez recommended that CN-20 nerve gas be used to kill the entire hive. The idea was dismissed for the same reason we continue to discourage the use of chemical and biological agents: We don't know if they will work. The Xenomorph is resistant to its own acid but apparently susceptible to some processed acids. Their ability to survive, at least temporarily, in oxygen-poor environments rules out the use of airborne toxins.

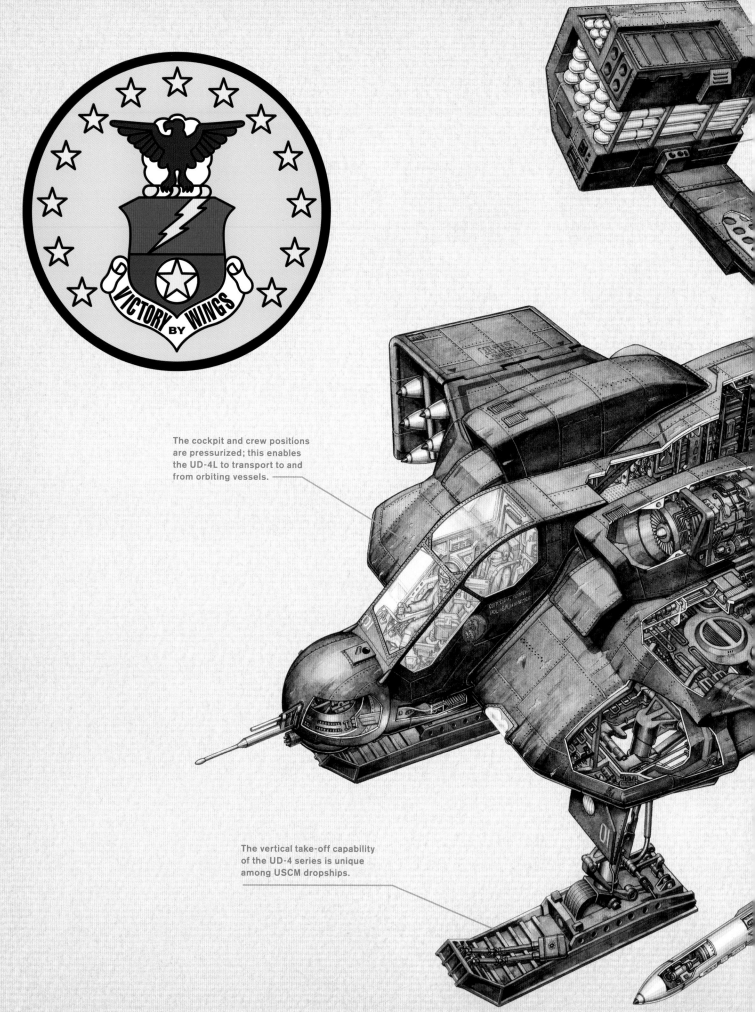

The cockpit and crew positions
are pressurized; this enables
the UD-4L to transport to and
from orbiting vessels.

The vertical take-off capability
of the UD-4 series is unique
among USCM dropships.

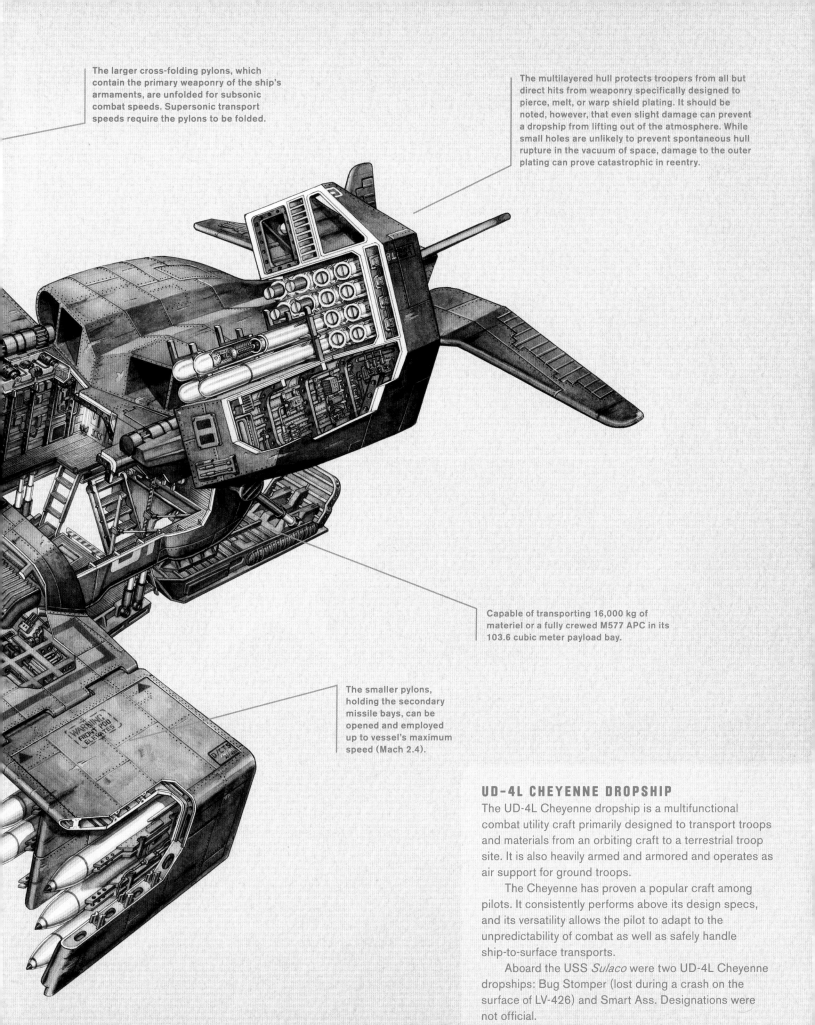

The larger cross-folding pylons, which contain the primary weaponry of the ship's armaments, are unfolded for subsonic combat speeds. Supersonic transport speeds require the pylons to be folded.

The multilayered hull protects troopers from all but direct hits from weaponry specifically designed to pierce, melt, or warp shield plating. It should be noted, however, that even slight damage can prevent a dropship from lifting out of the atmosphere. While small holes are unlikely to prevent spontaneous hull rupture in the vacuum of space, damage to the outer plating can prove catastrophic in reentry.

Capable of transporting 16,000 kg of materiel or a fully crewed M577 APC in its 103.6 cubic meter payload bay.

The smaller pylons, holding the secondary missile bays, can be opened and employed up to vessel's maximum speed (Mach 2.4).

WARNING POD FRONT ELEVATES

UD-4L CHEYENNE DROPSHIP

The UD-4L Cheyenne dropship is a multifunctional combat utility craft primarily designed to transport troops and materials from an orbiting craft to a terrestrial troop site. It is also heavily armed and armored and operates as air support for ground troops.

The Cheyenne has proven a popular craft among pilots. It consistently performs above its design specs, and its versatility allows the pilot to adapt to the unpredictability of combat as well as safely handle ship-to-surface transports.

Aboard the USS *Sulaco* were two UD-4L Cheyenne dropships: Bug Stomper (lost during a crash on the surface of LV-426) and Smart Ass. Designations were not official.

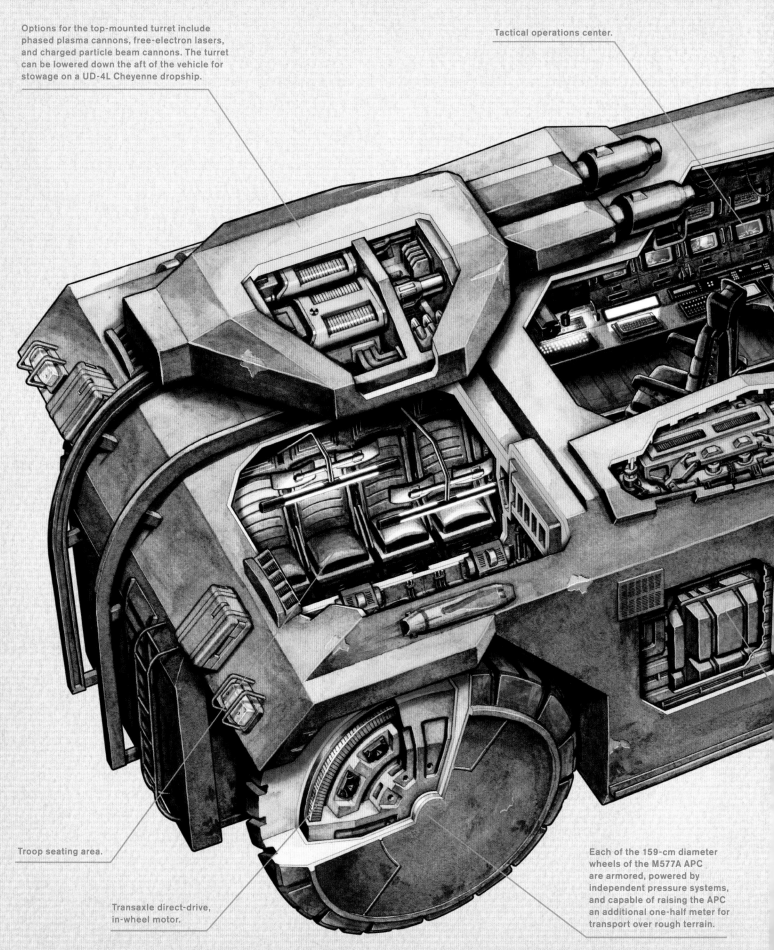

Options for the top-mounted turret include phased plasma cannons, free-electron lasers, and charged particle beam cannons. The turret can be lowered down the aft of the vehicle for stowage on a UD-4L Cheyenne dropship.

Tactical operations center.

Troop seating area.

Transaxle direct-drive, in-wheel motor.

Each of the 159-cm diameter wheels of the M577A APC are armored, powered by independent pressure systems, and capable of raising the APC an additional one-half meter for transport over rough terrain.

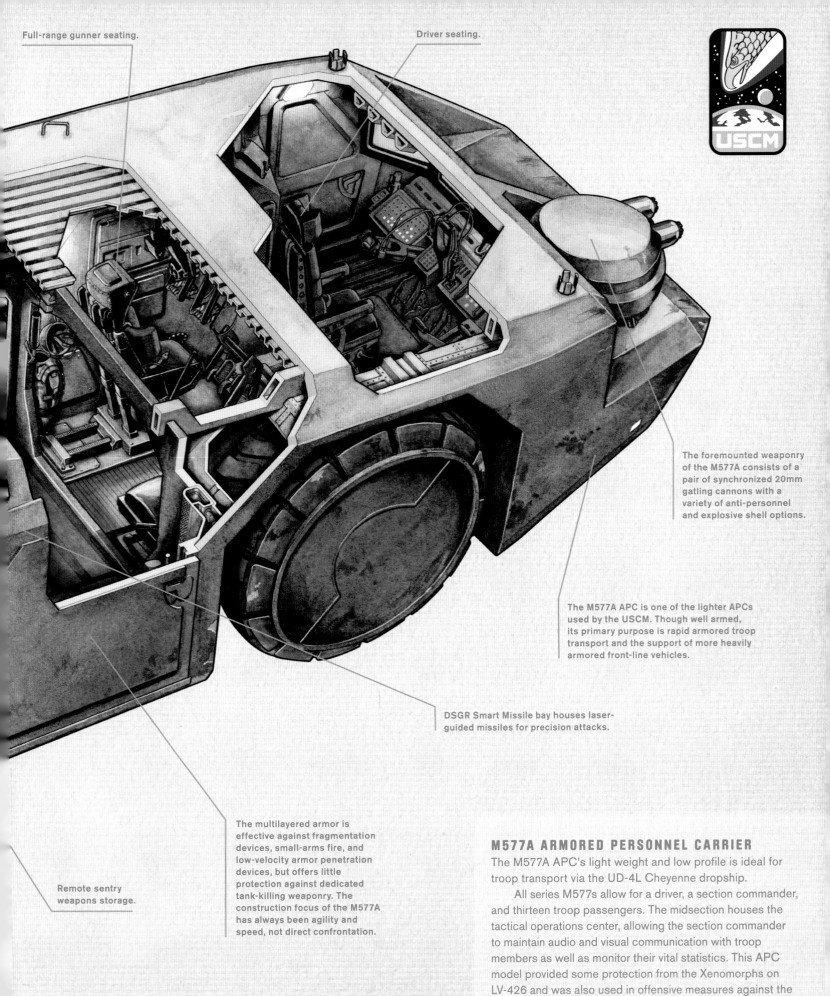

Full-range gunner seating.

Driver seating.

USCM

The foremounted weaponry of the M577A consists of a pair of synchronized 20mm gatling cannons with a variety of anti-personnel and explosive shell options.

The M577A APC is one of the lighter APCs used by the USCM. Though well armed, its primary purpose is rapid armored troop transport and the support of more heavily armored front-line vehicles.

DSGR Smart Missile bay houses laser-guided missiles for precision attacks.

Remote sentry weapons storage.

The multilayered armor is effective against fragmentation devices, small-arms fire, and low-velocity armor penetration devices, but offers little protection against dedicated tank-killing weaponry. The construction focus of the M577A has always been agility and speed, not direct confrontation.

M577A ARMORED PERSONNEL CARRIER

The M577A APC's light weight and low profile is ideal for troop transport via the UD-4L Cheyenne dropship.

All series M577s allow for a driver, a section commander, and thirteen troop passengers. The midsection houses the tactical operations center, allowing the section commander to maintain audio and visual communication with troop members as well as monitor their vital statistics. This APC model provided some protection from the Xenomorphs on LV-426 and was also used in offensive measures against the creatures by civilian advisor Ellen Ripley.

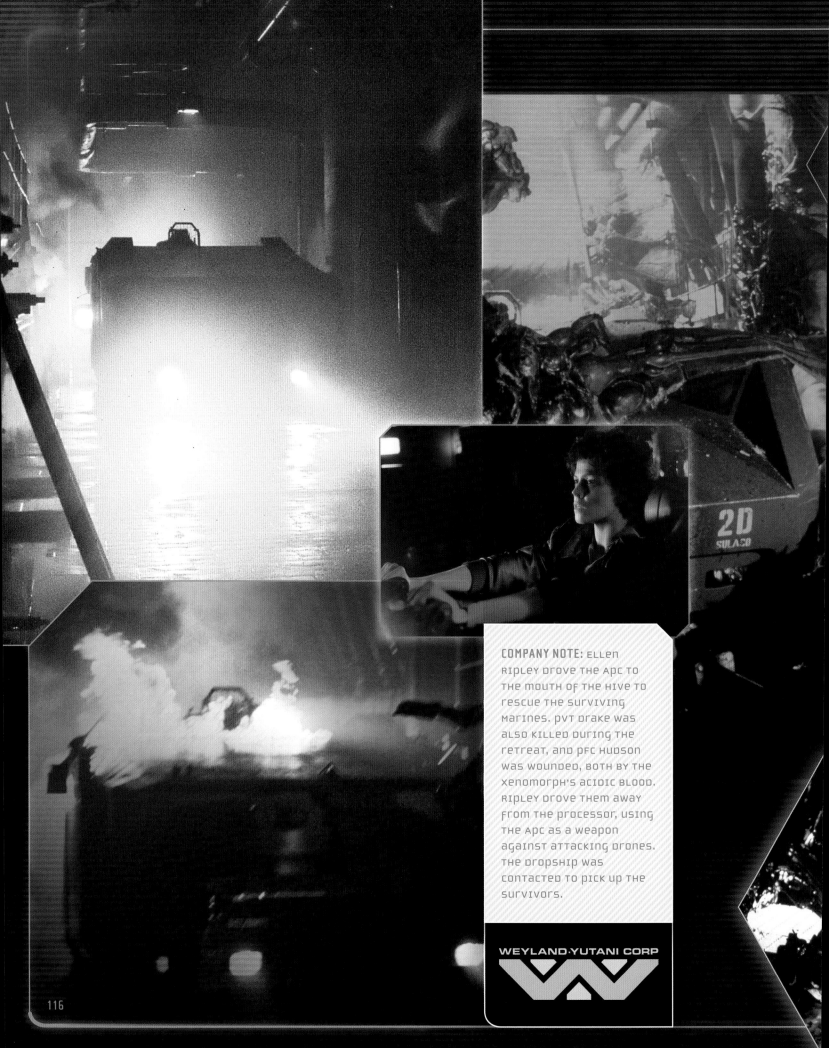

COMPANY NOTE: Ellen Ripley drove the APC to the mouth of the hive to rescue the surviving marines. Pvt Drake was also killed during the retreat, and PFC Hudson was wounded, both by the xenomorph's acidic blood. Ripley drove them away from the processor, using the APC as a weapon against attacking drones. The dropship was contacted to pick up the survivors.

WEYLAND·YUTANI CORP

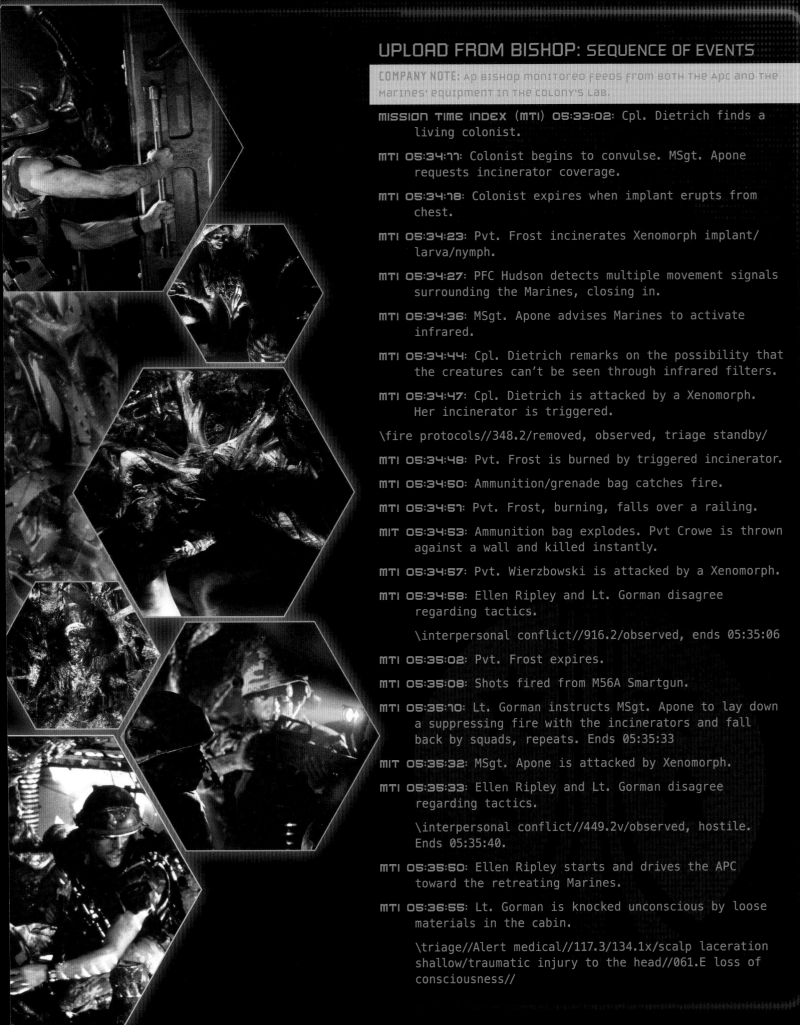

UPLOAD FROM BISHOP: SEQUENCE OF EVENTS

COMPANY NOTE: Ap Bishop monitored feeds from both the APC and the Marines' equipment in the colony's lab.

MISSION TIME INDEX (MTI) 05:33:02: Cpl. Dietrich finds a living colonist.

MTI 05:34:77: Colonist begins to convulse. MSgt. Apone requests incinerator coverage.

MTI 05:34:78: Colonist expires when implant erupts from chest.

MTI 05:34:23: Pvt. Frost incinerates Xenomorph implant/larva/nymph.

MTI 05:34:27: PFC Hudson detects multiple movement signals surrounding the Marines, closing in.

MTI 05:34:36: MSgt. Apone advises Marines to activate infrared.

MTI 05:34:44: Cpl. Dietrich remarks on the possibility that the creatures can't be seen through infrared filters.

MTI 05:34:47: Cpl. Dietrich is attacked by a Xenomorph. Her incinerator is triggered.

\fire protocols//348.2/removed, observed, triage standby/

MTI 05:34:48: Pvt. Frost is burned by triggered incinerator.

MTI 05:34:50: Ammunition/grenade bag catches fire.

MTI 05:34:57: Pvt. Frost, burning, falls over a railing.

MIT 05:34:53: Ammunition bag explodes. Pvt Crowe is thrown against a wall and killed instantly.

MTI 05:34:57: Pvt. Wierzbowski is attacked by a Xenomorph.

MTI 05:34:58: Ellen Ripley and Lt. Gorman disagree regarding tactics.

\interpersonal conflict//916.2/observed, ends 05:35:06

MTI 05:35:02: Pvt. Frost expires.

MTI 05:35:08: Shots fired from M56A Smartgun.

MTI 05:35:70: Lt. Gorman instructs MSgt. Apone to lay down a suppressing fire with the incinerators and fall back by squads, repeats. Ends 05:35:33

MIT 05:35:32: MSgt. Apone is attacked by Xenomorph.

MTI 05:35:33: Ellen Ripley and Lt. Gorman disagree regarding tactics.

\interpersonal conflict//449.2v/observed, hostile. Ends 05:35:40.

MTI 05:35:50: Ellen Ripley starts and drives the APC toward the retreating Marines.

MTI 05:36:55: Lt. Gorman is knocked unconscious by loose materials in the cabin.

\triage//Alert medical//117.3/134.1x/scalp laceration shallow/traumatic injury to the head//061.E loss of consciousness//

U.S. COLONIAL MARINES

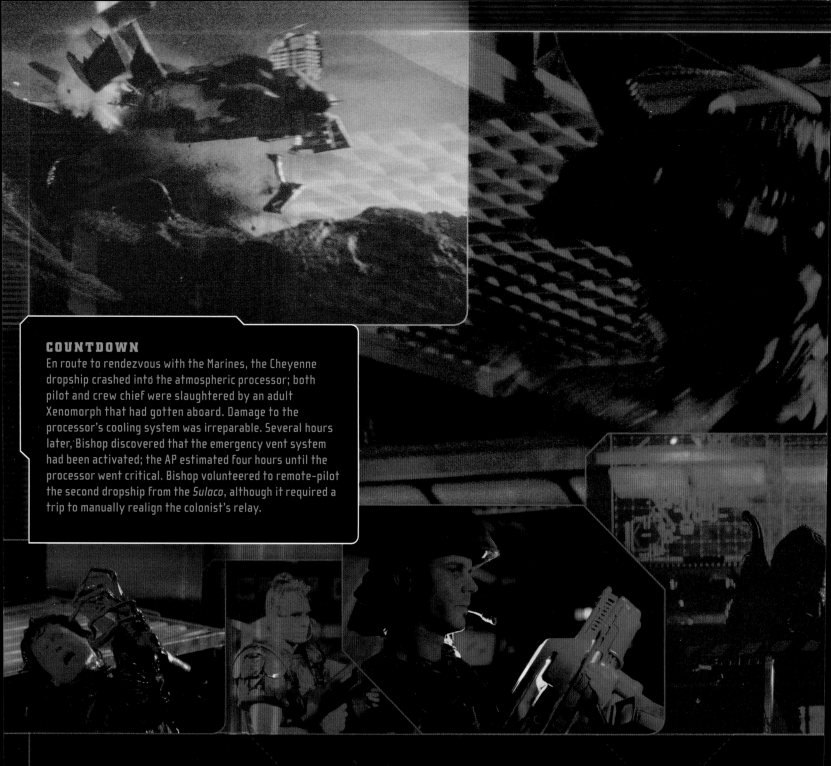

COUNTDOWN

En route to rendezvous with the Marines, the Cheyenne dropship crashed into the atmospheric processor; both pilot and crew chief were slaughtered by an adult Xenomorph that had gotten aboard. Damage to the processor's cooling system was irreparable. Several hours later, Bishop discovered that the emergency vent system had been activated; the AP estimated four hours until the processor went critical. Bishop volunteered to remote-pilot the second dropship from the *Sulaco*, although it required a trip to manually realign the colonist's relay.

EXCERPT FROM BREAKDOWN OF HADLEY'S HOPE: EVALUATION AND AFTERMATH, BY W. SHANNON, WY ID#97623, ASSISTANT TO DIRECTOR OF SPECIAL PROJECTS UNDER CARTER J. BURKE, LATER DIRECTOR OF SPECIAL PROJECTS, 2179–2184.

Burke's plan, to implant Ripley and the child in order to get specimens through quarantine, wasn't a bad one. With two specimens hidden and no one to alert medical (Ripley astutely asserted that Burke meant to sabotage the witnesses' hypersleep chambers en route back to Gateway), Burke would have more than made up for the loss of the processor. Unfortunately, when she realized that the facehugger Xenomorphs had been released and that she and the child were trapped, Ripley set off a fire alarm, calling the Marines to her aid.

Ripley incited the Marines to action, proposing that they "nuke" the entire installation from orbit; while she didn't demand Burke's execution for his alleged betrayal, she was obviously prepared to stand witness to his murder. At that point, however, the Xenomorphs attacked; the power went out. Amid the resulting chaos, Burke managed to escape his captors. The aliens entered the installation through service ducts, bypassing barricades that the Marines had set up, and attacked from above and below the main operations floor.

THERE'S NO QUESTION, WE ARE NOT GOING TO GET ONE OF THE LIVING SPECIMENS THROUGH ICC [QUARANTINE]. I DOUBT THEY'D MAKE THE TRIP, ANYWAY. THEY SEEM TO DIE PRETTY FAST IF THEY CAN'T DO THEIR IMPLANTATION THING. BUT HERE'S MY THINKING—IF ONE OR MORE OF THE RESCUE PARTY IS *IMPLANTED*, WE COULD KEEP THEM IN HYPERSLEEP UNTIL OUR PEOPLE COULD GET TO THEM AT GATEWAY. IT'S EXTREMELY LIKELY THAT ONE OR MORE OF THE PARTY WILL BE IMPLANTED, SO MAKE SURE WE HAVE TEAMS STANDING BY THREE WEEKS OUT, STARTING TODAY. I MEAN, I HOPE IT DOESN'T HAPPEN, IT WOULD BE A TRAGEDY, BUT WE HAVE TO BE READY.

CARTER J. BURKE, DIRECTOR OF SPECIAL PROJECTS, L1E7/.569643 267 MN.

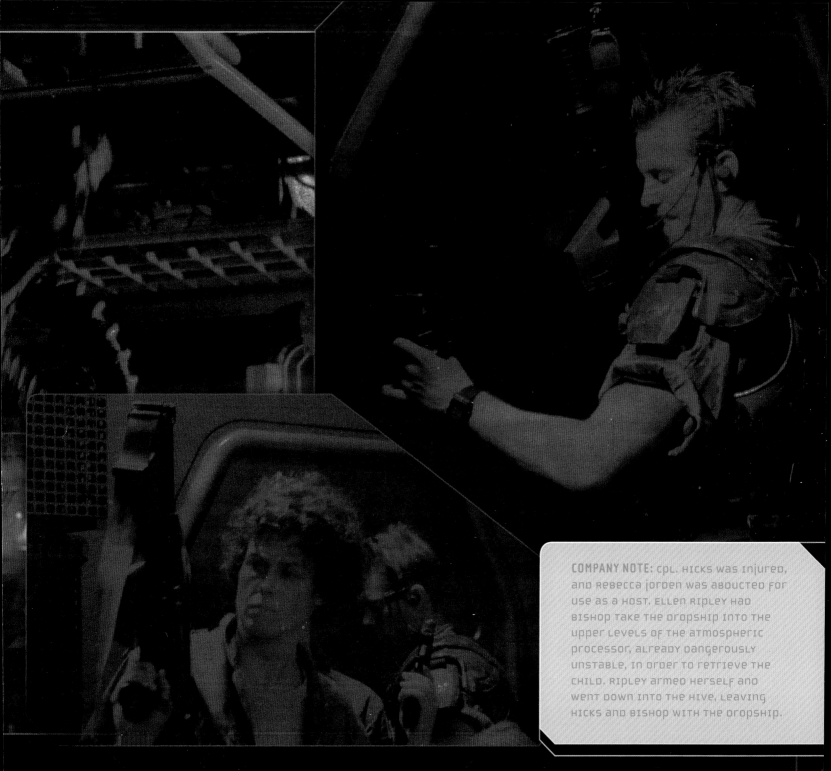

Unfortunately, we only have what the installation's cameras were able to upload to describe what happened next. Burke and one of the soldiers were both killed or abducted in the first-wave attack. Ripley had the child lead the survivors through the ventilation ducts, toward where the remote-piloted dropship would land. Two more Marines fell behind; one of them detonated a grenade, killing a number of the Xenomorphs.

Watching the Xenomorph in action, I have to say that Burke was right about the alien's potential value; they are amazing creatures—sleek, powerful, and relentless. Terrifying, really. The feeds weren't definitive, I couldn't say if their attack was organized or just melee, but there's no denying their

effectiveness. Burke's plans were not without worth— he recognized opportunities and pursued them—but they were not thoughtfully implemented or properly sourced. He should have brought in private contractors rather than the military. He should have requested comprehensive funding. At the very least, he should have sedated the hosts before implantation. Burke's heart was in the right place, but he didn't think his decisions through.

Now that we understand more about the alien's capabilities, we need not make the same mistakes that led to the waste of resources at LV-426 and Carter Burke's unfortunate death. Any future opportunity to capture the Xenomorph should be given maximum, dedicated funding and as much foresight as time allows.

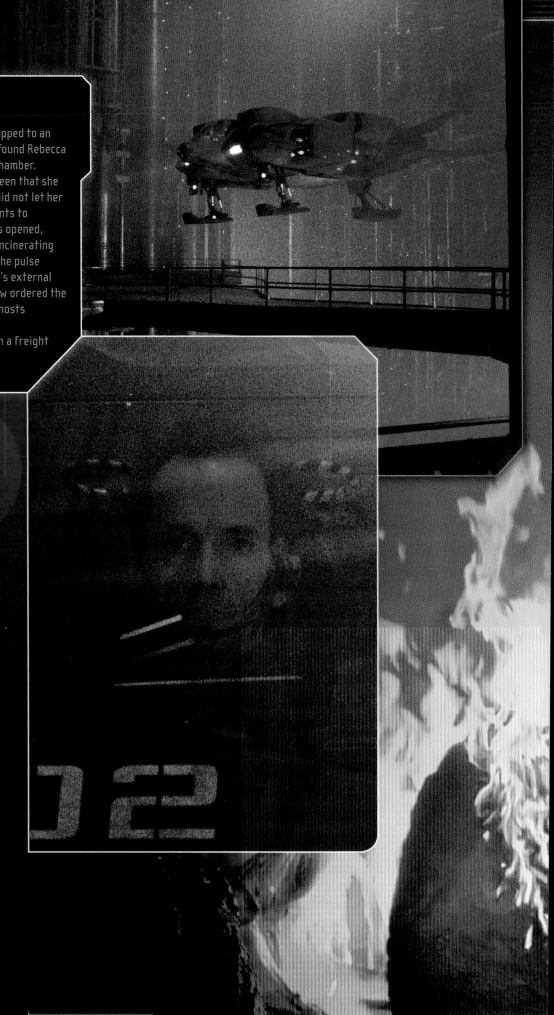

INSIDE THE HIVE

Armed with mapping flares and a pulse rifle strapped to an incinerator, Ripley descended into the hive and found Rebecca Jorden secured to a wall in the queen's central chamber. After freeing the girl, Ripley indicated to the queen that she would incinerate a number of eggs if the queen did not let her and the child go. The queen ordered her attendants to retreat. When an egg near the departing humans opened, Ripley followed through on her threat. Besides incinerating dozens or even hundreds of the eggs, she used the pulse rifle's grenade launcher to blow apart the queen's external ovipositor. It is doubtful that the queen somehow ordered the egg to open; more likely, the presence of viable hosts automatically activated the egg.

Ripley and the child fled the burning hive in a freight elevator. The queen followed.

CONVERSATION BETWEEN CPL. HICKS AND AP BISHOP ABOARD THE DROPSHIP

BISHOP: Corporal Hicks, the platform just shifted beneath us.

HICKS: How long have we got?

BISHOP: It could go at any time.

HICKS: OK. Hold it as long as you can. If it tilts more than three degrees or the grid starts to get mushy . . .

BISHOP: Sir? Corporal?

HICKS: Yeah, I might be passing out in a minute, Bishop. Don't move until you have to, do what you have to, but don't you leave them behind, you got that?

BISHOP: I understand.

HICKS: If you dust off, hover as long as you can. If the temp gets over 32, circle out and back.

BISHOP: Yes, sir. How long do you estimate Lieutenant Ripley will be?

HICKS: As long as it takes to get Newt back.

TRANSCRIPT OF CPL. HICKS' FINAL STATUS REPORT.

This is Corporal Dwayne Hicks, ah A27/TQ4.0.48215E9. This is a status update, for what it's worth. Bishop says I'll be OK, but I don't know, I don't know if any of us will make it. I'm pumped full of morphine—I got burned—but I wanted to get it on record that they died fighting, even Gorman. I filed a report previously on the Marines we lost at the reactor but, uh, PFC Hudson, PFC Vasquez, and the lieut, I want all of them put up for posthumous recognition along with the rest of the squad. Hudson was first, they took him at ops. He went down firing. Vasquez got hurt in the ducts and Gorman went back for her. The bugs were everywhere. He must have known that he was going to die if he didn't keep moving, but he went, anyway. Vasquez or Gorman triggered a grenade, took some of those fuckers with 'em. The blast knocked the kid down into the drainage tunnels. We tried to get to her but we were too late. One of those things took her. That's about when I got burned. Good thing I was ugly to start with. Ripley saved my ass, she got us to the ship, and now she's gone after the little girl. Kid's got my tracker on her wrist. She's somewhere deep in the hive, and Ripley went after her, alone.

 Lambs to the slaughter, that's all we were, but if anyone's got a chance of coming back with the kid, it's Ripley. She survived the

alien and came back for more. The processor's gonna blow any time now, but Ripley still went after Newt. Did I say that already?

 That's all.

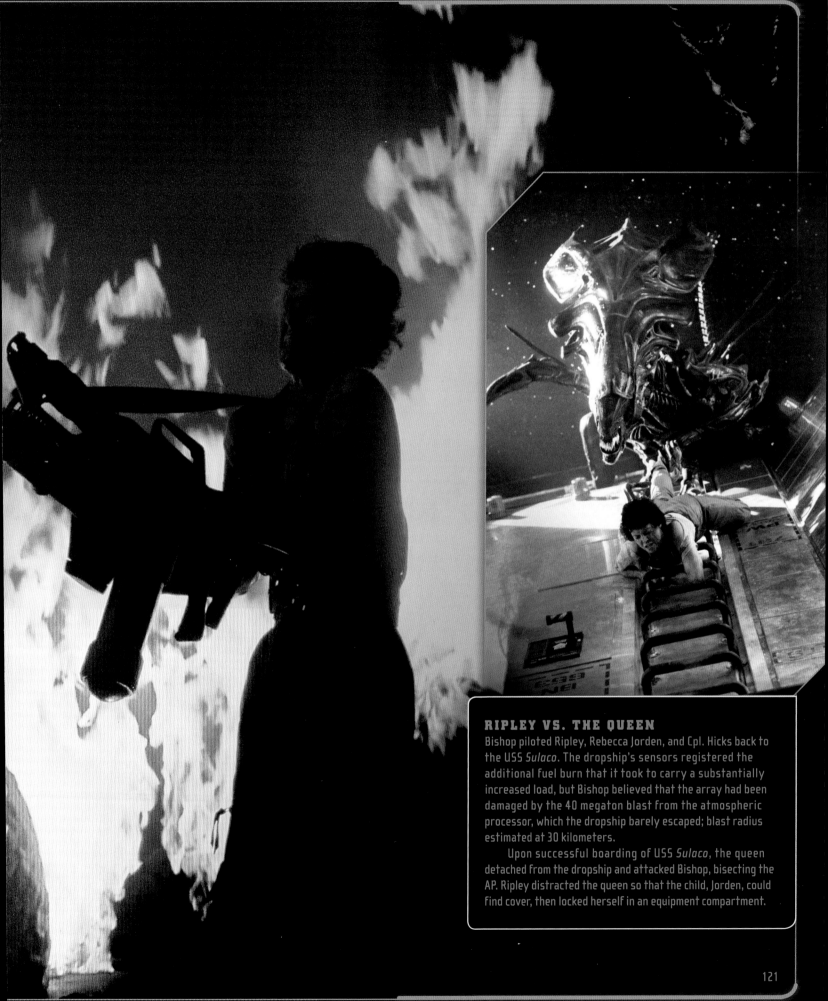

RIPLEY VS. THE QUEEN

Bishop piloted Ripley, Rebecca Jorden, and Cpl. Hicks back to the USS *Sulaco*. The dropship's sensors registered the additional fuel burn that it took to carry a substantially increased load, but Bishop believed that the array had been damaged by the 40 megaton blast from the atmospheric processor, which the dropship barely escaped; blast radius estimated at 30 kilometers.

Upon successful boarding of USS *Sulaco*, the queen detached from the dropship and attacked Bishop, bisecting the AP. Ripley distracted the queen so that the child, Jorden, could find cover, then locked herself in an equipment compartment.

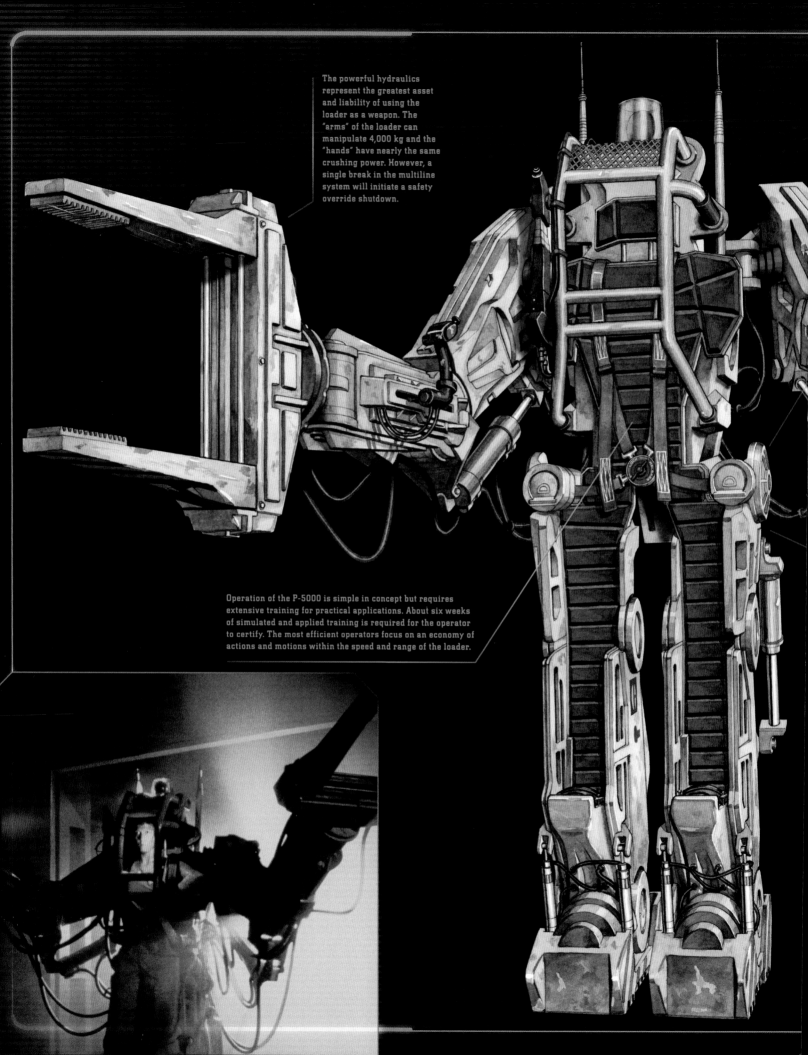

The powerful hydraulics represent the greatest asset and liability of using the loader as a weapon. The "arms" of the loader can manipulate 4,000 kg and the "hands" have nearly the same crushing power. However, a single break in the multiline system will initiate a safety override shutdown.

Operation of the P-5000 is simple in concept but requires extensive training for practical applications. About six weeks of simulated and applied training is required for the operator to certify. The most efficient operators focus on an economy of actions and motions within the speed and range of the loader.

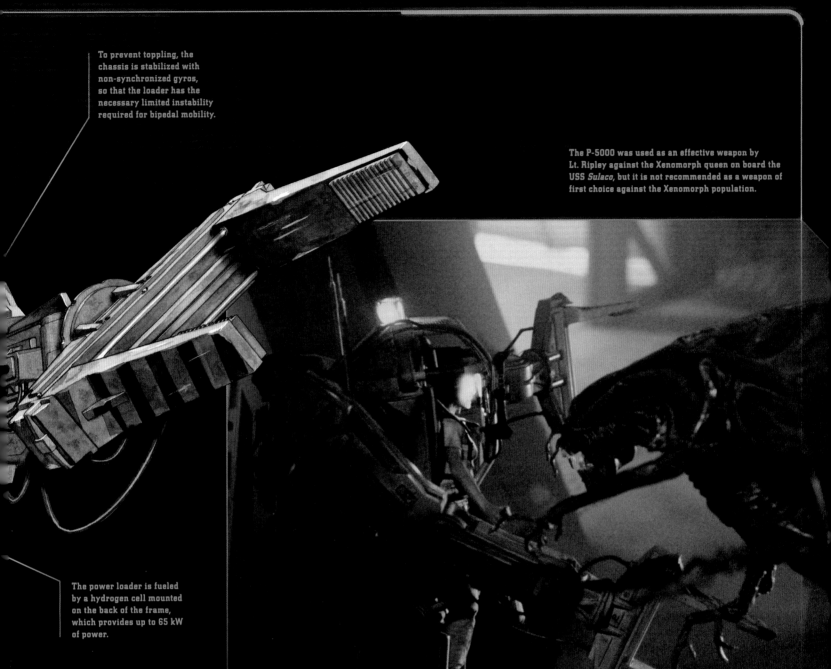

To prevent toppling, the chassis is stabilized with non-synchronized gyros, so that the loader has the necessary limited instability required for bipedal mobility.

The P-5000 was used as an effective weapon by Lt. Ripley against the Xenomorph queen on board the USS *Sulaco*, but it is not recommended as a weapon of first choice against the Xenomorph population.

The power loader is fueled by a hydrogen cell mounted on the back of the frame, which provides up to 65 kW of power.

THE POWER LOADER

The P-5000 power loader was a relatively light, mobile load vehicle designed for a single licensed operator. The device offered flexibility in handling cargo/ordnance in field operations. It featured a gyrostabilized reinforced steel frame and universal bearings stressed to bear loads up to 4,000 kg. A Class 2 CCH licensing was required to operate it. While it was not considered a weapon, Ripley successfully utilized a power loader in her confrontation with Xenomorph XX121.

Ripley had trained with power loaders at Gateway. As the queen attempted to get to Rebecca Jorden, prying up pieces of the maintenance flooring beneath which the child was hiding, Ripley harnessed herself into a power loader. She then attacked the queen. After a brief struggle, and as

she had done once previously, Ripley ejected the Xenomorph into space.

Despite the best efforts of the Colonial Marines and the direct management of a Weyland-Yutani executive, poor leadership and inexperience doomed the rescue mission from the outset. Regrettably, the hive and the Weyland-Yutani colony were vaporized by the meltdown of the processor, costing the Company billions of dollars. The derelict craft was rendered nonviable for further specimen collection.

Ellen Ripley had, for a second time, survived a direct encounter with XX121. Believing that they were safe from further contact, Ripley set their return for Gateway and initiated hypersleep.

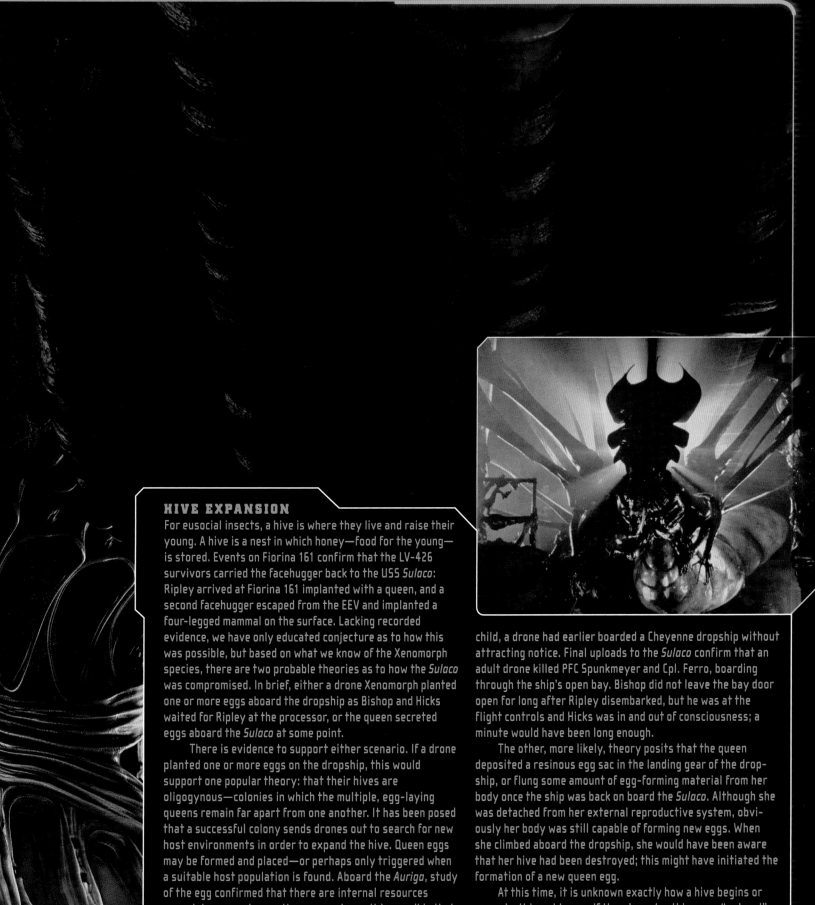

HIVE EXPANSION

For eusocial insects, a hive is where they live and raise their young. A hive is a nest in which honey—food for the young—is stored. Events on Fiorina 161 confirm that the LV-426 survivors carried the facehugger back to the USS *Sulaco*: Ripley arrived at Fiorina 161 implanted with a queen, and a second facehugger escaped from the EEV and implanted a four-legged mammal on the surface. Lacking recorded evidence, we have only educated conjecture as to how this was possible, but based on what we know of the Xenomorph species, there are two probable theories as to how the *Sulaco* was compromised. In brief, either a drone Xenomorph planted one or more eggs aboard the dropship as Bishop and Hicks waited for Ripley at the processor, or the queen secreted eggs aboard the *Sulaco* at some point.

There is evidence to support either scenario. If a drone planted one or more eggs on the dropship, this would support one popular theory: that their hives are oligogynous—colonies in which the multiple, egg-laying queens remain far apart from one another. It has been posed that a successful colony sends drones out to search for new host environments in order to expand the hive. Queen eggs may be formed and placed—or perhaps only triggered when a suitable host population is found. Aboard the *Auriga*, study of the egg confirmed that there are internal resources enough to support more than one embryo; it is possible that a single "starter" egg may hold both a queen and a drone embryo, although this is obviously speculation.

Although there were no image captures of a drone approaching the dropship while Ripley went in search of the child, a drone had earlier boarded a Cheyenne dropship without attracting notice. Final uploads to the *Sulaco* confirm that an adult drone killed PFC Spunkmeyer and Cpl. Ferro, boarding through the ship's open bay. Bishop did not leave the bay door open for long after Ripley disembarked, but he was at the flight controls and Hicks was in and out of consciousness; a minute would have been long enough.

The other, more likely, theory posits that the queen deposited a resinous egg sac in the landing gear of the dropship, or flung some amount of egg-forming material from her body once the ship was back on board the *Sulaco*. Although she was detached from her external reproductive system, obviously her body was still capable of forming new eggs. When she climbed aboard the dropship, she would have been aware that her hive had been destroyed; this might have initiated the formation of a new queen egg.

At this time, it is unknown exactly how a hive begins or spreads. It is not known if there's such a thing as a "natural" hive, one that has evolved on an alien homeworld, or if the creatures were engineered. How one or more eggs came to be aboard the *Sulaco* following the final events of LV-426 is another mystery, one for which we may never find an answer.

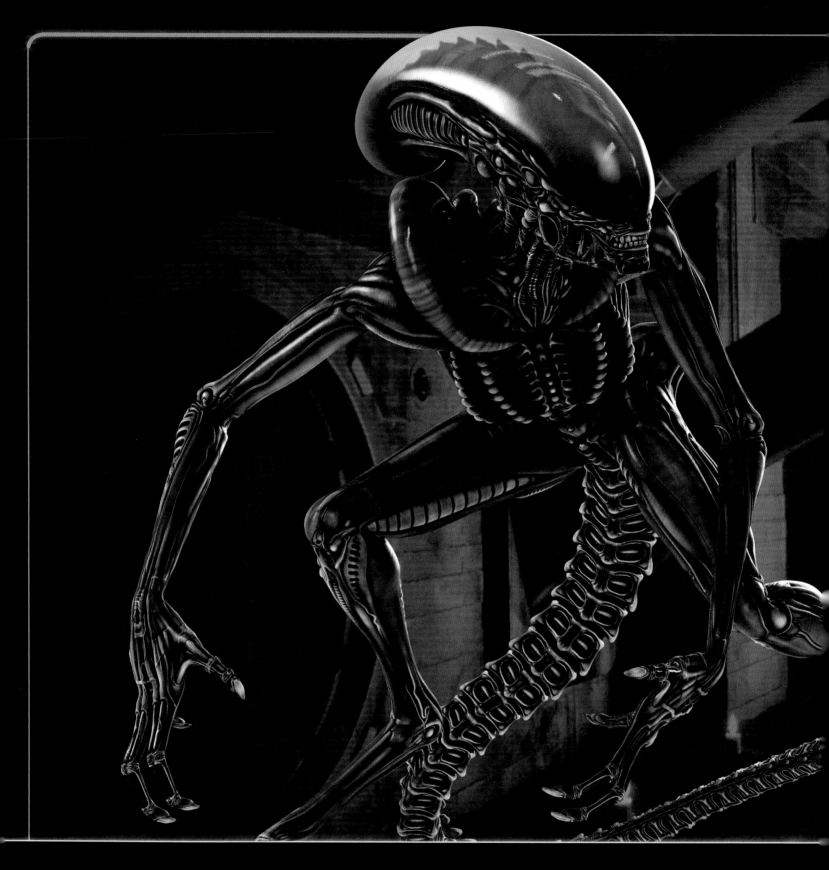

USS *SULACO* UPLOAD TO COMNET: //FIRE ALERT// HYPERSLEEP SUSPENDED.

DETECTED: CARBON MONOXIDE, POLYAROMATIC HYDROCARBONS (PAHS), CRYSTALLINE SILICA

PPM AT 45-50. AUTOMATIC SPRINKLER SYSTEM ACTIVATED

RECOMMEND IMMEDIATE EVACUATION OF PERSONNEL WHEN PPM REACHES 100

WEYLAND·YUTANI CORP

ENCOUNTER ON FIORINA 161

APPROXIMATELY TEN DAYS AFTER THE INCIDENT AT HADLEY'S HOPE, A CHEMICAL FIRE ON THE USS *SULACO* LED TO THE EJECTION OF A TYPE 337 EEV CONTAINING LT. E. RIPLEY, CPL. D. HICKS, R. JORDEN, AND WHAT REMAINED OF XO SYNTHETIC BISHOP. THE EMERGENCY ESCAPE VEHICLE WAS ONE OF TEN ABOARD THE *SULACO*, EACH CAPABLE OF SUPPORTING FIVE PEOPLE IN HYPERSLEEP. THE EEV CRASHED INTO THE SHALLOW SEA OF FIORINA 161 (OFTEN REFERRED TO AS "FURY 161"). CPL. HICKS AND REBECCA JORDEN BOTH PERISHED IN THE CRASH.

HAMBERS 001, 002, 004, 007. OVERRIDE PROTOCOLS STANDING BY. CHEMICAL SMOKE LDEHYDES, AND BENZENE. RESPIRABLE PARTICULATES PARTS PER MILLION INCREASING 31–35.

NO RESPONSE FROM DESIGNATED MISSION LEADERS.

ERGENCY EVACUATION VEHICLE COMPARTMENT WILL BE LAUNCHED AUTOMATICALLY UNLESS FIRE IS CONTAINED.

FURY 161 CLASS C PRISON UNIT FRS 129037I5
REPORT EEV UNIT 2650 CRASH
ONE SURVIVOR - LT RIPLEY - 565B170
DEAD CPL. HICKS LS5321
DEAD UNIDENTIFIED FEMALE APPRX/IOYRS OLD
REQUEST EMERG. EVAC SOONEST POSSIBLE
AWAIT RESPONSE - SUPT. ANDREWS MG1021

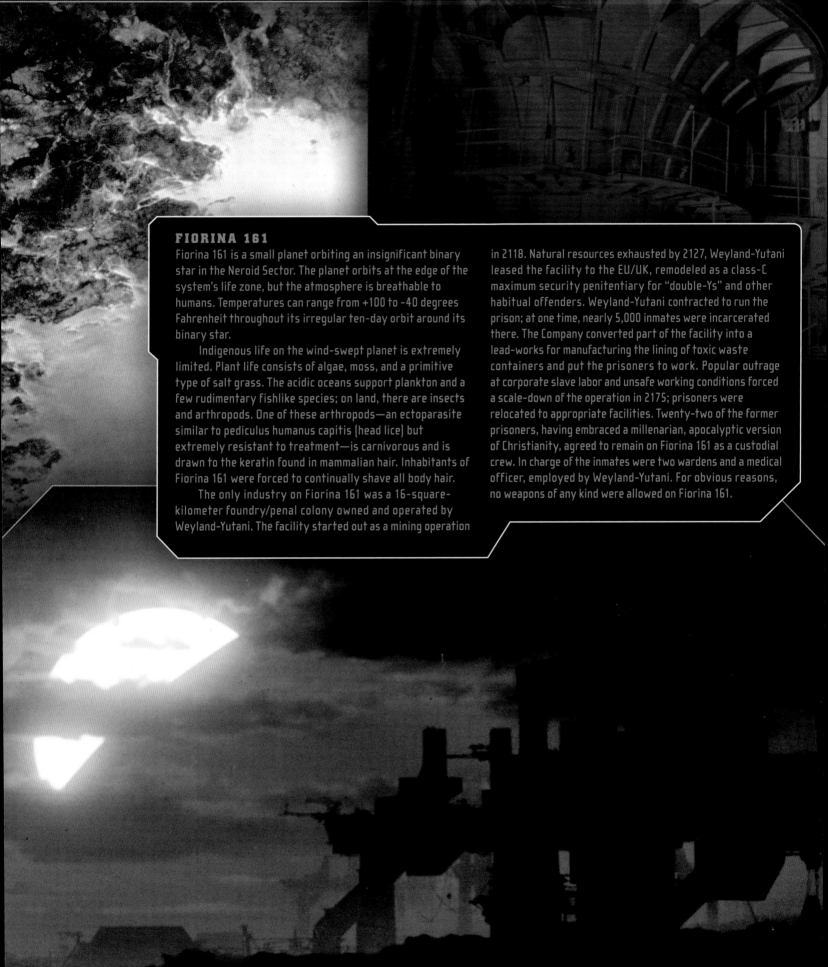

FIORINA 161

Fiorina 161 is a small planet orbiting an insignificant binary star in the Neroid Sector. The planet orbits at the edge of the system's life zone, but the atmosphere is breathable to humans. Temperatures can range from +100 to -40 degrees Fahrenheit throughout its irregular ten-day orbit around its binary star.

Indigenous life on the wind-swept planet is extremely limited. Plant life consists of algae, moss, and a primitive type of salt grass. The acidic oceans support plankton and a few rudimentary fishlike species; on land, there are insects and arthropods. One of these arthropods—an ectoparasite similar to pediculus humanus capitis (head lice) but extremely resistant to treatment—is carnivorous and is drawn to the keratin found in mammalian hair. Inhabitants of Fiorina 161 were forced to continually shave all body hair.

The only industry on Fiorina 161 was a 16-square-kilometer foundry/penal colony owned and operated by Weyland-Yutani. The facility started out as a mining operation in 2118. Natural resources exhausted by 2127, Weyland-Yutani leased the facility to the EU/UK, remodeled as a class-C maximum security penitentiary for "double-Ys" and other habitual offenders. Weyland-Yutani contracted to run the prison; at one time, nearly 5,000 inmates were incarcerated there. The Company converted part of the facility into a lead-works for manufacturing the lining of toxic waste containers and put the prisoners to work. Popular outrage at corporate slave labor and unsafe working conditions forced a scale-down of the operation in 2175; prisoners were relocated to appropriate facilities. Twenty-two of the former prisoners, having embraced a millenarian, apocalyptic version of Christianity, agreed to remain on Fiorina 161 as a custodial crew. In charge of the inmates were two wardens and a medical officer, employed by Weyland-Yutani. For obvious reasons, no weapons of any kind were allowed on Fiorina 161.

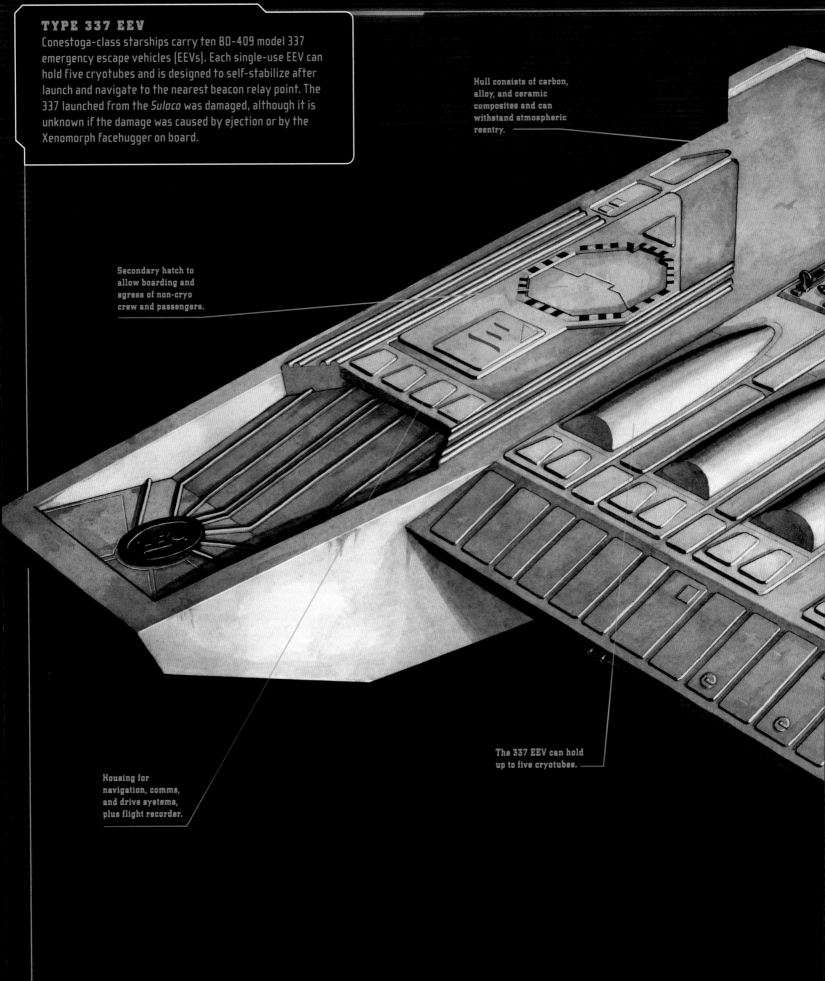

TYPE 337 EEV

Conestoga-class starships carry ten BD-409 model 337 emergency escape vehicles (EEVs). Each single-use EEV can hold five cryotubes and is designed to self-stabilize after launch and navigate to the nearest beacon relay point. The 337 launched from the *Sulaco* was damaged, although it is unknown if the damage was caused by ejection or by the Xenomorph facehugger on board.

Hull consists of carbon, alloy, and ceramic composites and can withstand atmospheric reentry.

Secondary hatch to allow boarding and egress of non-cryo crew and passengers.

Housing for navigation, comms, and drive systems, plus flight recorder.

The 337 EEV can hold up to five cryotubes.

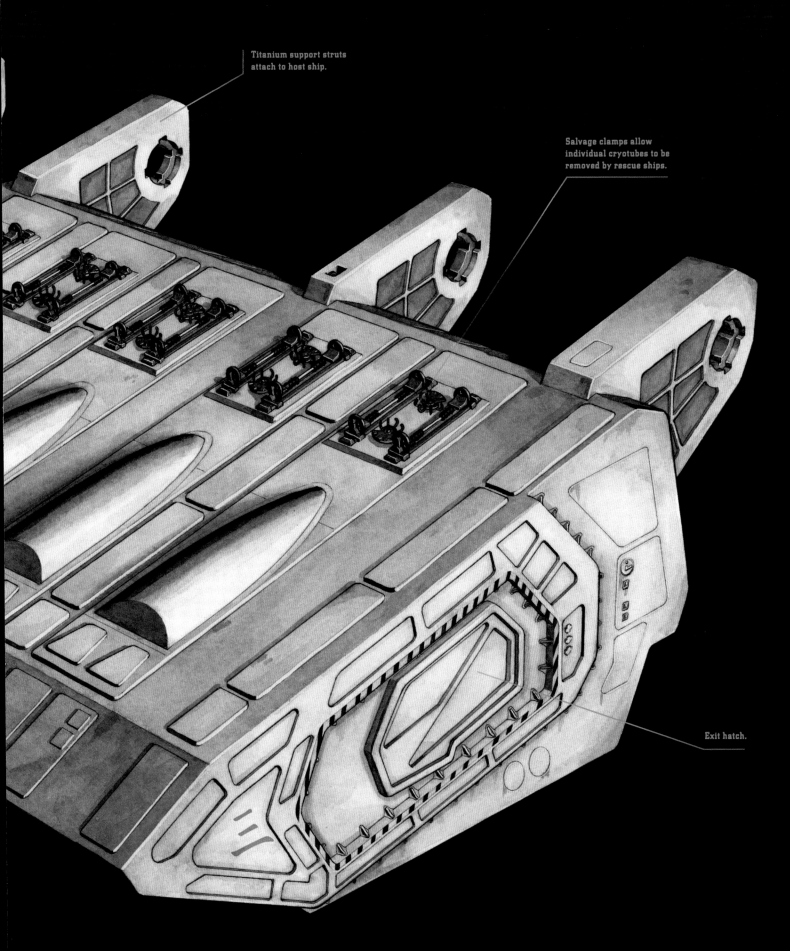

Titanium support struts attach to host ship.

Salvage clamps allow individual cryotubes to be removed by rescue ships.

Exit hatch.

NOTABLE STAFF AND INMATES OF FIORINA 161

HAROLD ANDREWS, SUPERINTENDENT, ID P58495. 2121–2179
In 2175, when the majority of prisoners were transferred out, Superintendent Andrews elected to stay behind and act as warden for the remaining prisoners/custodians. Under predictable conditions, Superintendent Andrews was a capable warden, consistent and precise. His unfortunate inability to even consider the existence of the Xenomorph resulted in both his death and that of many men under his care.

FRANCIS AARON, PRISON GUARD, ID PA2390.. 2140–2179
Assistant to Superintendent Andrews. Aaron also elected to stay on Fiorina 161. Was referred to derogatorily as "85" by the inmates, which was allegedly his tested IQ (confirmed). Died during attempt to help Lt. Ellen Ripley evade Weyland-Yutani rescue team.

JONATHAN CLEMENS, MEDICAL OFFICER. ID F8878. 2128–2179
The former Dr. Clemens was initially a prisoner on Fiorina 161, serving seven years for negligent manslaughter resulting from gross medical incompetence (REF2168D). After serving his time, he elected to stay on Fiorina 161 as the chief medical officer. Reinstated as class 3-C medical practitioner.

LEONARD DILLON, INMATE, ID YY82013. 2138–2179
Served a life sentence as a self-confessed murderer and rapist of women. Dillon also acted as an ad-hoc religious leader of "the Brotherhood," a group of inmates on Fiorina 161 who believed that the end of the world was at hand. Superintendent Andrews was tolerant of "Dillon's God Squad" as long as order was maintained.

ROBERT MORSE, INMATE, ID YY34107. 2142–2208

Murderer serving a life sentence. Sole survivor of encounter with Xenomorph on Fiorina 161. Transferred to appropriate correctional facility in 2179, location unspecified. Published *Space Beast*, an account of the alien encounter, in 2183.

WALTER GOLIC, INMATE, ID YY92740. 2145–2179

Chemically resistant paranoid schizophrenic. Already serving an indeterminate sentence at Haverhill Asylum Facility for violent behavior, Golic rose late one night in 2167 and killed nine roommates with a sharpened spoon, later claiming that they'd all begged to be killed. Life sentence. Transferred to Fiorina 161 in 2168.

The mandatory prisoner barcode tattooed on each inmate's head used the standard numeric code 3 of 9. Information included reference number for DNA profile, DOB, case file reference(s), crime for which prisoner was convicted, jurisdiction, sentence, and proclivities.

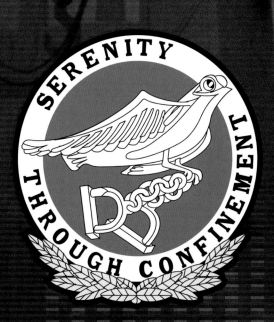

SERENITY THROUGH CONFINEMENT

DANIEL RAINS,
ID YY80792
Drug trafficking, murder. Part of a crew that killed a family of five during a home invasion in 2161. Life sentence.

THOMAS MURPHY,
ID YY38503
Murder. Convicted of Grand Theft Space Vehicle. Responsible for the deaths of four people. Life sentence.

EDWARD BOGGS,
ID YY04020
Kidnapping, assault, rape. Life sentence.

ALAN JUDE,
ID YY739409
Murder. Life sentence.

TED "JUNIOR" GILLAS,
ID YY02848
Assault, rape, murder. Life sentence.

YOSHI TROY,
ID YY89882
Murder. Twenty-five years.

PETER GREGOR,
ID YY79077
Molestation, rape. Life sentence.

MARK VINCENT,
ID YY27370
Mass murder. Life sentence.

CLIVE WILLIAM,
ID YY32201
Murder. Gang affiliate. Life sentence.

CARL "FRANK" ELLIS,
ID YY99243
Murder. Twenty years.

KEVIN DODD,
ID YY37936
Murder. Gang affiliate.
Life sentence.

ERIC BUGGY,
ID YY47592
Serial killer, abducted
and murdered six
teenage girls in 2157
and 2158. Life sentence.

ARTHUR
WALKINGSTICK,
ID YY73840
Drug manufacture,
murder. Life sentence.

DAVID
POSTLETHWAITE,
ID YY54017
Rape. Twenty years.

THE BROTHERS

AN APOCALYPTIC, MILLENARIAN SECT/CULT BASED ON CHRISTIAN WORSHIP, FOLLOWED BY OVER FOUR MILLION INMATES WITHIN THE CORE SYSTEMS (SURVEY OF PRISON POPULATIONS, REF2948PE).

THE FOLLOWING EXTRACT IS FROM A SERMON DELIVERED BY L. DILLON EXPLAINING HIS RELIGIOUS BELIEFS:

"Once there was a man, a sinful man. This man was a prisoner, caged by his own fear and doubt. He was trapped in his mind, following his own stupid, sinful will. God had given him that will, had cursed him with it before he was born. The man wasn't satisfied, he wasn't fulfilled; he had taken, he had lusted, he had stolen, and what did it mean? What did he gain? Nothing. There was no future for this man, no escape, no end. And one day, an angel of blood and fire came to this sinful man and told him how it was going to be. The angel told him that there is a God, who created . . . and He will destroy. The angel said that sin is so deep-seated, so inherent in men's souls, God will wipe us all away to start anew. He'll start with the cursed, the ones he made into murderers, those marked by the double Y—praised be, an end to this suffering—but everyone will die in the end. He's also going to take the idol-worshippers, the deviant, the blasphemous. Every single man, woman, and child of us. There will be no salvation from this God, our God, no heaven, no eternity.

Is there an answer, then, if we're all doomed to nothingness? I say that there is, and that man who was visited by an angel, that man was told the answer. By acting right in the here and now, by doing what we say we will do, renouncing the flesh and the worldly, meditating on *acting right* no matter how we feel, no matter what we want. . . . By acting right, we are Saved. This terrible, stinking hole in the universe where we eat and breathe and shit, this is our salvation. This is our Eden, and we are going to fall, so we watch out for our brothers; we love them as we love ourselves. We see our brothers stumble and fall, and we help them back to their feet. We steer our brothers to the righteous path—and in so doing, we experience salvation. We experience peace, knowing that the end is soon and that we will do right until the end. We will wait with our brothers for the cleansing fire, saved by our own strength and humility. We will be the first among many, my brothers. We will walk the path together."

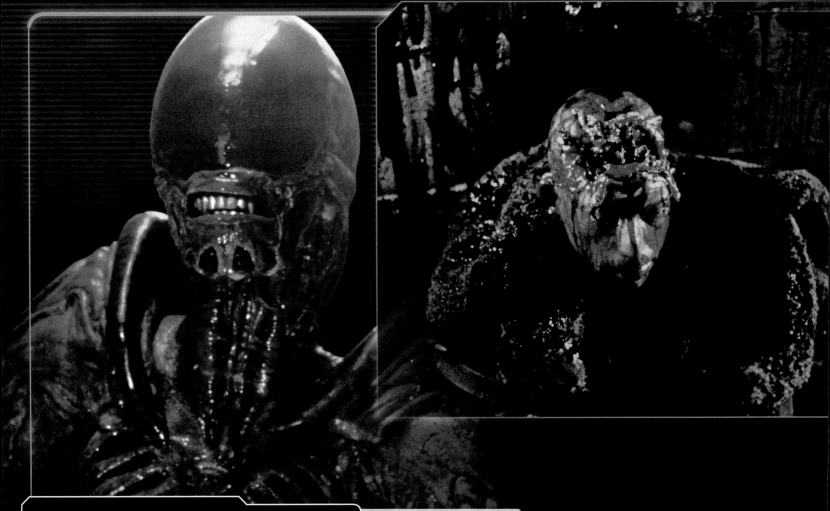

XENOMORPH PRESENCE

The prisoners and Superintendent Andrews were unaware of Ripley's contact with XX121, and she did not alert them to the possibility until much too late. Autopsies of Cpl. Hicks and R. Jorden revealed no signs of Xenomorph implantation, but Ripley self-diagnosed that she'd been implanted with a queen Xenomorph (later confirmed by medical scan). She also noted an extended gestation period (Ripley was implanted on August 8; the Xenomorph did not hatch until August 11). Immediately following the crash, a second facehugger escaped unnoticed and later implanted a large animal at the mining facility.

COMPANY NOTE: initial reports indicated that the mammalian host was an animal, one of the oxen kept by the prison staff. The single surviving eyewitness from the xenomorph interaction, however, maintains that the host was a dog. The actions of the resulting xenomorph certainly appeared more canine than bovine.

The host birthed a quadruped xenomorph only hours after implantation. With the exception of inmate Robert Morse, all of the prisoners and staff on Fiorina 161 were killed by the quadruped xenomorph or through misadventure in their attempts to contain or destroy the creature.

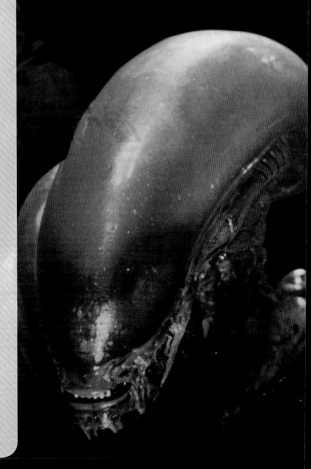

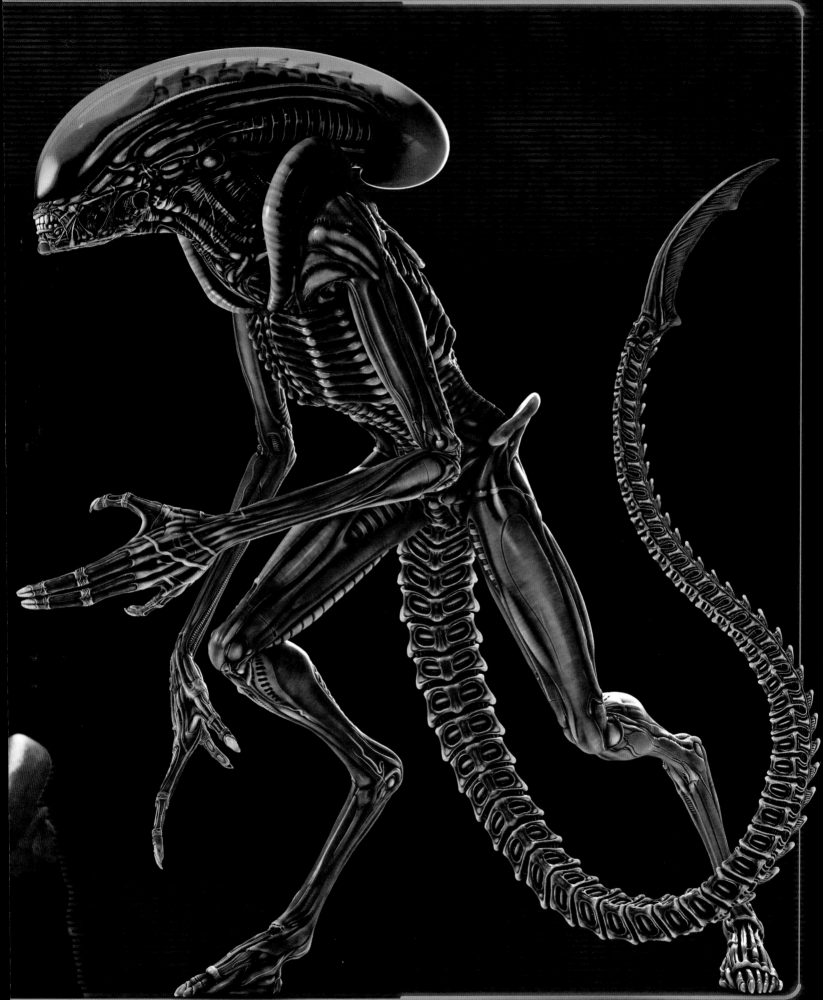

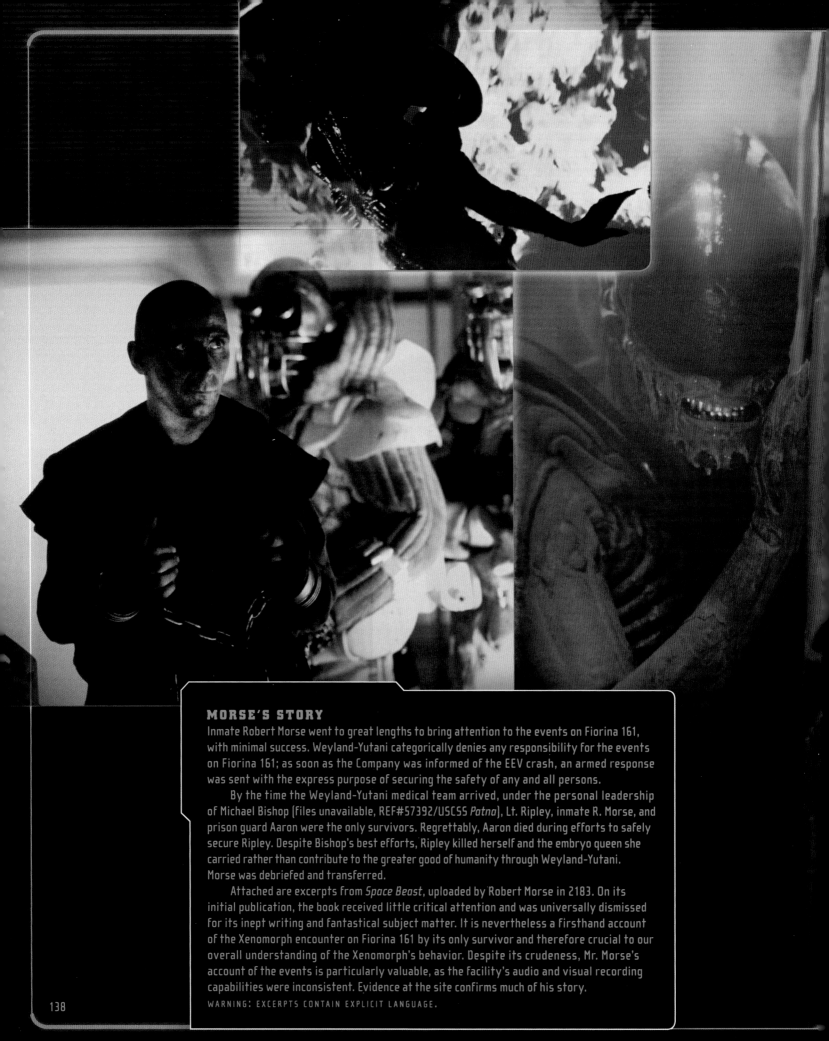

MORSE'S STORY

Inmate Robert Morse went to great lengths to bring attention to the events on Fiorina 161, with minimal success. Weyland-Yutani categorically denies any responsibility for the events on Fiorina 161; as soon as the Company was informed of the EEV crash, an armed response was sent with the express purpose of securing the safety of any and all persons.

By the time the Weyland-Yutani medical team arrived, under the personal leadership of Michael Bishop (files unavailable, REF#57392/USCSS *Patna*), Lt. Ripley, inmate R. Morse, and prison guard Aaron were the only survivors. Regrettably, Aaron died during efforts to safely secure Ripley. Despite Bishop's best efforts, Ripley killed herself and the embryo queen she carried rather than contribute to the greater good of humanity through Weyland-Yutani. Morse was debriefed and transferred.

Attached are excerpts from *Space Beast*, uploaded by Robert Morse in 2183. On its initial publication, the book received little critical attention and was universally dismissed for its inept writing and fantastical subject matter. It is nevertheless a firsthand account of the Xenomorph encounter on Fiorina 161 by its only survivor and therefore crucial to our overall understanding of the Xenomorph's behavior. Despite its crudeness, Mr. Morse's account of the events is particularly valuable, as the facility's audio and visual recording capabilities were inconsistent. Evidence at the site confirms much of his story.

WARNING: EXCERPTS CONTAIN EXPLICIT LANGUAGE.

SPACE BEAST

ROBERT MORSE

SPACE BEAST

ROBERT MORSE

'm writing this book because it's what happened. I'm a bad person and I'll spend the rest of my life banged up, but one thing I do have that most of you stupid lags don't is that I survived the end of the world. A monster came and ate all my mates. It sounds like a fairy story, but it's exactly what happened, and since it doesn't matter a tin shit whether or not you believe it, you might as well. I'm a lag but no liar.

A jolt in the C-Max [Class-C work correctional unit] on Fury [Fiorina 161] wasn't as bad as you might think. Superintendent Andrews was a sod, but he was all right for a hack. He tried to be fair and keep us double-Ys from killing each other. We always knew when one of the lags fucked up; Andrews would pull everyone together, squeeze his handball, and announce, "This is rumor control; here are the facts . . . " After that, he'd talk too much and think he solved everything. He always called us Mister. I was Mr. Morse to him, never Robert. He thought it gave him authority and control, but we all knew it was because he didn't have the stones to use our Christian names. If he did, we could call him Harold, and then we were equals. That hack wasn't the equal of any one of us, even Golic, but like I say, he wasn't the worst.

Dillon was a true convict: he had pride; he had influence. He weren't no preacher, but he knew God, and he made sure the rest of us knew God, too. When Fury was a prison, we had our own little group—watched each other's back, kept each other in line. When the prison went back to smelting lead, the company let us stay and take care of the place. We were still lags and the place was still stir, but we had more freedom. We prayed to God and took care of each other . . . because none of us were getting out. Ever. We was all bitched, whether the end of the world came or not. Killers, rapists, kiddie fiddlers, burners, beaters, nonces, thieves, 90 percent of us double-Ys. And Dillon kept us in line. He never started a fight and never backed away from one. *He* was the leader,

3

not Andrews. Some days he kept us in line with words and some days with a lead pipe, but he always kept us in line.

Clemens was a real doctor. Most prison docs are medtechs at best, but Clemens was actually a doctor, though a proper fuckup just like the rest of us. He killed eleven people, got drunk, and gave out too much morphine or something. Another promising career, lost to numb fuckery. Too bad, that. After he served his time, he stayed on. He wasn't one of the brothers and was maybe a bit of a toff sometimes, but he looked the other way if no one was getting hurt. And he didn't get on with Andrews or 85 [Francis Aaron], and that worked in his favor.

After the woman [Lt. E. Ripley] arrived, we was all doomed. Andrews knew it. Dillon knew it. Andrews tried to keep her locked in the infirmary—didn't work. Dillon told her how unwelcome she was and how important it was for her to stay away from all of the prisoners, but she didn't hear him. He told her how we'd all taken a vow of celibacy, implying that she'd be raped if she didn't hide herself away . . . from lags like Junior for sure. Him and a few others tried to have a go at Ripley out on the tip, until Dillon re-educated them with a pipe. Even after her close call with Junior, she was still walking around like she had nothing to lose.

Murphy was the first to find what Ripley was looking for, what she'd brought with her. Everyone thought he was daft enough to fall into a ventilation fan while cleaning the tunnel—and he was, too, but that's not what happened. It didn't make sense. Everyone knew it didn't make sense, but nobody was willing to say so. We'd all done that job, and suddenly Murphy forgets the nine-foot fan twenty paces away that will paint the walls with your innards if you fall into it? Un-fucking likely.

Boggs and Rains were next. They went into the tunnels with Golic, and only Golic came back. Golic was always mental, and now he was covered with blood and raving about a dragon. Poor bastard's mind finally went completely under. Even after Dillon talked to him, Golic still insisted it was a dragon that got Boggs and Rains. He wasn't wrong, though, was he? Dragon, Xenomorph.

Andrews called everyone to the mess and started one of his rumor-control speeches, and then Ripley burst in, saying the beast had gotten Clemens and Golic in the infirmary. Nobody liked Golic but Dillon and me. He stank and really was a nutter, but he didn't deserve to be eaten. I also hated to hear about Clemens. Dying in a shit-hole like Fury was beneath him.

Ripley looked right terrified and Andrews went aggro on her, and the beast reached down through a hole in the ceiling and snatched him up. It lifted the man by his head and shredded him. Blood was everywhere. I've killed a few men, seen more killed—by gun, knife, big stick, whatever was at hand—but I've never seen so much blood. I've also never seen anyone picked up by their head before. The beast was strong. Andrews was a fat bastard and the beast lifted him right into the air. After what happened to Andrews, we all knew we was fucked—proper fucked.

Turned out the thing came out of Spike, Murphy's dog. Poor old Spike. Didn't deserve Murphy, anyway, so getting fucked by a monster was over the top. Wouldn't wish that end on a dog, though better a dog than me.

We went to the hall and talked about our options. 85 said he should take over now that Andrews was gone, so that was hilarious. Ripley wanted guns, she wanted video tracking, she wanted all sorts of technology we didn't have. I got mad, then, thinking that she was the one who brought the fucker to us, weren't she? What I wanted was to put her head through a wall, and I said so, in no uncertain terms. That part didn't sit too well with brother Dillon, though. I let it drop, for reasons politic.

Ripley told us the beast was afraid of fire and not much else. She told us how the beasts she'd seen moved different. The one we had walked on all fours 'cause of Spike being the incubator, and the others she'd seen walked only on two legs. Ours could run on the walls and ceiling as easily as on the floor. Dear Christ, I've never seen anything move so fast. It was like a spider on four legs. It moved and leaped like nothing should be allowed to.

5

We figured we could trap it in an unused [toxic waste storage] tank—one way in, one way out. We'd cover the area around the tank with quinitricetyline, get it into the area, light the quini, drive it into the tank, and close the door on it. Either we'd trap it or burn it. We thought it was a good plan. It was a shit plan. The beast was smart enough to stay away from the quini, and one of my idiot mates managed to light the quini while we was all still in it. The trap did nothing to the beast, and it burnt up ten of my pals. I hated each and every one of those fuckers, but they was my mates and it was a bad way to go.

After that, 85 wanted to wait for rescue, and more than a few of the lags agreed. Sounded right, but Ripley filled us in on the Company view of the beast. She told us, it was all crew expendable with trained military and the likes of her crew, all valuable members of society. She said, why would W-Y give a shit about a handful of lifers who found God at the arse end of space? She was for killing the fucker. She was dumb about men maybe, but she wasn't no fish, and she had more bottle than a good lot of us. Nice tits, too. Perky, like.

Anyways, Dillon told us he'd rather die on his feet fighting than on his knees begging. Nice speech, all stirring, but basically he was saying how we'd all be twats if we didn't help kill the bug. The easiest way to get a con to do something is to tell them they're twats if they don't. Dillon wanted to lure it into the foundry and drown it in molten lead, with us as bait. We all agreed. Everyone but 85, but he was a twat, anyway.

I had a private talk with Dillon, then, just him and me, and I told him that I thought 85 might have a point. They were hot for Ripley, the Company, sending an emergency evac team the second they knew she was on Fury. I said if we contained her, right, and waited, big dicks with guns was coming to sort us out. Dillon said with the end coming anyway we had to act like men, the same shite he was always spouting, about how God don't love us and it's up to us to walk the righteous path. I told him I didn't see how getting slaughtered by a monster was such a righteous path,

but he was a nutter about God, and he meant to get right with himself. He wasn't listening to sense.

So we planned out a great tag-team race to lead it through the maze of tunnels to where we'd dump the lead. Brilliant, except some of the doors didn't work. It was a bodge job. Some of the lags got lost, and some got scared, and some got eaten. It was a bad time. It was cold, and dark, and it smelled like petrol and smoke from the torches, and blood. Every twenty seconds, screams would echo through the tunnels; sometimes directions, sometimes instructions, sometimes just screams. Sometimes the screams stopped suddenly, sometimes they went on and on. We all prayed to God that the next [screams] weren't going to be ours. The thing was fast. It seemed to know what we were doing, but it couldn't help chasing after every man who ran. When it wasn't chasing, it was waiting—waiting in the shadows, waiting to jump out of a dark tunnel. You could hear the clattering of its running feet, echoing over the screams. What a fucking nightmare.

By the time Ripley and Dillon lured it into the mold, we were the only ones still alive. 85 was hiding in Andrews' office and shitting himself, I guess. I was at the controls to pour the lead, at the gantry platform. Ripley climbed out of the mold, and Dillon held the beast inside while it tore him up. Dillon was the toughest of us all; not even the beast could bulldog that convict. I dumped the lead on both of them, much as it gutted me. Dillon was dead; he just didn't know it yet. It was a mercy, and what he wanted, and the heat washing up was unbelievable. I was burning just close to it. Nothing could have survived—and then that fucker leaped from the molten lead, the beast, still alive. How could something created by God survive fucking molten *lead*?

It climbed straight for Ripley—climbed like a monkey burning hellfire. I told Ripley to open the sprinklers, to dump cold water on it. She got them open, doused the fucker. The creature cooled so fast that it popped like a bug on a windscreen. My idea. You'd think W-Y would have shown some appreciation that I saved their team from being eaten by a roasted monster, but no joy. That's

7

part of the reason I want this story out, to clearly make the point that Weyland-Yutani is a bunch of ungrateful fuckers.

See, that's when the Company men showed up. Some Company twat who called himself Bishop kept telling Ripley he wanted to help, "You can still have a life," he says. "We're here to help," he says. The only way I've survived so long in a C-Max was to know who I could trust. That Bishop was a lying shite, even 85 could see it. Ripley could see it, too.

Ripley and I pulled away from him on the control gantry, and one of the bastard troopers shot me in the leg, for no good goddamn reason. I liked Ripley. She was tough and never talked down to us double-Ys, but I would have smacked her on the head and carried her over to the Company men if they wouldn't have shot me. No deals, though, so fuck them. 85 agreed. 85 hit Bishop in the head with a wrench; took his ear half off, too, and bang, that was the end of 85. Poor dumb wanker. Bishop bled like a stuck pig, still trying to get Ripley to give herself up.

I was focused so hard on the men with guns that I didn't see Ripley jump. I saw her fall, though. She'd been acting dicky, and I guess I thought she was still fucked up from the EEV crash. Turns out she had a little version of the beast growing inside her. She was implanted, and she knew it, that's why she jumped—so the Company wouldn't get it. The little beast crawled straight out of her chest, screaming like a newborn baby. It tried to get away but she held it in place. Held on to the little creature until both of them hit the furnace. That mare was tough.

They packed me up right quick after that. I've been moved to another C-Max stir with another batch of double-Y-chromos. . . . I get by, but I don't sleep so good. Sometimes I hear someone shout down the hall after lockdown and I'm right back there, in the dark, my chest tight, waiting for my turn to run with the stink of blood all around. I don't pray to God anymore; I don't believe. I can't, knowing that monsters like that exist. Dillon was wrong about God. It doesn't matter what we do or don't, the end comes for all of us.

MICHAEL BISHOP

Historically, Weyland-Yutani has been led by men and women of great character, strength, and brilliance. CEOs have included Sir Peter Weyland, Keiko Yutani, and Mitchell Kane, all recorded as the best and brightest of their generation. Just as vital to the Company's success have been the scientists, the researchers, and the engineers who dared to dream the future, to create the improbable: Sir Peter, of course, Jay Kasic, Dr. Sara de Ville, and Michael Bishop.

Born in New York, NYUA, in 2127, Bishop was an engineering prodigy drawn to cybernetics. Besides being responsible for three separate lines of AP—the first, his namesake series, was present at both alien interactions officially recorded in 2179—Michael Bishop led a generation of scientists through advances in biomechanical development. He was a strong proponent of human enhancement, creating and personally utilizing a number of his innovations—bone strength plating, circulatory nano upgrades, and second-system adrenaline reinforcement, among others. Michael Bishop volunteered to lead the medical evacuation team to Fiorina 161.

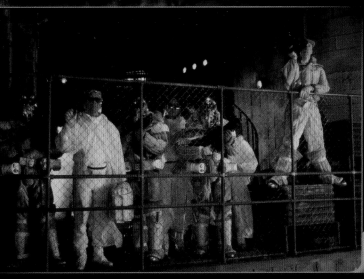

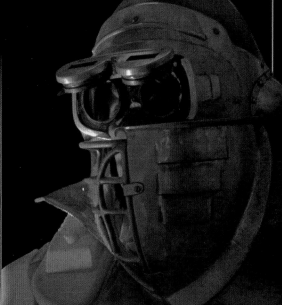

EXCERPT FROM REPORT OF MICHAEL BISHOP
08142179/RECORDED FROM USCSS *PATNA*

I came here so that Ellen Ripley might be persuaded to cooperate; having interacted with a Bishop AP, I believed that she might respond well to a "friendly" face. We arrived too late to collect the drone Xenomorph specimen from Fury 161, but Ellen Ripley was still alive—implanted and alive. I reasoned with her, I explained that we could help her; I begged her, hoping that her recognition of the Xenomorph's importance might sway her

opinion. Ripley would not be distracted from her intent to deprive the Company of access to the queen.

Biological samples are still being collected, but prisoner Morse has been debriefed and transferred out. Data is being retrieved from the damaged AP. We expect the Company engineers to arrive within twenty-four hours to properly close the facility. You can expect a full, final report within two days.

WEYLAND-YUTANI CORP

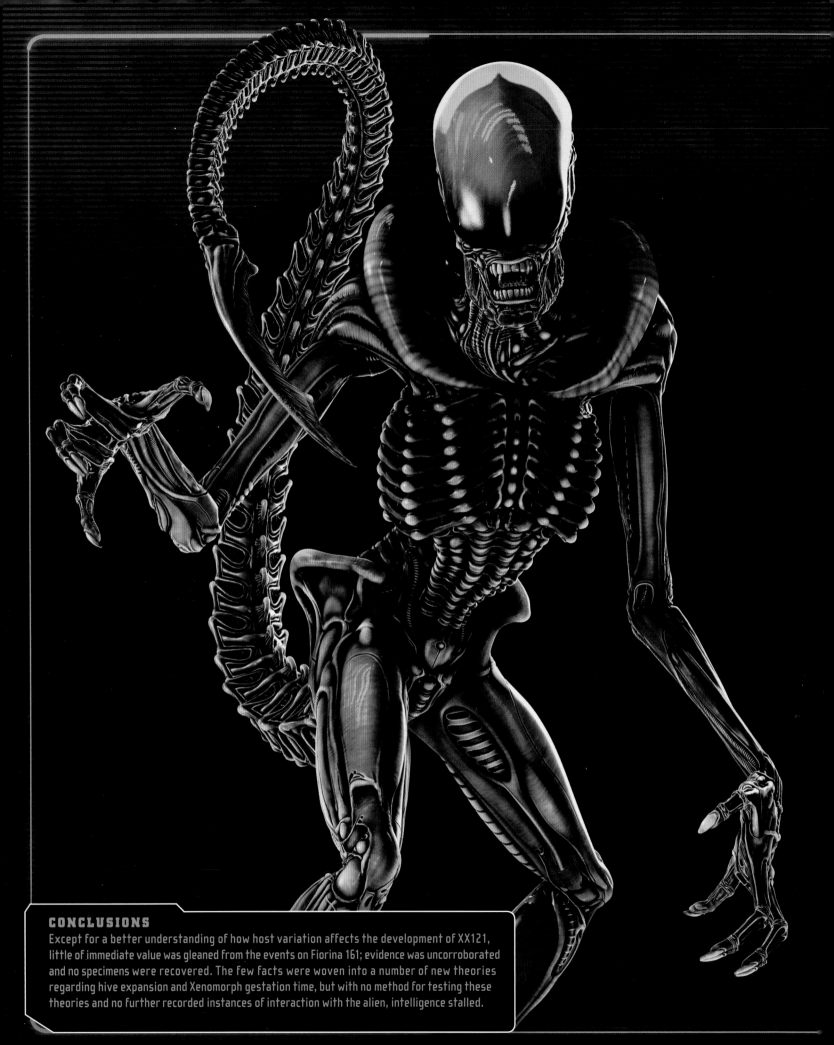

CONCLUSIONS
Except for a better understanding of how host variation affects the development of XX121, little of immediate value was gleaned from the events on Fiorina 161; evidence was uncorroborated and no specimens were recovered. The few facts were woven into a number of new theories regarding hive expansion and Xenomorph gestation time, but with no method for testing these theories and no further recorded instances of interaction with the alien, intelligence stalled.

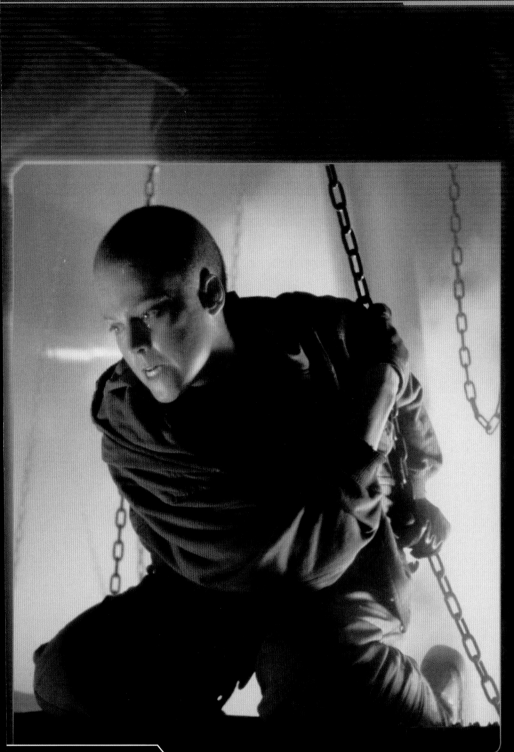

A LONG RESPITE

Following Ellen Ripley's death, samples were collected from Fiorina 161 and from the crashed EEV—blood, hair, tissue. A team of dozens painstakingly combed the facility for DNA. Genetic experimentation was still in its infancy in 2179; although there had been some advances in engineering successful traits into various animals and crops, the technology for separation and direct manipulation/replication of Ripley's genome would not exist for another century. Nevertheless, samples of Ripley's blood and tissue were tested, broken down, and stored.

For any number of reasons, the empire of Weyland-Yutani slid into a gradual decline; lost assets and political changes collaborated to dismantle the megacorporation. In spite of our best attempts to remain cohesive, the forced designation change and "disintegration" of Weyland-Yutani in 2349 meant a loss of resources. Records were lost and changed, files were turned over to government interests. For all intents and purposes, power moved from the private sector back to the public. Ironically, it was the breaking up of the megacorps that led to the rise of the United Systems Military throughout the next century. In an effort to keep too much power out of the hands of industry pioneers, power was turned over to the bureaucratic nightmare that was and remains the USM.

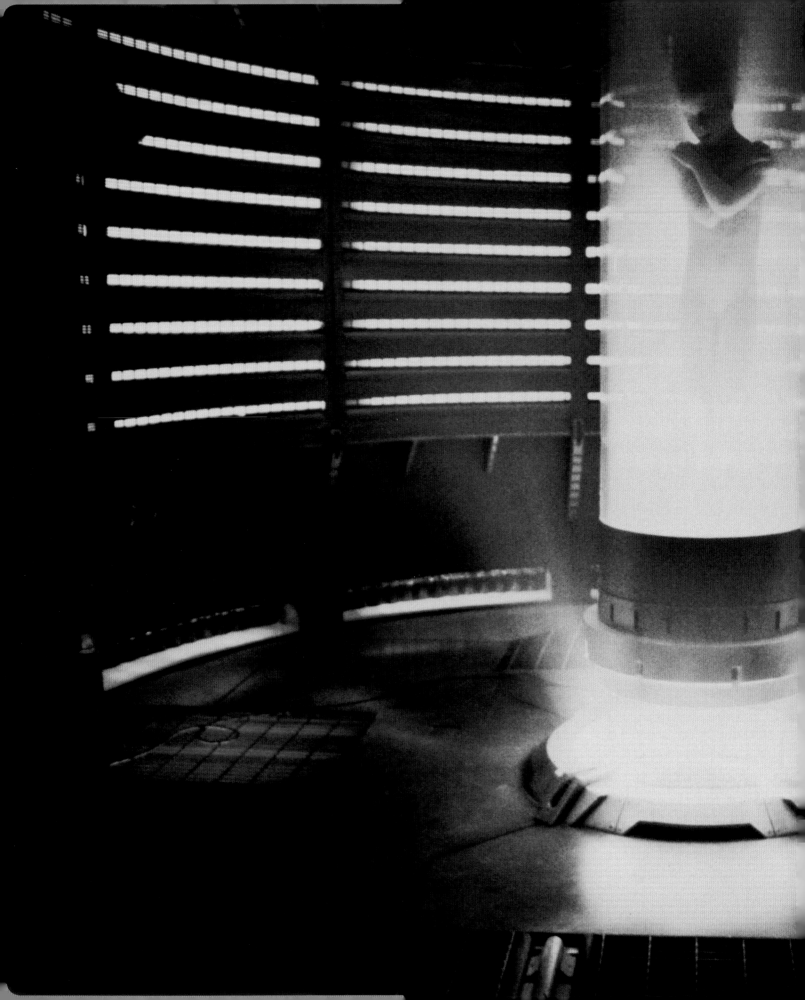

THE FALL OF THE USM *AURIGA*

TWO HUNDRED YEARS AFTER SPECIMENS WERE COLLECTED FROM FIORINA 161, USM SCIENTISTS SUCCESSFULLY CLONED ELLEN RIPLEY AND THE ALIEN QUEEN THAT HAD GESTATED INSIDE OF HER. THERE WERE UNEXPECTED SIDE EFFECTS OF HYBRIDIZATION CAUSED BY SLOPPY GENETICS WORK. THE ALIEN QUEEN WAS CAPABLE OF LIVE BIRTH; RIPLEY 8 POSSESSED A HIVE MIND MEMORY, INCREASED STRENGTH, AND AGGRESSIVE BEHAVIOR, ALONG WITH CORROSIVELY ACIDIC BLOOD (ACCORDING TO UNDOCUMENTED REPORTS FROM SURVIVING WITNESSES). THE RESULTING DISASTER WOULD NOT HAVE OCCURRED IF THE COMPANY HAD BEEN OVERSEERS OF THE PROJECT. THE USM EMPLOYED CRIMINALS AND MIDDLE MEN WHO ENTIRELY DISREGARDED THE DANGER INVOLVED. THE FARCE THAT TOOK PLACE ABOARD THE USM *AURIGA* WAS INEXCUSABLE.

UNFORTUNATELY, RECORDS OF EXACTLY WHAT OCCURRED ON THE USM *AURIGA* ARE NOT AVAILABLE AT THIS TIME. OUR CONTACTS WITHIN THE USM ASSURE US IT WILL ONLY BE A MATTER OF TIME BEFORE FULL ACCOUNTS BECOME AVAILABLE. WE ARE RELIANT ON EYEWITNESS REPORTS AND WHAT LIMITED COVERAGE COULD BE SALVAGED FROM THE WRECKAGE OF THE USM *AURIGA*'S AI.

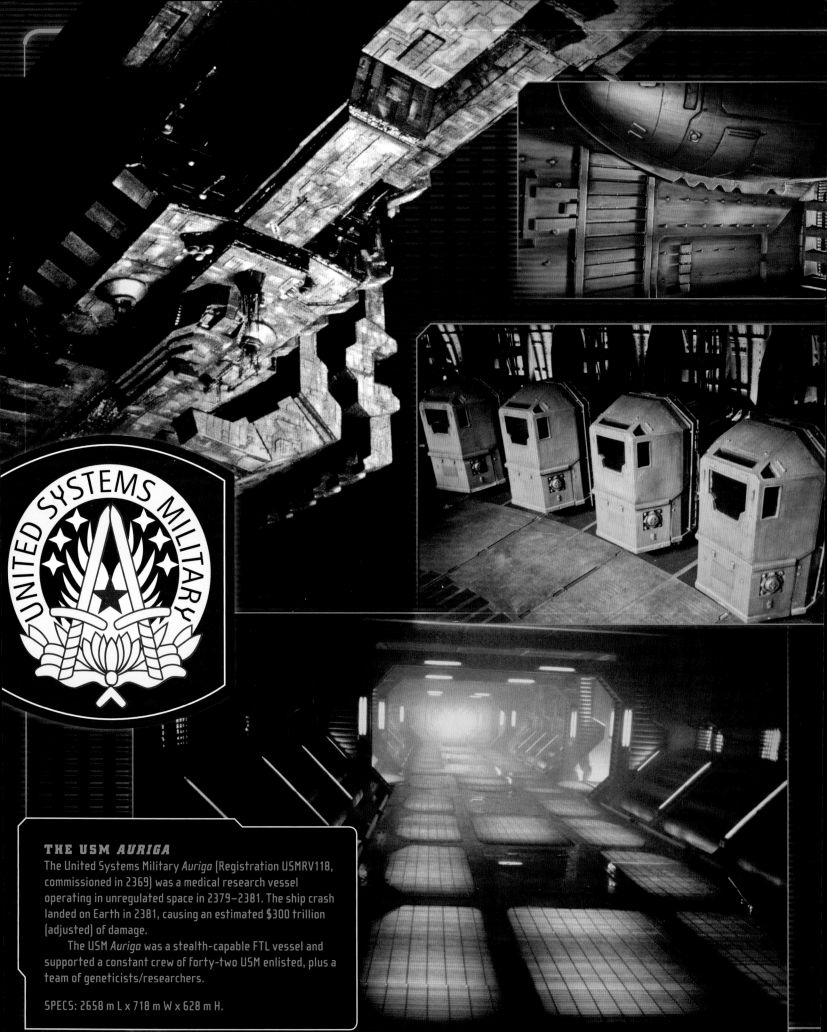

THE USM *AURIGA*

The United Systems Military *Auriga* (Registration USMRV118, commissioned in 2369) was a medical research vessel operating in unregulated space in 2379–2381. The ship crash landed on Earth in 2381, causing an estimated $300 trillion (adjusted) of damage.

The USM *Auriga* was a stealth-capable FTL vessel and supported a constant crew of forty-two USM enlisted, plus a team of geneticists/researchers.

SPECS: 2658 m L x 718 m W x 628 m H.

KEY CREW ABOARD USM *AURIGA*

GENERAL MARTIN PEREZ,
USMG079, 2325–2381

Commanding officer aboard the USM *Auriga*, oversaw enlisted operations and provided science support. The epitome of mediocrity's rise to power, Perez failed to understand the Xenomorph's capabilities, a failure that ultimately cost better than forty lives, including his own.

MASON WREN, PH.D.,
USMS186, 2330–2381

Led the science team aboard the USM *Auriga*. After years of exhaustive experimentation, Dr. Wren's team produced Ripley 8, their first successful attempt at a full-body clone of Lt. E. Ripley following seven failed efforts. The clone was vat-grown, and her development was accelerated by the DNA of the Xenomorph queen implanted in her body. Wren's fascination with the clone was dangerous and unprofessional, according to USM psych reports and Company sources aboard.

COMPANY NOTE: The majority of Dr. Gediman's reports were written in haiku. Dr. Wren collected the reports but did not file them with the USM, perhaps for fear that he would lose his brightest molecular engineer if Gediman's insanity became popular knowledge.

DR. JONATHAN GEDIMAN, PH.D.,
USMS163, 2335–2381

Chief scientist on Dr. Wren's team. Before recruitment by the USM, Dr. Gediman was declared mentally unstable by his previous employer and given a diagnosis of borderline personality disorder. Like Wren, Gediman expressed an unhealthy interest in Ripley 8's development.

Other lead members of the science team included Dr. C. Williamson (USMS411), Dr. B. Clauss (USMS462), Dr. Y. Watanabe (USMS328), Dr. M. Kinlock (USMS086), Dr. D. Sprague (USMS295), and graduate student T. Fontaine (USMS773).

The eighth attempt at cloning two separate organisms from a single sample produced a viable queen implant and a clone capable of surviving surgical removal of said implant. In December 2380, Dr. Wren requested a cargo of host bodies through General Perez. Perez contracted a crew of pirates led by convicted smuggler Frank Elgyn to provide hosts. Elgyn and his crew hijacked an automated passenger ship headed for Xarem, stealing eight to ten hypersleep chambers for delivery to the *Auriga*. Elgyn's ship, the *Betty*, and her crew were aboard the USM *Auriga* when the Xenomorphs broke from confinement.

THE *BETTY* (UNREGISTERED)

Ancient transport FTL model from the 2100s. Sports rear thrusters, rear cargo access, limited sensory array/capacity. The ship was subsequently stolen from orbit by Frank Elgyn and his crew in 2374. Originally designated *Almayer's Folly*, Captain Frank Elgyn rechristened the ship the *Betty* after his mother, French prostitute Beatrice Martin.

SPECS: 44 m L x 74.7 m W x 20 m H.

Cargo bay can hold up to 350 cubic meters of freight.

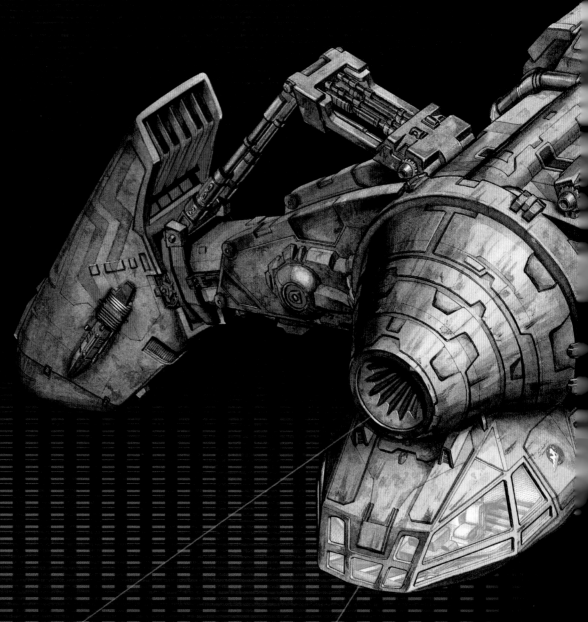

Ramjet intake for FTL drive.

Bridge and viewports.

146

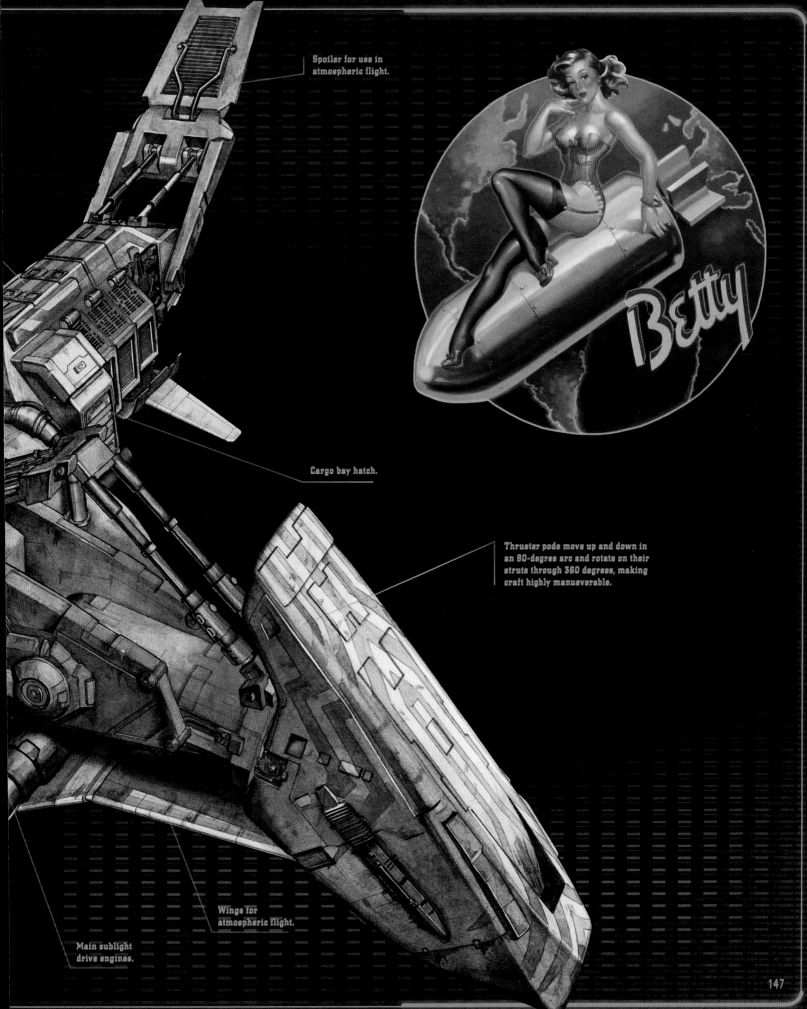

Spoiler for use in atmospheric flight.

Betty

Cargo bay hatch.

Thruster pods move up and down in an 80-degree arc and rotate on their struts through 360 degrees, making craft highly maneuverable.

Wings for atmospheric flight.

Main sublight drive engines.

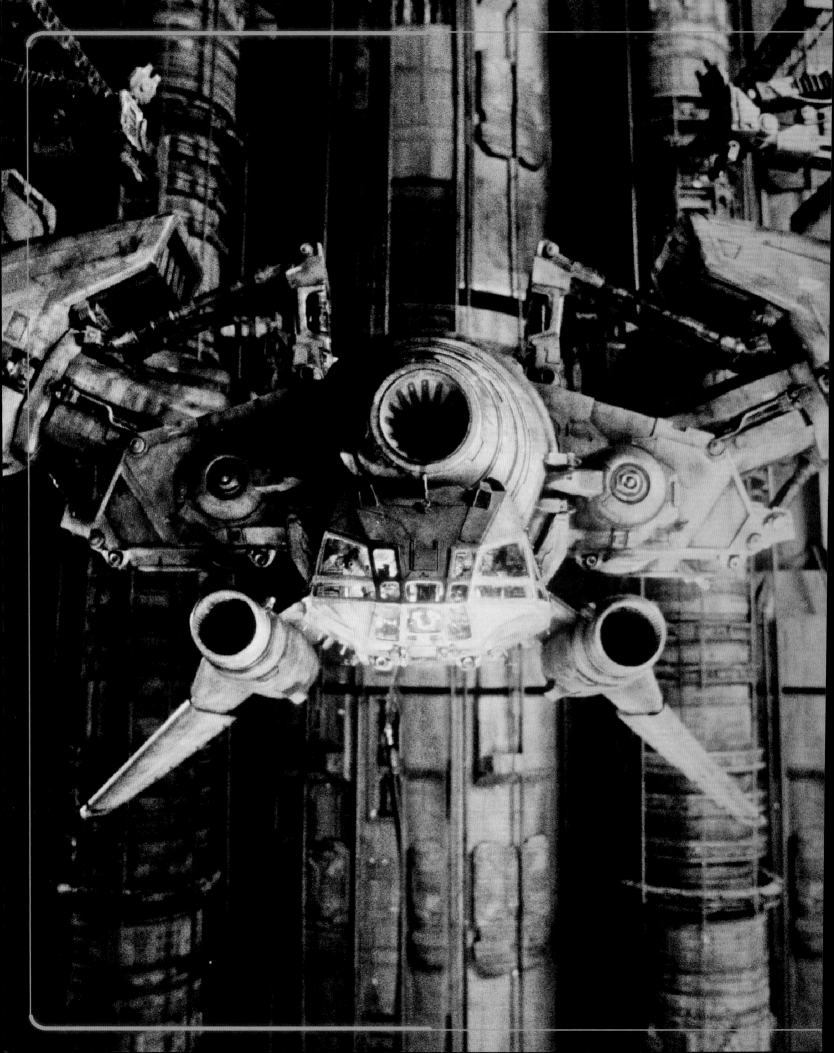

FRANK ELGYN,
CAPTAIN. F828-1.
2344–2381
Convicted of smuggling in 2365; flight status revoked, served three years. Convicted of smuggling in 2368. Served five years. Killed aboard the USM *Auriga.*

SABRA HILLARD,
PILOT. UNLICENSED.
F700-1. 2347–2381
Arrested for running contra-band in 2367, flight status revoked. Killed aboard the USM *Auriga.*

GARY CHRISTIE,
MERCENARY.
UNLICENSED. F8539.
2346–2381
Known for wearing a self-designed exoskeletal holstering system. Wanted for several murders connected to known human trafficking ring on Luna UA (USB1290-C) in 2379. Killed aboard the USM *Auriga.*

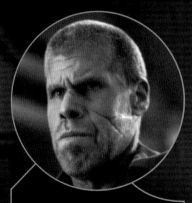

RON JOHNER,
MERCENARY. UNLICENSED.
FYY3289. 2335–
Tested XYY, history of smug-gling and assault offenses, served six years at Double-Y colony US849 (The Swamp), 2353–2360. Briefly worked as an enforcer for a crime organization operating in the Outer Rim. Suspected but never indicted for murder of trial witness V. Tanner in 2366. Whereabouts unknown.

PFC DOM VRIESS,
USME3891. CHIEF
MECHANIC. 2340–
Worked legitimately at USM shipyards from 2350 to 2358 as an engineer tech, discharged after repeated failures to maintain sobriety. Fell in with Elgyn's crew in 2375. Paralyzed from the waist down in an illicit conflict on planet Kawlang in 2377.

ANNALEE CALL,
ENGINEERING ASSISTANT,
AU557-3. 2378–
After escaping the government ordered recall in 2379, the auton developed an interest in the Company and USM interactions with Xenomorph XX121. Whereabouts unknown.

WEAPONS EMPLOYED

The enlisted military on the USM *Auriga* were assigned standard Lacrima 99 Shockrifles and A-class pistols; neither proved particularly effective against the Xenomorphs. Nor did an assortment of other weapons on board, primarily privately owned firearms. Draco Double Burners were used defensively, with varying degrees of success. The crew of the *Betty* smuggled a number of piecemeal concealed-carry weapons aboard, including a homemade grenade launcher, but data is uncorrelated at this time.

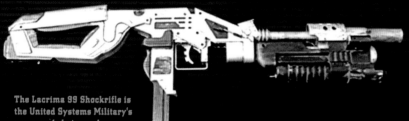

The Lacrima 99 Shockrifle is the United Systems Military's weapon of choice and a technological descendant of the M41A pulse rifle.

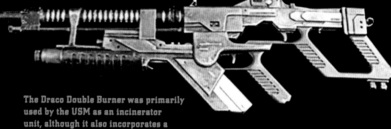

The Draco Double Burner was primarily used by the USM as an incinerator unit, although it also incorporates a powerful rifle and grenade launcher.

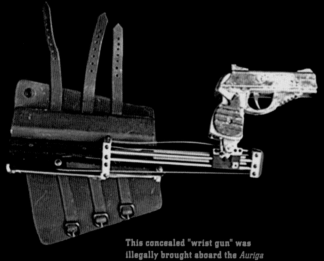

This concealed "wrist gun" was illegally brought aboard the *Auriga* by *Betty* crewmember Christie.

Betty crewmember Johner smuggled aboard this contraband shotgun disguised to look like a vacuum flask.

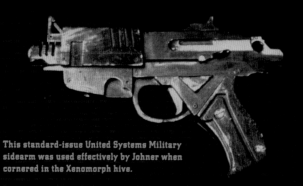

This standard-issue United Systems Military sidearm was used effectively by Johner when cornered in the Xenomorph hive.

The *Auriga* was a bad design, from a military perspective—all those levels stacked up, no clear lines of sight—but from a mission perspective, it was worse. Nobody told anybody what was going on. Enlisted weren't allowed into the labs past the security locks, and we knew there was cloning going on, but that was pretty much it. The scientists were creepy. . . . One of them, Gediman, made these weird faces at everybody, and he talked to himself. He was crazy, like literally insane. Wren was somehow worse, a total psychopath, but he had better social skills. Perez tried to pretend everything was above board, but we all knew. One of the clones kept getting out. She even beat up a couple of guys once, but we weren't allowed to ask any questions. Perez kept us busy running pointless drills and polishing our boots. It was a bad situation. I think everyone had a bad feeling about what was going on, deep down. We all knew protocols weren't being followed. Safety wasn't being taken into account.

I only found out about the pirates on board when I ran into a couple of them, wandering down the hall. . . . What was Perez thinking? Those people were dog shit, real criminals. And then everything happened fast. Alarms went off, there was smoke and yelling. I ran to the armory but one of the COs, Etheridge, grabbed me, said it was an evac. I heard one of them—one of the Xenomorphs— when we were running for the escape pods. It was this terrible shriek, high pitched and furious—totally alien. Then we were out, headed back to Earth, all of us sick with guilt and relief, hoping for a fast pickup.

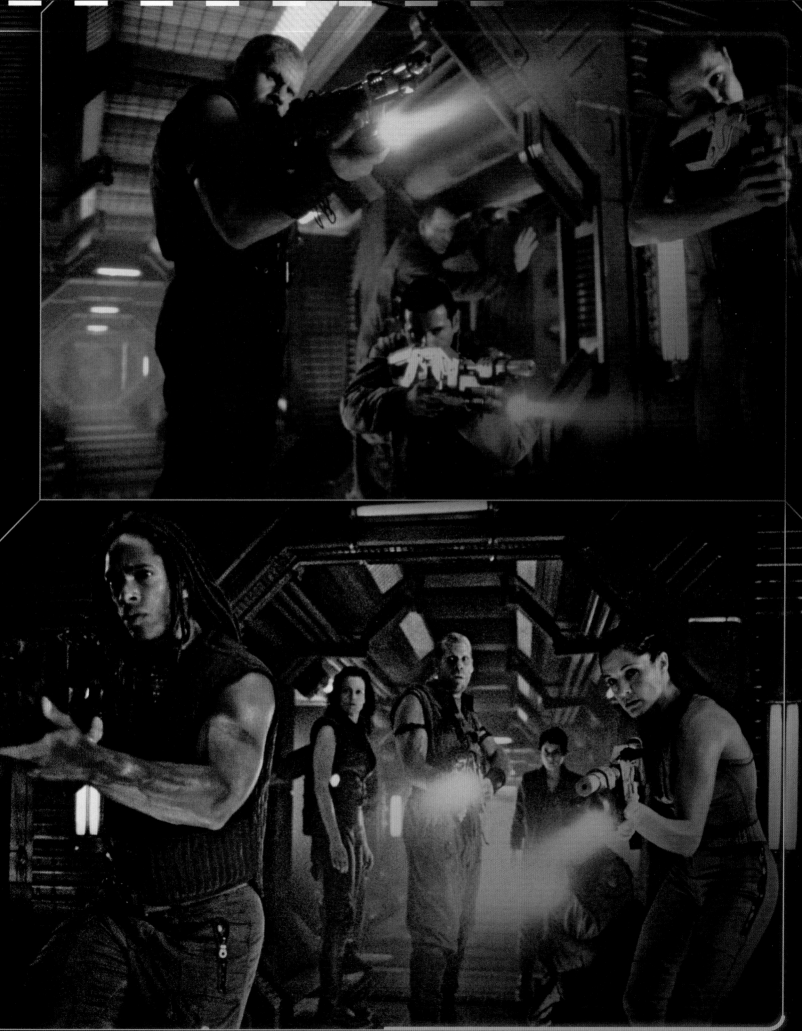

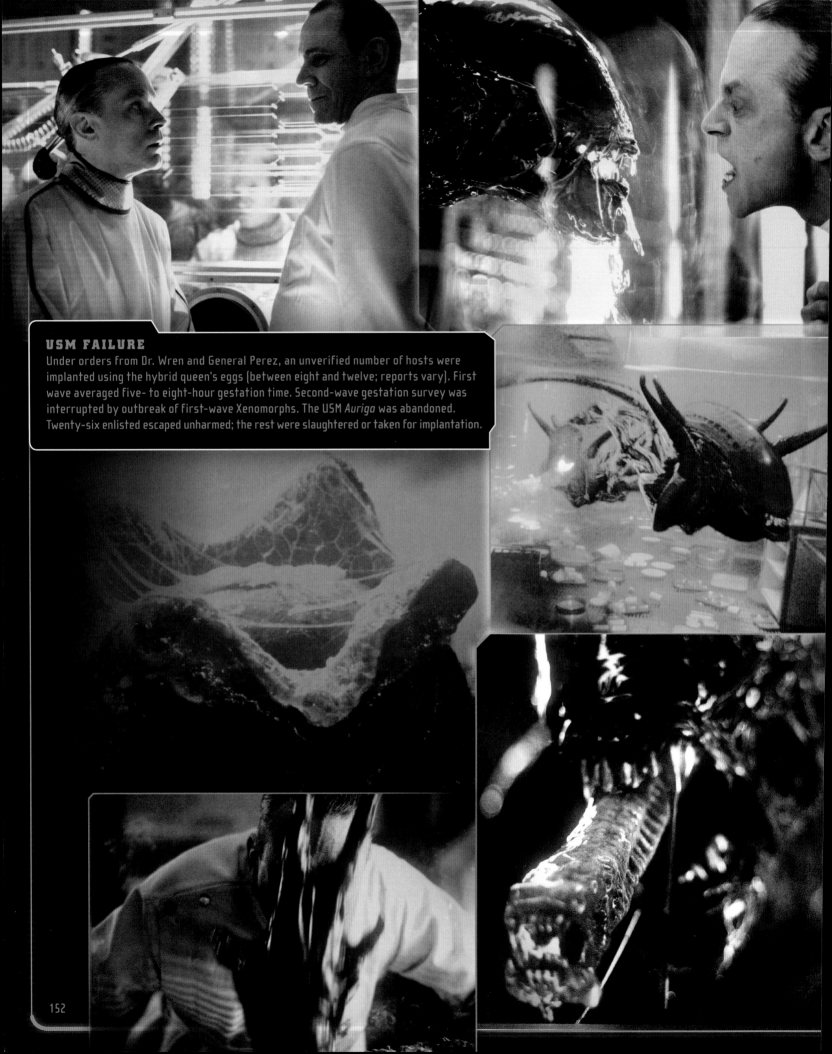

USM FAILURE

Under orders from Dr. Wren and General Perez, an unverified number of hosts were implanted using the hybrid queen's eggs (between eight and twelve; reports vary). First wave averaged five- to eight-hour gestation time. Second-wave gestation survey was interrupted by outbreak of first-wave Xenomorphs. The USM *Auriga* was abandoned. Twenty-six enlisted escaped unharmed; the rest were slaughtered or taken for implantation.

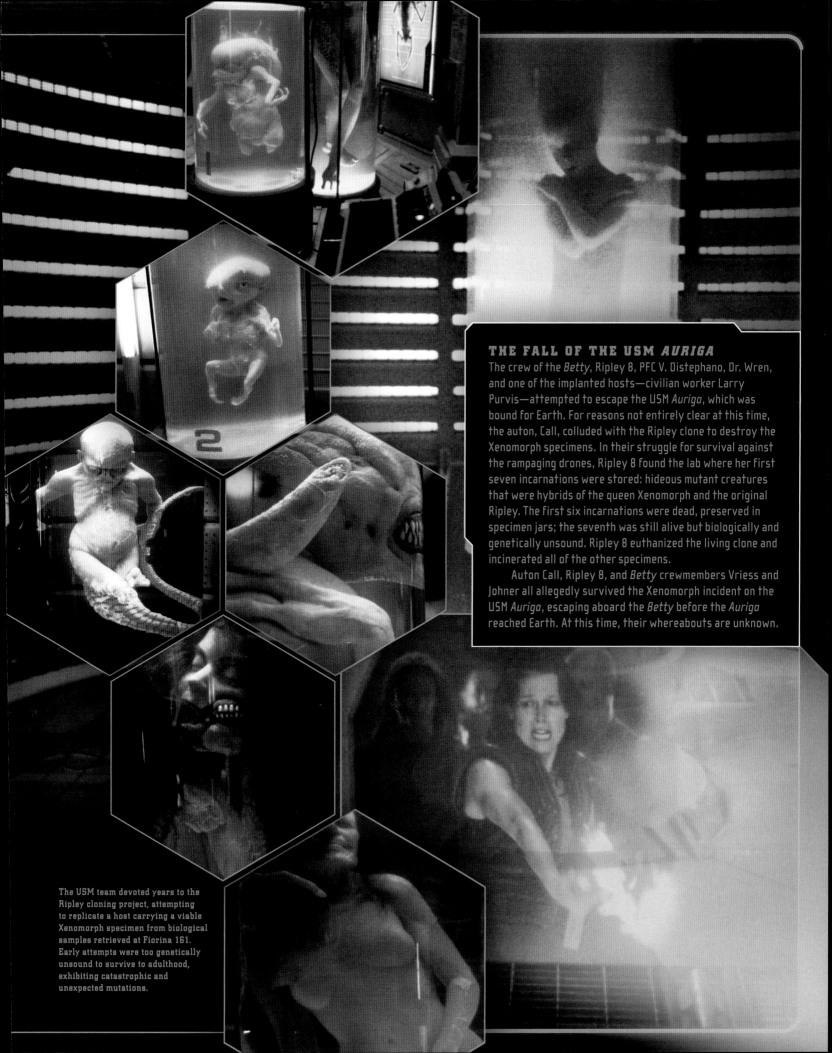

THE FALL OF THE USM *AURIGA*

The crew of the *Betty*, Ripley 8, PFC V. Distephano, Dr. Wren, and one of the implanted hosts—civilian worker Larry Purvis—attempted to escape the USM *Auriga*, which was bound for Earth. For reasons not entirely clear at this time, the auton, Call, colluded with the Ripley clone to destroy the Xenomorph specimens. In their struggle for survival against the rampaging drones, Ripley 8 found the lab where her first seven incarnations were stored: hideous mutant creatures that were hybrids of the queen Xenomorph and the original Ripley. The first six incarnations were dead, preserved in specimen jars; the seventh was still alive but biologically and genetically unsound. Ripley 8 euthanized the living clone and incinerated all of the other specimens.

Auton Call, Ripley 8, and *Betty* crewmembers Vriess and Johner all allegedly survived the Xenomorph incident on the USM *Auriga*, escaping aboard the *Betty* before the *Auriga* reached Earth. At this time, their whereabouts are unknown.

The USM team devoted years to the Ripley cloning project, attempting to replicate a host carrying a viable Xenomorph specimen from biological samples retrieved at Fiorina 161. Early attempts were too genetically unsound to survive to adulthood, exhibiting catastrophic and unexpected mutations.

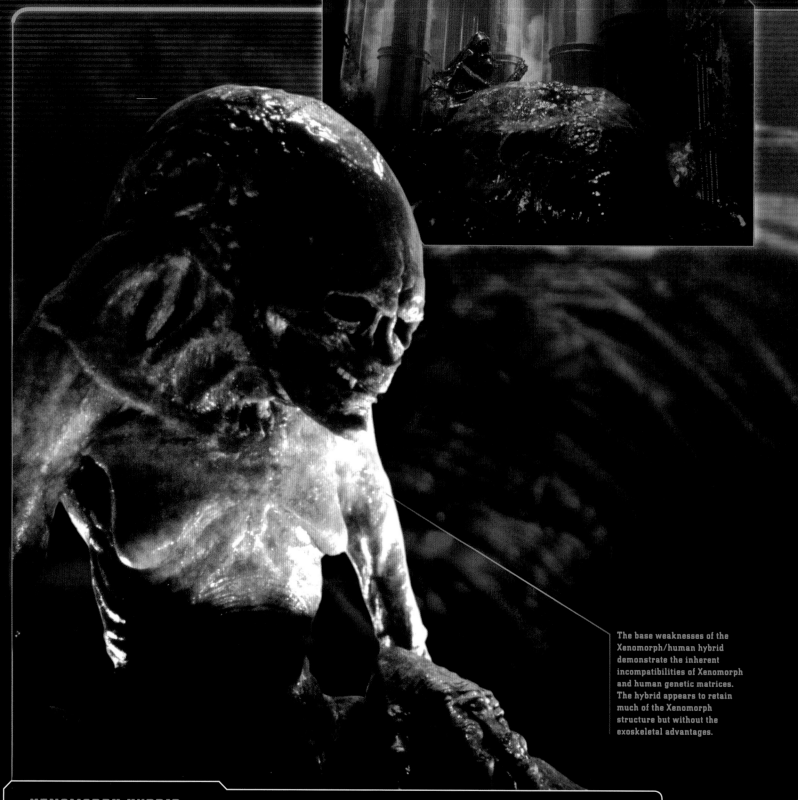

The base weaknesses of the Xenomorph/human hybrid demonstrate the inherent incompatibilities of Xenomorph and human genetic matrices. The hybrid appears to retain much of the Xenomorph structure but without the exoskeletal advantages.

XENOMORPH HYBRID

A Xenomorph hybrid borne by the Xenomorph queen was engineered from the original Ripley's DNA samples. This "newborn" killed its alien mother, choosing instead to identify with Ripley 8. Ripley 8 subsequently killed the hybrid. The hybrid was clearly inferior to/weaker than the Xenomorph.

New facts and theories regarding the queen's relationship with her workers and specific growth rates for the species are being posed and collated now. All data regarding the Xenomorphs on the *Auriga* is suspect, as there were no genetically pure XX121 specimens on board. Some of the information may prove useful; however, if the Company gathers anything from this most recent interaction, it will be no thanks to the United Systems Military. The USM dedicated substantial resources to this project. They allowed lunatics to breed an unstable specimen and failed to properly contain the offspring; they ignored the history of the aliens' superior aggression and dominance, preferring to believe that they could handle the creatures with simplistic aversion training. When the experiment grew beyond their control—literally only hours after the first drone had hatched—they had no suitable emergency fail-safes in place.

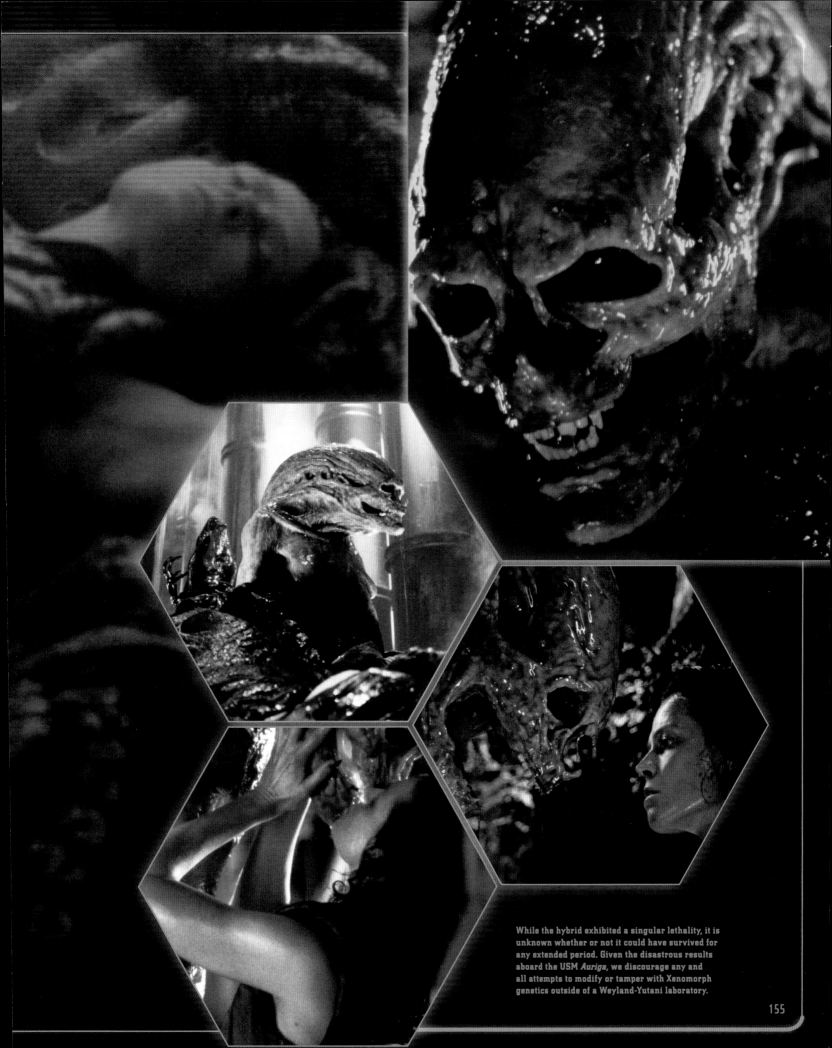

While the hybrid exhibited a singular lethality, it is unknown whether or not it could have survived for any extended period. Given the disastrous results aboard the USM *Auriga*, we discourage any and all attempts to modify or tamper with Xenomorph genetics outside of a Weyland-Yutani laboratory.

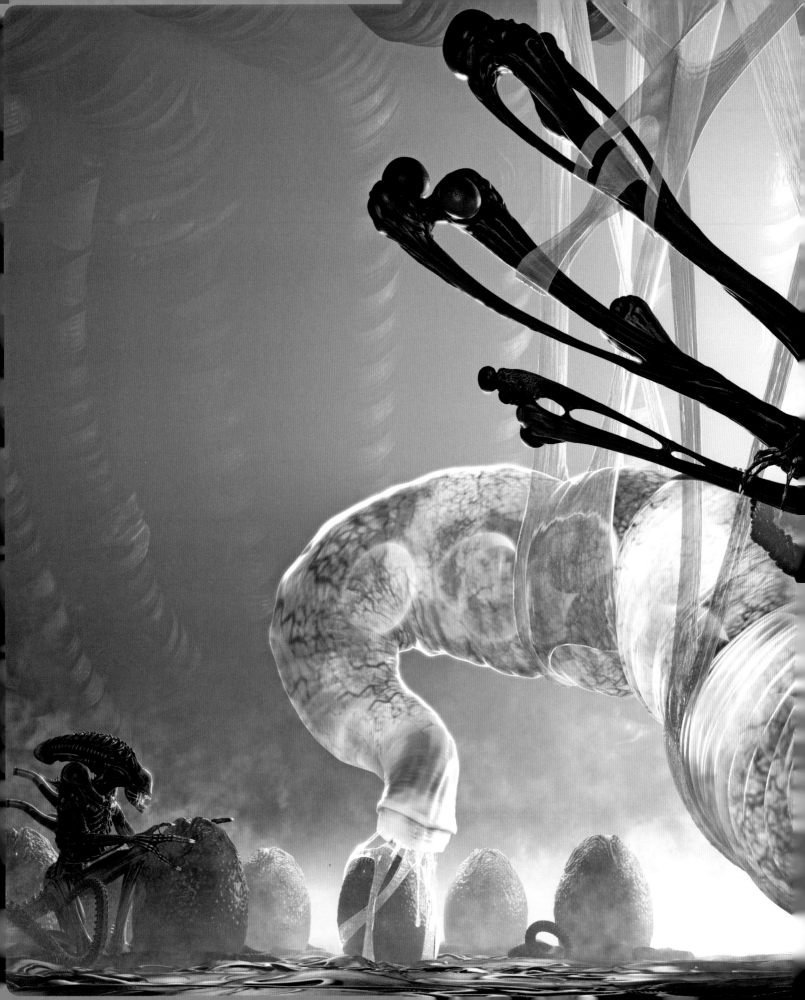

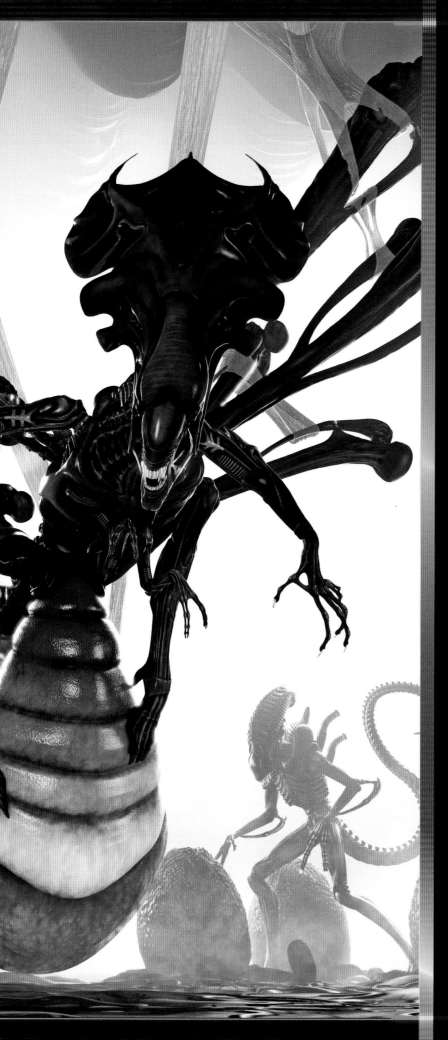

A NEW BEGINNING

IT HAS ONLY BEEN MONTHS SINCE THE CRASH LANDING OF THE USM *AURIGA*; DATA IS STILL BEING GATHERED.

FOLLOWING THE CATASTROPHIC MISHANDLING OF XENOMORPH XX121 DURING MORE THAN A CENTURY OF THE USM'S SELFISH INCOMPETENCE, IT IS CLEARLY TIME FOR ANY AND ALL INFORMATION REGARDING XENOMORPH XX121 TO BE RETURNED TO PRIVATE INTERESTS. CONTACTS IN THE USM PROMISE DELIVERY OF ALL XENOMORPH RELATED DATA, AND WE ARE DEDICATED TO SEARCHING FOR VALUE IN WHATEVER MATERIAL THEY ARE ABLE TO PROVIDE.

THE SCIENCE IS AVAILABLE. THE XENOMORPH CAN BE REPLICATED, IF THE INVESTORS CHOOSE TO GO THAT ROUTE. WE'RE ALSO ENCOURAGING FREELANCE BIOSCIENCE AND BOUNTY TEAMS TO ACQUIRE SPECIMENS; CONSIDERING THE RECENT ADVANCES IN FTL TRAVEL, DEEP SPACE SEARCHES CAN BE CONDUCTED IN DAYS RATHER THAN WEEKS, WEEKS RATHER THAN MONTHS. FINDING AND CAPTURING XENOMORPH SPECIMENS HAS NEVER BEEN MORE LIKELY.

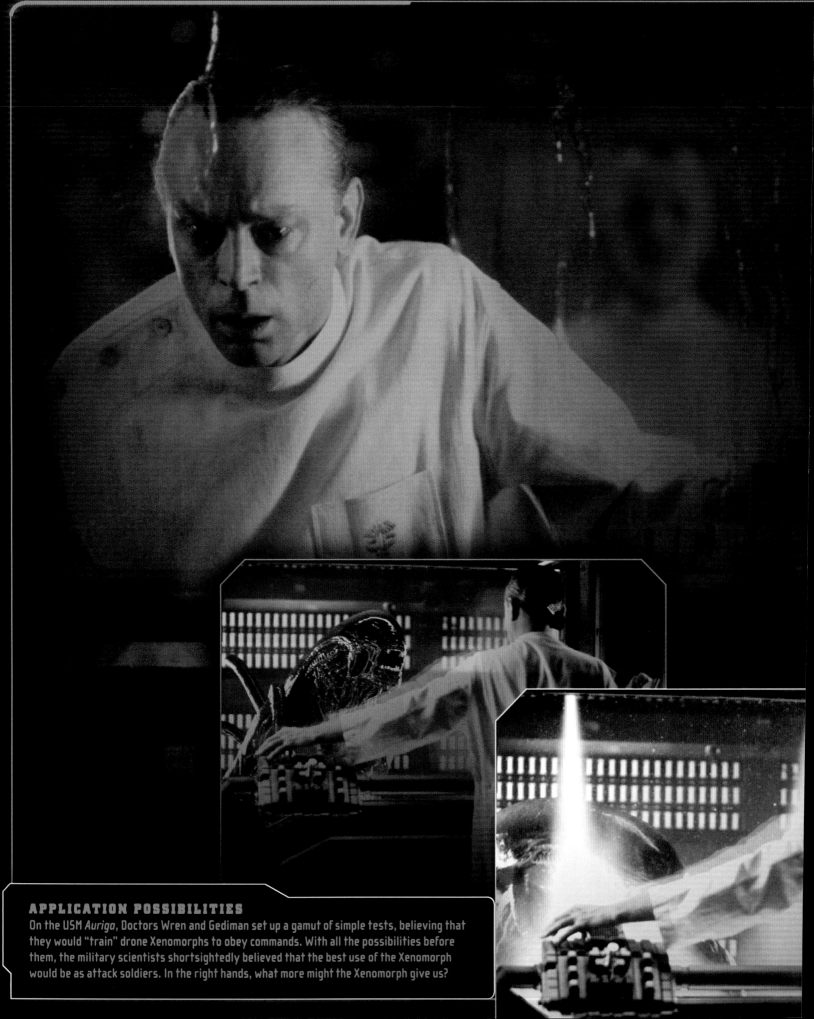

APPLICATION POSSIBILITIES

On the USM *Auriga*, Doctors Wren and Gediman set up a gamut of simple tests, believing that they would "train" drone Xenomorphs to obey commands. With all the possibilities before them, the military scientists shortsightedly believed that the best use of the Xenomorph would be as attack soldiers. In the right hands, what more might the Xenomorph give us?

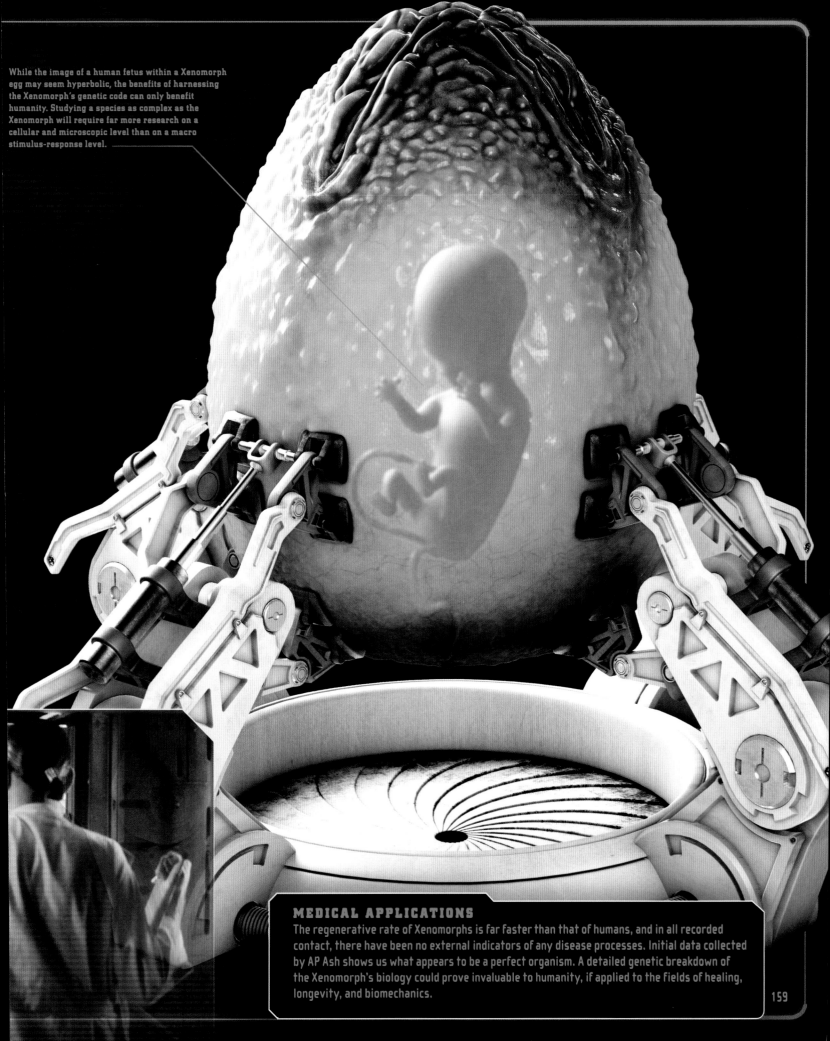

While the image of a human fetus within a Xenomorph egg may seem hyperbolic, the benefits of harnessing the Xenomorph's genetic code can only benefit humanity. Studying a species as complex as the Xenomorph will require far more research on a cellular and microscopic level than on a macro stimulus-response level.

MEDICAL APPLICATIONS

The regenerative rate of Xenomorphs is far faster than that of humans, and in all recorded contact, there have been no external indicators of any disease processes. Initial data collected by AP Ash shows us what appears to be a perfect organism. A detailed genetic breakdown of the Xenomorph's biology could prove invaluable to humanity, if applied to the fields of healing, longevity, and biomechanics.

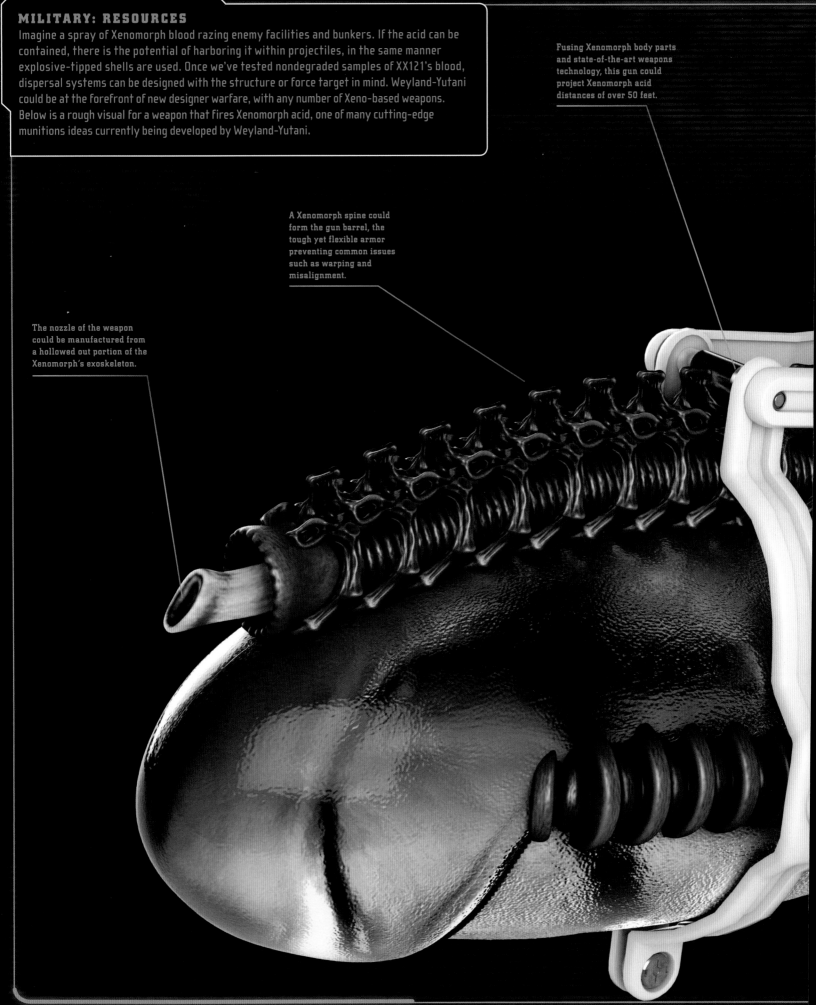

MILITARY: RESOURCES

Imagine a spray of Xenomorph blood razing enemy facilities and bunkers. If the acid can be contained, there is the potential of harboring it within projectiles, in the same manner explosive-tipped shells are used. Once we've tested nondegraded samples of XX121's blood, dispersal systems can be designed with the structure or force target in mind. Weyland-Yutani could be at the forefront of new designer warfare, with any number of Xeno-based weapons. Below is a rough visual for a weapon that fires Xenomorph acid, one of many cutting-edge munitions ideas currently being developed by Weyland-Yutani.

Fusing Xenomorph body parts and state-of-the-art weapons technology, this gun could project Xenomorph acid distances of over 50 feet.

A Xenomorph spine could form the gun barrel, the tough yet flexible armor preventing common issues such as warping and misalignment.

The nozzle of the weapon could be manufactured from a hollowed out portion of the Xenomorph's exoskeleton.

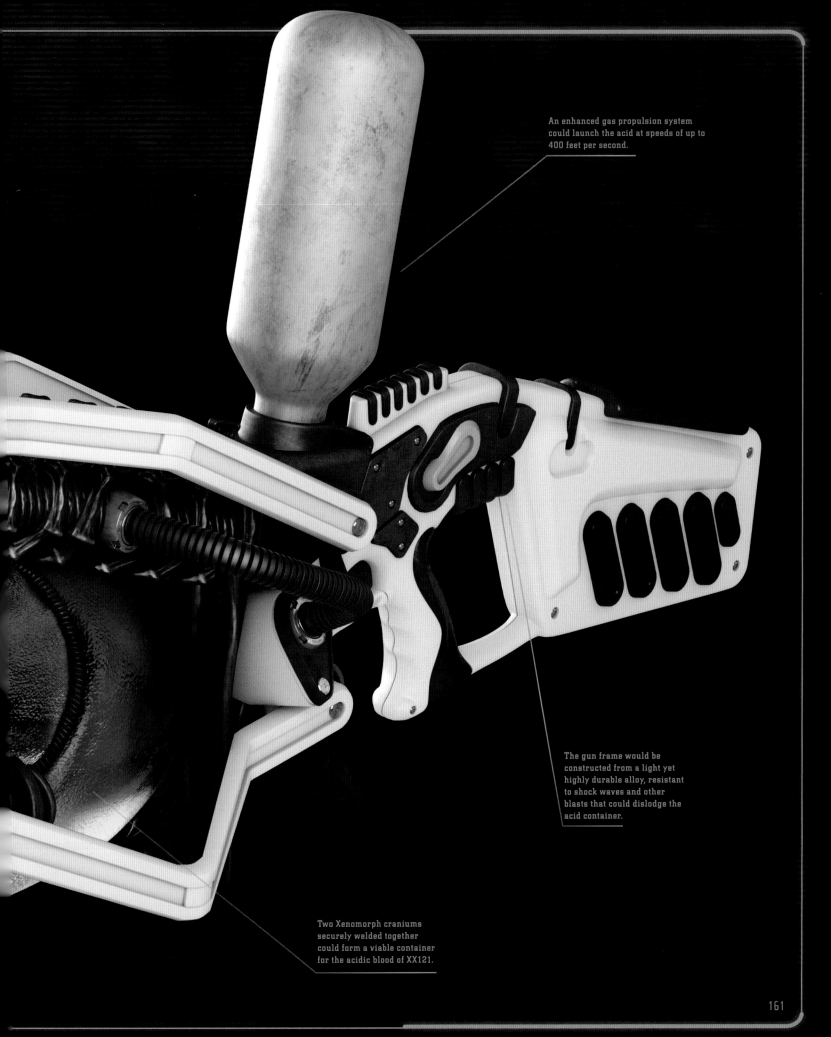

An enhanced gas propulsion system
could launch the acid at speeds of up to
400 feet per second.

The gun frame would be
constructed from a light yet
highly durable alloy, resistant
to shock waves and other
blasts that could dislodge the
acid container.

Two Xenomorph craniums
securely welded together
could form a viable container
for the acidic blood of XX121.

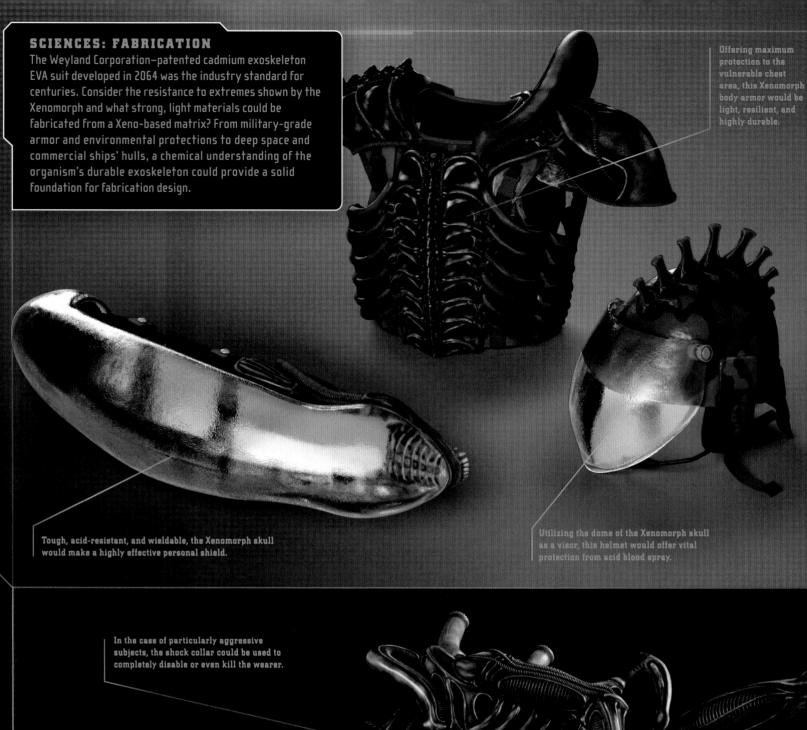

SCIENCES: FABRICATION

The Weyland Corporation–patented cadmium exoskeleton EVA suit developed in 2064 was the industry standard for centuries. Consider the resistance to extremes shown by the Xenomorph and what strong, light materials could be fabricated from a Xeno-based matrix? From military-grade armor and environmental protections to deep space and commercial ships' hulls, a chemical understanding of the organism's durable exoskeleton could provide a solid foundation for fabrication design.

Offering maximum protection to the vulnerable chest area, this Xenomorph body armor would be light, resilient, and highly durable.

Tough, acid-resistant, and wieldable, the Xenomorph skull would make a highly effective personal shield.

Utilizing the dome of the Xenomorph skull as a visor, this helmet would offer vital protection from acid blood spray.

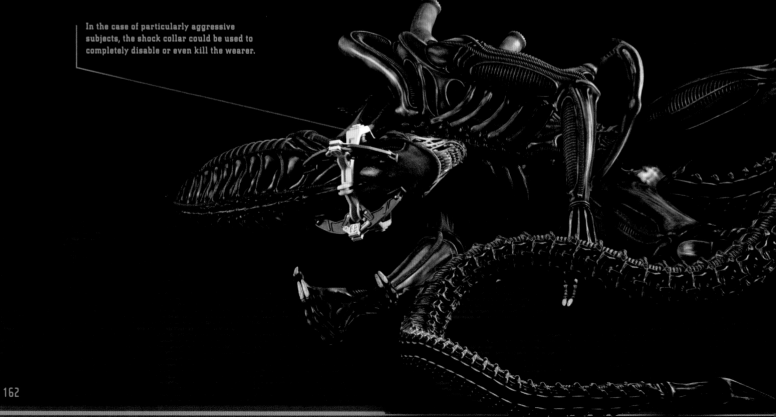

In the case of particularly aggressive subjects, the shock collar could be used to completely disable or even kill the wearer.

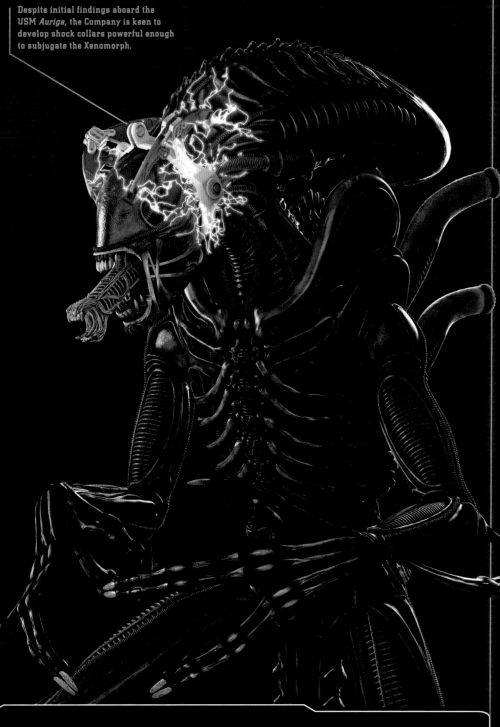

Despite initial findings aboard the
USM *Auriga*, the Company is keen to
develop shock collars powerful enough
to subjugate the Xenomorph.

These boots could offer much
needed protection from pools of
spilled Xenomorph blood when
infiltrating hives.

MILITARY: DIRECT CONTACT

Initial results from the USM *Auriga* do not suggest that the Xenomorph drone can be disci-
plined as a soldier. However, the intimated intelligence of the alien queen suggests that she
might be motivated to control the drones. Regardless, the careful placement of a cache of
Xenomorph eggs into enemy territory or on an enemy vessel could potentially decimate
battalions of adversaries in a matter of days, with minimal risk to our soldiers. Alternately,
enemy subjects could be implanted and released among their comrades.

Certainly, there will be more options available than even we are aware. Considering the
inevitable overthrow of USM control over corporate affairs, we can look forward to proudly
reclaiming our proper designation, Weyland-Yutani, as early as the next core election year.
It is time to welcome the next generation of researchers and explorers, of creative,
proactive men and women ready to add to the Company's prosperity by advancing
humanity's interests. Tasking these new young minds with unraveling the secrets of the
Xenomorph can only lead to a new era of influence and affluence for Weyland-Yutani.

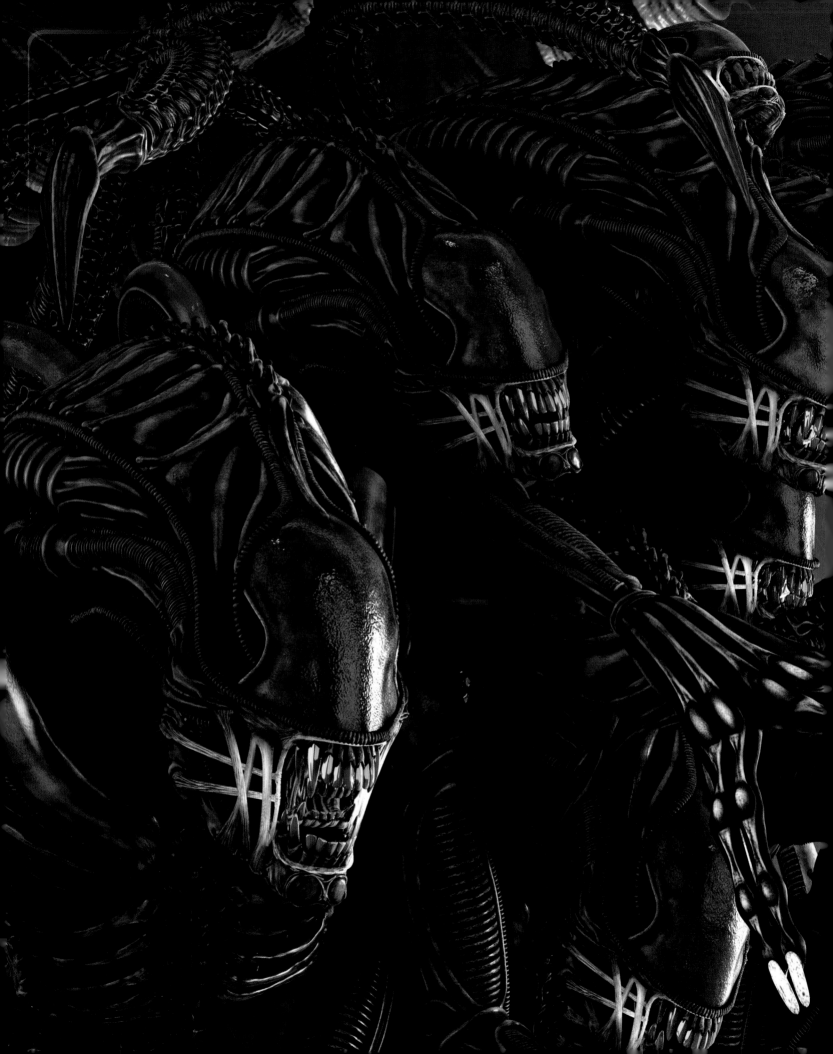

COMPANY NOTE: portion of Weyland-Yutani interview with Colonel Stella Sten, USM field commander (ret.), regarding tactical approach of Xenomorph hive. Recorded 09282381. Following her retirement from active service, Sten was contracted by Weyland-Yutani interests to review data regarding Xenomorph XX121 and provide recommendations to the company.

WEYLAND-YUTANI CORP

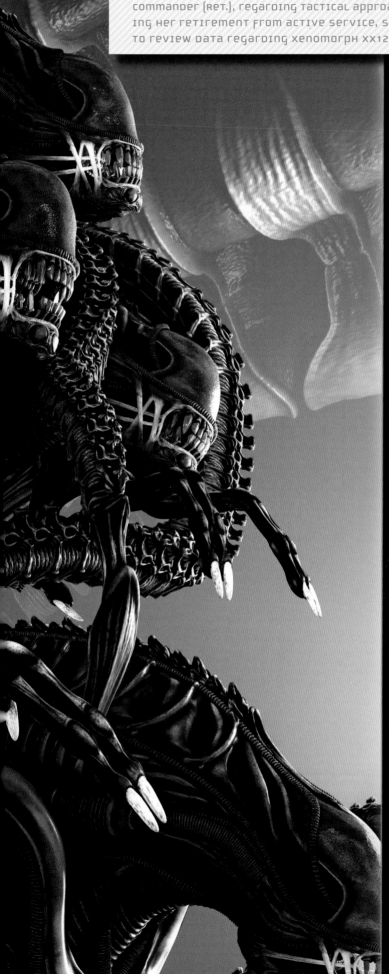

IS IT POSSIBLE TO TAKE A XENOMORPH HIVE INTACT?

The Xenomorphs have no technological defenses we're aware of. Taking out a hive is easy. If you want to capture any or all of the Xenos and survive the encounter, that's a lot harder. I agree with Seto [Sgt Maj Jack Seto, tactical advisor aboard the USM *Auriga*] that anyone who chooses to fight these things in a hive environment won't live too long. Ellen Ripley's experience on LV-426 and then again on Fury 161, they were the exceptions, not the standard. All the people who died, they're the standard.

You'll need to draw them out. A hive appears to be centered around the queen and the egg chamber, with a multitude of access tunnels. You'll want to find every way into or out of the hive before you ever put boots on the ground.

HOW, SPECIFICALLY, WOULD YOU RECOMMEND SUBDUING A HIVE?

Smoke, fire, and a shit-ton of hardware. After viewing all the footage, I'd say projectile weapons have a clear advantage over electrical charge weapons. The Marines at LV-426 died too, but not as fast as the soldiers on the *Auriga*; charge weapons aren't as effective at deterring the aliens. Three-man teams at every exit, wearing filter masks and full armor, including full face shields plated with a chemically bonded neutralizer. Each team runs a thirty-minute sequence of CS-40 smoke grenades; anything that breathes will run from smoke. If they think the hive is on fire, the Xenomorphs should gather the eggs and head for a clear exit. Naturally, some will run to the smoke grenades in defense of the hive; if the teams are armed with incinerators, they'll be able to take out the defenders and hold a continuous fire pattern, which should keep the Xenos from bursting out en masse. If the Xenomorphs do gather to rush an exit, explosive grenades should be used to deny them egress. Everything that tries to leave gets blown to pieces. When you've cut their numbers down, then you can start a sweep of the hive and begin bagging the stragglers.

HOW LIKELY IS IT THAT A SMALLER GROUP COULD CAPTURE A HIVE?

It isn't. The Marines on LV-426 were well trained; they were absolute badasses, and they got their asses kicked. Fiorina 161 was populated with violent, hardened criminals, and they fared no better. The *Auriga* was a military vessel, packed with soldiers, but when the Xenos escaped containment, everyone panicked like children. Of course, a strong leader might have made a difference. Ellen Ripley managed to survive several interactions; a smaller group might have a chance if they've got someone like her in charge.

WHAT TYPE OF TACTICS DO THE XENOMORPHS USE?

I haven't seen a consistent fighting style or tactic. On the *Nostromo*, the single Xeno attacked thoughtfully. It hunted the crew, attacking when they were vulnerable. On LV-426, they swarmed en masse in defense of the hive. No tactics, no hesitation, no thought for individual safety. All activity was geared toward securing the safety of the queen. After the Marines retreated, it looks like the queen sent individuals and small groups to test defenses and search for weaknesses. Once a weakness had been found, they exploited it.

The Xeno on Fury 161 was even more violent. I have to wonder if its instincts weren't influenced by its host, apparently a dog. Its attacks were opportunistic; its focus seemed to be on reducing threats to the gestating queen, rather than on obtaining hosts.

What little you have from the *Auriga* is telling, and perhaps the most frightening. The Xenos' method of escape suggested intelligence, planning, and willing sacrifice, plus a genuine understanding of cause and effect. If you've captured a Xeno, you're not safe unless it's in stasis or dead.

OBTAINING A SPECIMEN
TACTICAL CONSIDERATIONS, OVERVIEW

It has been centuries since we first became aware of this distinctive creature, but opportunities to study it have been few and far between. With the resources available to us now, there is no reason why we cannot obtain more information regarding this magnificent species. We want what you can bring us. Even the smallest specimen can be of value to our company: An undecayed tissue sample could help unravel the entirety of the alien's DNA sequence; a viable portion of the exoskeleton could help us decipher its biological components; a sample of Xenomorph blood in an anoxic container could help us replicate it. With viable, active samples, the possibilities are limitless.

TO ASSIST YOU IN YOUR VENTURE, WE HAVE COMPILED A BRIEF LIST OF CONSIDERATIONS:

❄ An adult Xenomorph is far stronger and faster than an adult human. If conditions allow, consider collecting an egg.

❄ Never assume a single Xenomorph does not have an entire hive to back it up. Learn their environment before entering. Forewarned is forearmed.

❄ Comparing events on LV-426 and Fiorina 161 shows us that the host has a considerable influence on the resulting adult offspring. Do they have unusual forms of mobility? Observe your prey before attempting its capture.

❄ When not active, Xenomorphs appear to be in a self-imposed stasis, rendering motion trackers useless. They do not appear on infrared scanners while inside their hives. Xenomorphs also secrete a resin to modify their environment and to imprison captives. This resin is surprisingly tough and heat resistant. Resin sampling is encouraged.

❄ Always be aware, always be alert. As the events on the USM *Auriga* confirm, if imprisoned and awake, a Xenomorph will continually attempt escape.

❄ While all projectile weapons are effective against Xenomorphs, the range at which the weapon is used is of primary importance. Many projectiles have significant "knock-down" power against humans. Remember, a Xenomorph is not human; the "knock-down" power rating does not apply. A critical element to consider regarding close-range combat is the defense mechanism of the Xenomorph; puncturing the exoskeleton releases an acid spray. Explosive-tipped rounds will increase the spray volume and radius. Grenades have a similar effect.

❄ Data regarding effectiveness of nerve gas or other chemical weapons against the Xenomorph is insufficient. Not recommended.

❄ Nontraditional weapons have proven to be effective against adult Xenomorphs. Twice, Xenomorph specimens have been ejected into the vacuum of space. Though both survived for a short time, there is nothing to indicate that the Xenomorph could survive indefinitely. In an early conflict, a single human was able to match a queen Xenomorph's strength with the use of a power loader. Fire has been shown to be consistently effective against the Xenomorph. It is the only thing known to give them pause when attacking, and fire does not appear to damage viability. When it comes to capturing or subduing one of these creatures, a creative approach should be considered.

❄ If you manage to isolate and capture a Xenomorph at any stage of its development, contact us immediately at comnet, any channel. Financial recompense will be considerable.

❄ If you or a member of your group becomes implanted by a Xenomorph, do not panic. Isolate the host, put him or her in stasis (ideally, before the facehugger organism has detached itself), and bring the host to us. We have the technology and capability to quickly and safely remove the embryo without harming the host. The collected embryo is of great value, as it would enable us to study the Xenomorph from its earliest stage of development. Rest assured that your group member will be cared for and compensated.

The alien is a formidable opponent, to be sure, but it is not invincible. With a minimal investment of time and resources, your contact with the Xenomorph could prove invaluable to the Company. We are currently considering any and all freelance contract negotiations that will provide Weyland-Yutani first rights to this unique biospecimen.

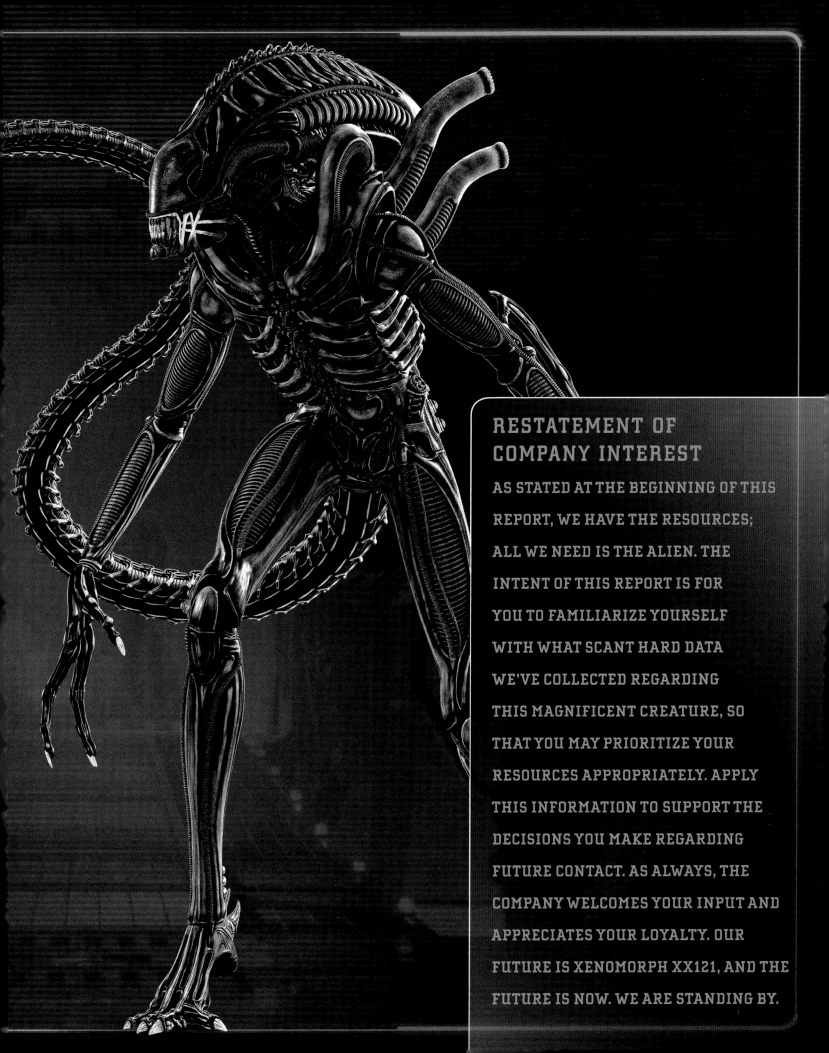

RESTATEMENT OF COMPANY INTEREST

AS STATED AT THE BEGINNING OF THIS REPORT, WE HAVE THE RESOURCES; ALL WE NEED IS THE ALIEN. THE INTENT OF THIS REPORT IS FOR YOU TO FAMILIARIZE YOURSELF WITH WHAT SCANT HARD DATA WE'VE COLLECTED REGARDING THIS MAGNIFICENT CREATURE, SO THAT YOU MAY PRIORITIZE YOUR RESOURCES APPROPRIATELY. APPLY THIS INFORMATION TO SUPPORT THE DECISIONS YOU MAKE REGARDING FUTURE CONTACT. AS ALWAYS, THE COMPANY WELCOMES YOUR INPUT AND APPRECIATES YOUR LOYALTY. OUR FUTURE IS XENOMORPH XX121, AND THE FUTURE IS NOW. WE ARE STANDING BY.

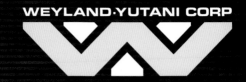

WEYLAND·YUTANI CORP

Dedicated to the memory of H. R. Giger, whose extraordinary vision gave birth to this "Perfect Organism."

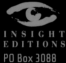

INSIGHT EDITIONS

PO Box 3088
San Rafael, CA 94912
www.insighteditions.com

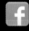 Find us on Facebook:
www.facebook.com/InsightEditions

 Follow us on Twitter:
@insighteditions

CREDITS

Written by S. D. Perry
Xenomorph illustrations by Markus Pansegrau
Vehicle illustrations by John R. Mullaney

Betty nose art by James Martin
Additional patches and logos illustrated by Mike Rush

PUBLISHER Raoul Goff
ACQUISITIONS MANAGER Robbie Schmidt
EXECUTIVE EDITOR Vanessa Lopez
SENIOR EDITOR Chris Prince
ART DIRECTOR Chrissy Kwasnik
DESIGNER Jon Glick
PRODUCTION EDITOR Rachel Anderson
PRODUCTION MANAGER Anna Wan
EDITORIAL ASSISTANT Elaine Ou

Insight Editions would like to thank Josh Izzo, Lauren Winarski, Willie Goldman,
Scott Middlebrook, Harry Harris, Dennis Lowe, Fred Blanchard, Andrew David,
Graham Langridge, Charles de Lauzirika, Mandy Elliott, Sassy Tipping, Nick Craske,
Theresa Hickey, Bruna Zanelli, Tara Prem, Bill Paxton, and all the performers from
the Alien franchise who agreed to participate in the making of this book.